Another how-to book for wo[men]... book? Sure—if the conventi... ... Donald Miller, C.S. Lewis, Brennan Manning, Mother Teresa, and Bono in attendance. I haven't had this much fun since Chesterton's *Orthodoxy*, and yes, it's all here in a book for women who are mothers.

In *Running into Water*, Angela Blycker unflinchingly addresses the guilt that, rationally or not, accompanies our efforts to be good women, moms, or Christians. She unapologetically calls women to a clearly painful yet far easier way to raise children and walk out Christianity before an unimpressed world: in Christ alone. Blycker shows both the human beauty and futility in our own efforts, and continually points to Christ for his freedom, his way. Here's the glorious kicker: she shows just how we *can* lay down our will, and the monstrous strength therein, and make an ally of God for his strength, his vision, his hope.

Speaking of . . .

I say of this work what C.S. Lewis said of a certain trilogy by a colleague of his, a guy by the name of Tolkien: it is "good beyond hope." That's what Angela gives us for the long haul in this dynamite volume—refreshing, immersing, and relieving hope. It's a book destined to be annotated, underlined, quoted, beat-up, and not lent out. You'll say of it with unqualified selfishness, "Get your own. The oil in this baby's mine."

TRACY GROOT, award winning novelist, author of *Madman*

Angela Blycker's breath-taking book *Running into Water* is a visionary work with a fresh voice that captures the essence of God's great heart for the high calling of women and motherhood. Fed by the richness of her global experience and infused with incisive yet accessible literary and theological references, Blycker's book will stir the souls of mothers and all those thirsting to pass a deep love for God to a new generation. *Running into Water* is a book that will stand as a classic, speaking to women across cultures and generations.

SHELLY BEACH, 2008 Christy Award Winner, author of *The Silent Seduction of Self-Talk* and contributor to *The NIV Stewardship Study Bible*

This book is a personal, global, and theological journey that compels a woman to unabashedly plunge into the *living water*, no matter the stage of life. Many women who are mothers tend to put their intellectual and spiritual development "on hold" only to find they are withering. *Running into Water* will motivate, refresh, and integrate women and mothers globally toward wholeness and purpose with a sense of grace and power.

DR. JO ANN LYONS, founder of *World Hope International*,
a faith based relief and development organization
alleviating suffering and injustice through education,
enterprise, and community health, and current
General Superintendent of the Wesleyan Church

Here is a completely unexpected and wondrous book, a wise and often profound journey to the place where the holy and mundane meet in our everyday lives as women and as mothers. With bracing honesty, courage, and depth, Angela Blycker shows us how to better lead our children in soul formation, and grow ourselves. This book shimmers with revelation, and I'm so excited to tell my thoughtful fellow women and mothers about *Running Into Water*.

LORILEE CRAKER, author of several parenting books,
including *Just Give Me a Little Piece of Quiet*,
and the co-author of the 2008 New York Times Bestseller
*Through the Storm: A Real Story of Fame and
Family in a Tabloid Age* with Lynne Spears

A reflection of experience in the realities of life globally as a woman and a mother, *Running Into Water* demonstrates the refreshing, sustaining blessing of an intimate relationship with the author of this life, God himself. This fresh and compelling book will lead the reader deeper into God. A perceptive thinking woman and dedicated mother, Blycker presents the Water of Life in a way that will satisfy every thirsty soul.

DR. RONALD BLUE, former president of *Central American Mission International* and current International Mobilizer of Latin Missions and coordinator of the Spanish Doctor of Ministries at *Dallas Theological Seminary*

RUNNING INTO WATER

RUNNING INTO WATER
WOMEN IMMERSED IN THE PURSUIT OF GOD

ANGELA BLYCKER

Authentic

COLORADO SPRINGS • MILTON KEYNES • HYDERABAD

Authentic Publishing
A Ministry of Biblica
We welcome your questions and comments.

USA 1820 Jet Stream Drive, Colorado Springs, CO 80921
 www.authenticbooks.com
UK 9 Holdom Avenue, Bletchley, Milton Keynes, Bucks, MK1 1QR
 www.authenticmedia.co.uk
India Logos Bhavan, Medchal Road, Jeedimetla Village, Secunderabad
 500 055, A.P.

Running Into Water
ISBN-13: 978-1-60657-030-2

Copyright © 2009 by Angela Blycker

11 10 09 / 6 5 4 3 2 1

A catalog record for this book is available through the Library of Congress.

Cover design: Sarah Hulsey
Interior design: projectluz.com
Editorial team: Bette Smyth, Kay Larson, Susan Rollins

Printed in the United States of America

FOREWORD

Thomas Merton once wrote, "Our minds are like crows. They pick up everything that glitters, no matter how uncomfortable our nests get with all that metal in them."

If you are a young mother like me, you will probably admit to standing occasionally in a bookstore, drawn by exhaustion and sheer habit to the "Christian Inspirational Writing" section, with no real direction. You are fragmented and wilting from apathy, desperately scanning the shelves for ANYTHING that speaks to *you*. You stare through a fog of depletion into the great abyss of titles that promise to speak to women's needs. Many of them seem to be shiny and pink and full of anecdotal Jesus-y ways, to help you be the mother you were meant to be with a more organized pantry and a scrapbook that screams Proverbs 31. Another pinkish book has extremely helpful suggestions on staying whimsical and sexy for that guy it seems you married. For reasons that only millions of other women understand, in your strained delirium, you frantically pluck it from the shelf. It glitters.

Welcome to my nest.

It is hard to grasp how marginalized and condescending most writing for Christian women is until you stumble disbelievingly onto something that is so profoundly . . . not. This book left me breathless. Stung at first by its many truths, the way an ocean's wave slaps you sideways before it retreats into gentle waters beckoning reluctant toes into the deep. And deeper has never meant easier. Don't waste your money on this if your soul needs more chicken soup.

Angela Blycker has no interest in defining the role of a

Christian mother. (Who, but God, could carve that into each heart?) Rather, she longs to baptize us first with the knowledge of who we are before Christ, and then show us with beautiful enthusiasm how we might swim at the center of that powerful current, no longer struggling against it. Understanding the deep thirst in a mother, she fills our cup over and over, leading us back to the One who "has the divine ability to satisfy thirst with even more good thirst." I shed many tears into my own cup at this realization.

Angela's writing is fiercely alive with conviction and challenge, yet still utterly personal, both raw and revealing. I will read it again and again and again.

Nichole Nordeman
October 2009

NOTE TO THE READER

The narratives of the women in this book are true. While I have chosen to use my family members' real names, in all other accounts the names and identifying details of others have been changed in order to maintain confidentiality.

Because this book is written from the perspective of a woman and a mother and is intended for same, it does not elaborate on the indispensable role of men, husbands, and fathers. This omission is not intended to dishonor men nor suggest that the spiritual formation of women and children is separate from their presence and partnership, which the author regards as vital.

Most writers who follow Christ write to work out the truth of their own salvation; most readers read to know they are not alone. Both are necessary. My gratitude for you and in the part you play in this process is indescribable.

C.S. Lewis talked of "receiving" a book instead of "using" it.[1] A user sees reading as a pastime, but a recipient rests in the ideas. To receive it is to explore what is being said and to let the author take you on a walk. Taking in all the scenery, you let yourself be challenged. You respond to God about what you've read. When we receive a book instead of using it, it adds to our life and blesses us with the re-orientation of our thinking. This is my hope for you and this book, that you will receive it and respond as the Holy Spirit leads.

"Books are sacraments that make communion between an author and a reader possible. The paper and the words are merely the elements of the sacrament. What is sacred is the heart that writes the book and the heart that sits in silent communion to take and read what has been written."[2]

Words are my best offering.
I bring this compilation to the One True King.

With love, gratitude, and hope for my children,
Larsen Philip, Anders Ezekiel, and
newly-born Kiersta Linnea,
and their coming generations.

In honor of the man without whom
I would not have had the courage to present
this offering:
my beloved and most essential husband,
Benjamin.

CONTENTS

YOUR INVITATION

We pursue God because, and only because, He has first put an urge within us that spurs us to the pursuit. It is by this prevenient drawing that God takes from us every vestige of credit for the act of coming. The impulse to pursue God originates with God, but the outworking of that impulse is our following hard after God.[1]
—A. W. Tozer

Water is "the great fact of life, the always possible escape from dullness. The sun rose out of it, the day began there: it was like an open door that nobody could shut. The land and all its dreariness could never close in on you. You had only to look at the water, and you would know you would soon be free."[2] —Willa Cather

Come, come all who are thirsty; come to the waters . . . that your soul may live. Isaiah 55:1–3

ONE EVENING I RAN INTO WATER.

It was near sundown, and my five-year-old son and I stood and looked out at the water. Lake Michigan in the summer holds

out its hand, those pulsating fingers teasing you, reaching out for the sand, and then retreating. The roar of a million liquid tongues floods all sound, strangely soothing and inviting. When I remember my childhood, I always remember that water, a long blue smear.

"Last one in is a rotten dog biscuit," I yelled to Larsen as I tore off my watch and threw down my keys. He looked at me with surprise, then with glee, not far behind as I began to run straight into the lake with my clothes on. I reached back to grab his hand, still so small and always open to take mine, and we ran together into the waves.

I twirled Larsen around and around, his slender legs cutting through the white waves, firm and joyous. After awhile we climbed back out of the shallow water, creeping onto the shoreline on all fours to plop on the sand. We stared out at the horizon, mesmerized by the far-off edge and the sailboats moving into the harbor. Lars broke the silence, "What is water made out of?" Before I could attempt an answer, he listed all the reasons we need water.

Pausing in his list, he just sat back on his elbows and announced, "Well, you can know about water, but not really know it until you know that you need it. Until you run into it. Then you know water. Even if you do not understand how it is made exactly. But you just have to run into it, right, Mom?"

"Right, Lars, right." I replied slowly as I put my wet arm around his small shoulders, thinking of us there together, woman and mother, boy and son.

I never knew what motherhood was made of until I was absorbed into it and began my swim, my mothering practice which has pulled me into an even deeper God-immersion. I have sensed that this endeavor demands that I not only be a

heartfelt woman but also an intellectual one. Truly, mother-hood is not the place for easy sentimentality and humdrum rearing.

There are greater expectations of us than this. Perhaps you sense the gravity of the ancient maternal patterns from which you have come and from which you are now called to break free or set anew. I know I am not the only woman, the only mother, who has wrestled to discern what it truly means intellectually, willfully, emotionally, and practically to be on my own spiritual journey and properly use the cultivation power I have over the spiritual lives of my children.

This personal grappling has propelled me to write, for I do not believe that I am placed "on hold" during this season of motherhood. This is not the time for disengagement, but the opportunity for a level of engagement as I have never known. I know I stand shoulder-to-shoulder, deep in thought and passion, with a vast army of women, my sisters. They cover the globe, these mothers that birth the generations and the nations of the world. The history of their power and their tenacity to endure are vast—their tales composing an epic that is still being written this very moment, a constant movement that instigates and initiates the formation of entire cultures.

As women we hold a faint remembrance, especially when we first peer into the faces of our newborns, of what it was to be children ourselves in serious need of soul tending. Indeed, our own motherhood awakens within us our own dormant spiritual-ity or challenges the quest we have set on. We know instinctively that transmitting religious rules and mere facts, perpetuating checklists and traditions, enhancing our bodies and bank ac-counts will *not* satisfy—they all fall short of being the conduits of purpose we desperately long for them to be. Yet, we do not know

what else to do to foster true soul formation—both our own and those of our children.

All of us are born as image bearers of God, potential studiers of him with eternity set in our hearts. Even young children have a sense of transcendence expressed through their wonder, imagination, and creativity. They lack the language, but they are born with the capacity to engage in a life-long conversation with God. Humanity has attempted through the ages to give language to this innate spirituality, a spirituality only activated from the enlightenment of the Spirit of God.

We women engage in our own pursuits of God, trying to connect with him through our unique dialect of culture and calling while lifting up our own children in hopes they will do likewise— for what mother has ever desired spiritually flat children? The potential, the vision of what we will all become in this passionate venture of finding (because he first found us) and following God (our response), is much larger than the daily, mundane, tiny, and seemingly inconsequential moments.

If we lose this vision, we have lost all. If we neglect this vision—the revival of the intellect along with the redemption of the heart and soul—as women, we have not understood our calling. We may have gained the whole world, but we will have lost the soul of noble, honest, and intentional mothering. We will have forfeited transformation of great proportions, what we as women practicing motherhood and our offspring as children practicing growing were both intended to become—*wholly* transformed and renewed, going from one phase of beauty to another by the God who originated such a holy idea.

My little boy, his mind so warm and supple in his observations about the world around him, had unknowingly made a poignant commentary on what it is to immerse yourself in Jesus,

God incarnate, for this transformation I refer to—to go from being a mere acknowledger of God to a follower of him, entering into true spirituality.

In fact, that evening we both had set a metaphor for what it all means. It was the night of a bold mother willing to immerse herself in the water to be refreshed. The water so great and abundant showed itself to be that which could restore, purify, and quench as it washed over her. It was also the night of the eager child following his mother, invited by his own need, by the water before him, and by the hand of his mother.

The concept of water as something meaningful, internal, and cleansing is an ancient concept. Water is crucial to understanding much of the Bible, both metaphorically and literally. In fact, it is mentioned 722 times in Scripture.[3] Throughout God's story, water is depicted to be mutable, sublime, sustaining, and destructive. Representing birth and death, water's rushing power holds the hope of freedom and transformation.

Plunging into such water before God was to show the true intention of a heart inclined toward him as well as a tangible illustration to the holiness of life experiences such as conversion and marriage. Water, this clear ethereal liquid, was often symbolic of God's blessing, provision, care, and spiritual refreshment.

It was the waters God split to lead his people into freedom on dry land, and it was water he brought forth from a rock to quench their weary thirst. John the Baptist used bodily immersion into water to prepare the way for the Messiah and give believers the opportunity to express their repentance that primed them for the reception of their great deliverer. This deliverer Jesus, with the water of servant leadership, washed the feet of his small band and declared he must if they were to truly be his followers. Still today, thousands of years later, we follow his mandate to

enter into the waters of baptism, expressing an inner reality in an outward expression.

It is significant that God has chosen miraculous, mysterious, and glorious water to encapsulate so much of physical and spiritual life. We all need, crave, and pursue it. Even if we cannot see it in its invisible gaseous state, it is ever all around us. Our bodies and our blood are comprised of almost 70 percent water. As the primary mode for transportation of all nutrients in the body, it is essential for proper circulation. Planet earth would be nothing but a parched asteroid without it, as it is the most abundant molecule on the earth's surface. Hell itself is a place depicted to be void of water (Luke 16:23–24). It is essential to all forms of life. Without water, there is no life.

We all desperately need water; we all desperately need God. As Leo Tolstoy confessed, "He is there; the one without whom there could be no life. To know God and to live come to one and the same thing. God is life. Live, seeking God, for there can be no life without God."[4] This God of Water, he extends to *you* an invitation to run to him and find the life you were created for.

Running into Water is a three-part compilation of what it may look like to run hard after God as a woman and as a mother, even as he runs hard after us. This book is a plea to move beyond ourselves and much of what engulfs us, to consider what it means to be a transformed follower of Christ and of what it is to be a part of a greater global community, raising up the next generation even as we ourselves are growing with greater depth. Weaving narratives from women around the world and my own experiences, I hope you will find stories that speak into yours. Join me as I explore and interweave the theological beliefs and questions, spiritual practices, and ultimate intentions of women and mothers globally.

I believe our essence is our spirituality: satisfied and expand-ed in our restored relationship with God through Jesus Christ, which he has first initiated within us. All other aspects of what it is to be human—developing morally, physically, emotionally, and intellectually within our various cultures—flows out from this one eternal thing. I write out about this restored spiritual essence, as it determines the basis of every other area.

This pursuit of following Christ with authenticity has noth-ing to do with the common notion presented to women that the main reason to pour into the next generation is for who they will become. I believe that the reason we pour ourselves into the next generation is as much for who *we* will be as it is for who *they* will become. This book is not a plea to believe in yourself as a confident, powerful woman and mother, for as G.K. Chesterton wrote in his brilliant little volume entitled *Orthodoxy*, "Believing in oneself is one of the commonest signs of a rotter. . . . It would be much truer to say that a man will certainly fail, because he believes in himself. Complete self-confidence is a weakness. Believing utterly in one's self is a hysterical and superstitious belief."[5] This book is rather a call to embrace the belief that to follow Christ, to desire his fullness and realize his desire for you, means having your womanhood and your motherhood redefined. Your life becomes anything but commonplace; your mothering becomes anything but ordinary. Your immersion into Christ is much more than mere good morality for you or your children; it is a resurrection.

Pursuing this depth in your life is like rising to run and go forth into the river of life. Rise up and join me in the run! For we all are running somewhere, so let it be to the best place. The implications of millions of women and their children in global unison immersed in the discipleship lifestyle of being Christ

followers, utterly captivated by his excellencies, is as powerful as a mighty rushing river. This river winds in every direction, breaking up dry ground in different ways and in various times, but always with the intent to deliver life now and in the coming generations. Let us experience in mighty movement such a magnificent immersion into the Water.

Let our generation of women be known as the Ones Who Ran.

PART I:

BELIEFS

GOD IS:
THE GRAVEST BELIEF

Be strong, do not fear; your God will come ... he will come to save you. ...Water will gush forth in the wilderness and streams in the desert. The burning sand will become a pool, the thirsty ground bubbling springs. Isaiah 35:4, 6–7

MY OLDEST SON, BY AGE TWO, POSED QUESTION AFTER question, as if he were trying to uncover the instigator, the cause behind everything he saw or heard. The answer "God" satisfied him deeply and even brought him a particular gladness; children are far more receptive to the concept of the supernatural world than adults. For children, taught by parents who rightly define God, often easily fall into a life-long conversation with their Creator. In spite of studies showing they do not have the ability for abstract thoughts until they are much older, children still have a God-consciousness.[1]

With my youngest son, it is no different. He looks at me, waiting for how I respond to him. I find him in his crib every morning rising up on his plump little legs with pleasant excitement. He

waits for me to reflect that joy back to him in my expressions, in my movements. I imagine he receives his identity from the attention I give him. Later on he will transfer, perhaps unaware, what he saw in my eyes to what he perceives in God's. We constantly speak to our children of who God is. The conversation is ceaseless, whether we are aware of it or not.

I spoke recently to a woman in Thailand about this conversation between her and her children. Her conviction is that the God she met in her girlhood remains. A.W. Tozer stated that what we think about God is the single most important thing about us. For this reason the gravest question is always connected to what we, in our deepest heart, perceive God to be like. The answer to this question predicts with certainty the spiritual future of each person.[2] Learning Eve's answer to this question and hearing her story, I saw that apart from her faith, life would be cynical and aimless, void of hope and purpose. Are not all of our stories that way, apart from a redemptive God?

Eve elaborated on her life, sitting thousands of miles away from me in the sweltering heat. Rag nearby to wipe her forehead, hand on her very pregnant belly, she stayed up late into the night to give me her words.

She was born in Ecuador, lifted out of an orphanage as a three-month-old baby to be placed in the arms of a North American family. In the culture of her family, through music, particularly the singing about God's character, her concepts of him developed and crystallized. Exposure to these truths left an indelible mark.

Eve recounted many of her personal struggles as a woman, as a wife, and as a mother. The adjustment of moving and starting over many times during her growing up years as the daughter of a pastor and the pain of seeing churches split and crack open had

not been forgotten. As a grown woman, unexpected hard issues in marriage came, followed by the difficult birth with their first child and ensuing back problems.

Recently was the sorrow of losing their friends and their fellow teammates in Thailand. Their friends' little boy, during a routine doctor visit for a mere cold, had been diagnosed with acute leukemia. They had to return to the United States for immediate medical treatment.

"In the last month and a half, I have experienced great suffering and loss, having watched our friends experience even more. But I have also experienced literally hundreds of people come together in prayer for all of us, and the power that comes with prayer far exceeds the suffering and pain," said Eve reflectively.

I asked her how she believed in God in spite of all she had witnessed and endured. The thought of blaming God or ceasing to believe in his existence had never crossed her mind; he has never been a factor in the equation of pain, but the solution.[3] God is blamed for a great deal, instead of thanked each day for breath all those days when it seems nothing is happening, when in fact it is a wonder we survive in such a broken world. Yet, Eve's belief is still not enough unless she enters into having a living, breathing, daily, and tangible *relationship* with God. Belief does not equate to a relationship, unless that belief operates in daily, committed, and persistent faithfulness.

Our greatest step forward into true spiritual development is to think about God not just as a collection of Christian beliefs all neatly bound together, all to be examined and adhered to in order to keep us in moral alignment, but as the actual ever-alive and flowing channel in which he has chosen to reach out and engage in relationship with all of humanity.[4] This begins only with humility.

I lived for several years in the heart of Chicago. Some mornings I took walks east down the main avenue to catch the rising of the sun over the Great Lake. Inevitably, I smiled down at a homeless person, another mother's baby grown up—well past the age of my own young sons now—making a home on a slip of cardboard, lying on the edge of the soon-to-be-crowded sidewalk. This scene would always renew my belief in God, for in this person I saw the truest vision of myself. The posture of destitution is the clearest vantage point from which to see God.

My own destitution of neediness, dishevelment, good intentions with poor follow through, competence lacking character, moodiness to measure all thought, selfish pleasure, exhaustive striving, elusive perfection, expectations, idols of impermanence, and bruised relationships are all part of that posture. Sin, in all of its imperfect glory laid bare, paradoxically gives hope to my children and me.

God stands and looks from afar at those who are proud and haughty.[5] He looks at them from a distance. He literally cannot come near such pride. He is not a Father who desires forced love. He will not barge into the human heart uninvited; he will not stoop that low.

The titles and accolades we give each other and bestow on ourselves are of no real consequence—they have no ability to give us a full sense of competence or elevation, no more than fig leaves could take away the new awareness Adam and Eve had of their nakedness. However, like the first humans, we deceive, we hide, and we feel the shame. We pile on even fancier fig leaves, building our personalities, and even our noble role and practice of mothering in our own efforts, by our own means and according to our own ideas.

My elder sister Kim, early in her motherhood practice with two toddler boys, typed out a simple prayer for them and placed it in a frame over her kitchen sink. The last part of the short prayer reads, "And give them a vision of their sin."[6] Rocking her children, I had the initial impression at the time that this was a rather morbid desire for such sweet boys. Years later I now see the foundational wisdom God had given her, the hope discovered in understanding the surprising relationship between our sin and God's grace.

Such understanding is to recognize that our spirituality has very little to do with our preferred path to find God and everything to do with our desperate, most severe state. We must renew our reverent fear and our inescapable need of the one true God, daring to go back to the curiosity and humility we had as a child. The premise that God *is* can never be divorced from awe and need and thus from relationship.

Amazingly enough in our position as the created, truly laden with need, our Creator does not pity us. As Jo Ann Lyons, founder of World Hope International, has written, "Pity emphasizes the distance between people. No relationship is possible when one person pities another. Compassion, on the other hand, is a commitment between the helper and the needy that is based on relationship. Compassion requires intimacy."[7]

If we believe in this compassionate God and accept how he looks at and redeems vagabonds out of his great kindness, then, and only then, can we look at others—even at our own children—with this sort of compassion and not burn out. Presently, my little one is teetering around the room with a fist full of crackers, wearing a T-shirt that says, "I Am Definitely Up To Something" and is in severe need of a diaper change. The moment I start treating him with pity is the moment mothering becomes

burnout. On the other hand, if I can look at my little person with true compassion, I can see the intimacy of trust we have and the relationship of ours that will grow as we grow. Compassion has in mind the vision for what we are becoming and what our children will become. Pity only saps that vision and makes care an obligation.

We women are wrestling with this vision, and thus with our Christian faith, in ways that perhaps our mothers and grand-mothers did not, sensing that the faith we possess may be weak and floppy. If we are honest, a sense that ours is an inferior faith only intensifies when we become mothers. The fires are hot, for now it is not just about us. If we do not move into a purpose-ful existence of relational faith in God, we may simply continue to slowly die within, ever thirsty but never satisfied. Research has shown that globally women are the spiritual backbones of families, thus the essential supporting structures of the nations of the earth![8] Therefore our overall well-being, including our theological beliefs and how we model them, have direct relation to the well-being and life-long choices of our children. We *cannot* afford to be self-centered, uninformed, or complacent in our beliefs about the one true God.

In the evening after we get our boys in bed, I often find myself uncovering these beliefs so I might learn how to live and teach. I discover, as many have before me, the distinctiveness of the God of the Bible—a God who is wholly unlike any other. Hindus, bearing the heavy weight of karma, believe in thirty thousand gods. Buddhists, whose basic doctrine is salvation by personal effort, believe there is no deity. New Age followers believe God is present within everyone's most authentic self. Muslims believe in a powerful but detached god. Many, espousing religious

tolerance, believe that essentially people of all faith—Christians, Muslims, animists, everyone—know the same God.

But the God of the Bible is set apart.

He is an eternal God, a Father who is bent on being with his people in their temporal state and infusing his glory into all their mundane activities. He is the God of small things and great things alike. He addresses the strange tension we feel as we walk the earth day after day; as we wake up and eat a bowl of cereal and bathe a baby; as we make a lunch in a bag and pump gas in a car so that the lunch may be eaten and the arrow return to empty; as we rake the leaves and scrape the lint out of the dryer's filter; as we stay up late finishing a novel or listening to a symphony in the quietness of a living room; as we need a cup of hot coffee and a place to go when it has all become too much.

God makes sense of all this, the macro and the micro—from the testing of nuclear weapons for mass destruction and the convening of the United Nations to cars crashing on the interstate, mothers fading away from HIV/AIDS while their babies lie on their chests, and to innocent people being senselessly massacred in US schools and in Darfur. God comes down and gives a bigger picture to us as women and mothers in our great endeavor. The eternal God created humans for eternity and called women out to be the transmitters of such!

In this he comes down, God-incarnate, insisting on removing the veil of elusiveness to such a degree that we can see all we really need to see—a God who is personally reaching out to my heart, to your heart, to the hearts of our children. Tell me, what more could we long for? How could we? What other god in any other religion blatantly desires an intimate relationship with you and equally so with your children?

It is true. We fulfill this deep need for an intimate, inexhaustible relationship only in the triune God. Marriage *cannot* fulfill this, friendships *cannot*, a career *cannot*, a hope to help change the world and create a sense of significance *cannot,* and the bond between a woman and her children *cannot.* They all have their limits. Pursue them above pursuing a love relationship with God through Jesus and the disappointment will choke your soul, leaving the constant feeling of not being able to get enough air to survive, let alone thrive.

I think Eve has found this to be true or she would not be where she is now. Hearing her story and picturing her an ocean away, walking through her days with temptations and victories so common to every woman and mother, inspires me. We need to hear each other's stories, both locally and globally.[9] Not only do our stories remove the lie that we are alone, but they increase in our thinking the magnitude and diversity of our God. We, as well as our perceptions, come out of the boxes. We all need this if we are to grow.

Eve's deep desire for her children is that they walk with their eyes wide open to God's daily miracles and his consistent delight in them, in spite of the surrounding suffering and evil. Although they will grow up in a shame-based society, they can live as gospels of freedom.

It is a profound thing to see the hand of God in the faith of a child. It is a wild thing to dare to be in relationship with God. For within that relationship, Eve said, lies simultaneous realities of inevitable earthly pain and the hope that we are not left alone in it—nor are we merely victims of this pain, but in reality, conquerors.

She closed her thoughts, just days away from giving birth to her second child in a Bangkok hospital, with a searing comment,

"I would never, never choose to bring a child into this world without there being the truth of a Savior for them."

Nor should I, nor should you. Nevertheless, we can because the one true God is not trapped in heaven; he has come and shown his face so we might be reconciled to him. He chose to lie down on that cardboard next to us in our pathetic grime, becoming one of us—one of us women, one of our children.

RUNNING

My Father God, I come to you in the posture of humility. Apart from you, all of my own efforts are weak. Enable me to have compassion on others around me, including my children. I praise you that you are a relational God, set apart from all other gods men have devised. I confess that you not only exist, but that I choose to be an active participant in a committed relationship with you. Honor my thirst for you and increase it. Enable me to develop relationally with my children in a rich and true way. Reveal to me who they see you to be, and allow me to tell and show them who you truly are. Thank you for the stories of women like Eve. Create thirst in the minds and spirits of all the women and children in Asia, and make them aware of such thirst. In your compassion satisfy their souls and rescue them from shame. I run to you; I immerse myself in you. Amen.

DEEPER IMMERSION

We are all prone to believing lies about God, often based on our own experiences of and personal reactions to our parental figures and life experiences. What we believe about God radically affects the ways our children will perceive him. Perhaps there are "cracks" in your own beliefs. Compare what you believe about who God is with who he has revealed himself to be in the

following Scriptures that show his character: *Loving*: Jeremiah 31:3; *Forgiving*: Isaiah 1:18; *Gracious and Accepting:* Romans 3:23–24; *Merciful:* Ephesians 2:4, Psalm 111:4; *Personal:* Jeremiah 1:4–5; *Faithful:* Deuteronomy 7:9; *Source of Peace:* Isaiah 26:3–4, Philippians 4:6; *Good Father:* Psalm 68:5; *Perfect:* Deuteronomy 32:3–4; *Trustworthy:* Psalm 5:11–12.

FOLLOWING THE SAGE:
DIVINE APPRENTICESHIP

Whoever drinks this water I give him will never thirst. Indeed the water I give him will become in him like a spring of water, welling up to eternal life. John 4:14

LAST YEAR I READ A HISTORICAL NOVEL ABOUT THE little-known story of the vast underground effort by Italian citizens who saved the lives of forty-three thousand Jews during the final phase of World War II. The first paragraph in the last chapter of this haunting work reads: "This is what they remember about their mother: she never cried. Each of her children tells of some crisis that failed resoundingly to elicit maternal compassion. The cancer. The divorce. The miscarriage. In their mother's mind, nothing that happened in Canada could ever justify lament. 'Save your tears,' she always said. 'You may need dem later.'" [1]

What her three grown children never knew about were the atrocities she witnessed and endured in the holocaust. They never understood how since then she measured pain from that

standpoint and everything always had fallen short of earning the right to grieve. Context was everything. If they had known, they could have discovered their mother's humanity. Perhaps they could have extended grace for the sin *done* to her, which evoked sin *within* her that ultimately caused sin *against* them. Instead, they evaluated her from their own limited viewpoints.

Have we not done the same with our own mothers? Will our children not do the same with us? We are all prone to make judgments based on our expectations and what perspective we see of a person, of a situation. As Madeleine L'Engle wrote, "I have *a* view, you have *a* view, but God has view."[2]

It is this broad and generous view that we must not only afford our own evolving mothers and pray our children afford us, but with which we must see the life and teachings of Jesus and the context in which they are set. Our creeds, our memorized doctrine accentuates—and rightly so—his virgin birth and atoning death. We often do not insert within them the profound importance of his life. He did not come only to die so we might live; he came also to live so we might know *how* to live. Jesus pronounced a blessing on our physicality and gave stunning, shocking examples of how we are to function.

Truly, the biblical Christian faith has been wrapped up in the brilliance of the incarnation; our life is lived in the reality of God coming in and breathing life into what has been dead, splendor into what was deemed commonplace, and truth into what has been a vacant search. The incarnation is everything. It encompasses not only birth and death, but also the in-between, daily life.

You and I need to know that the Savior of the world considered the true fading luster of our days—that he, with whom there is no time, surrendered to ours. He had normal moments

that slipped and ebbed away. When I consider this, my mind is eased and I resist the urge to beg or bargain for what will be. What I have now—the remarkable existence of my children, of my husband, of me, of the love of God, of the trees outside my window, and the sound of thunder in the distance—today can be enough to fill me, to fill you, with pleasure. Yes, to live well as children of God and to be mothers of children of God, we must see the brilliance of the incarnation; otherwise, we may miss the purpose of our own existence and the exquisite nature of our own days.

Being the oldest of four brothers and several sisters, Jesus was familiar with family life as well as what it felt like to relocate. His area of Galilee was generally urban and his education was typically Jewish. This involved extensive Torah memorization for boys under the age of thirteen, at which point, unless they were unusually gifted to become a full-time disciple of a great sage (teacher), their education ended.[3]

Jesus dressed like any male of his day, and his physical appearance drew no attention. He came as a full member of his culture, understanding the commonalities of both urban and rural life, of habits of the mind and of the hand. Perhaps this is what the Scriptures mean when they tell us that Jesus grew in *both* wisdom and stature (Luke 2:52).

He grew to become a rabbi, a sage, and a teacher who had studied under many of the great teachers of the law of his day.[4] The Bible reveals that his understanding of Scripture was unusually insightful even as a young boy. He was, after all, fully human and fully God. Not only well versed in the Scriptures and in the folklore of the day, Jesus was also familiar with the cultural and political arenas. With his first-hand knowledge of the happenings of life under Herod the Great, he conversed easily and

intelligently regarding such matters. As a sage and the incarnate God, he carried more authority than any other rabbi. A man who knew and understood his times, he used all of these elements to be a master communicator.

Sages of the day practiced a trade—there was the common belief in the danger of simply developing an academic life.[5] Everyone needed a trade or a skill to give balance. Jesus was a carpenter trained by his own father, Joseph.

The sages were the best of the best, the cream of the crop. Hundreds and perhaps thousands of them circulated through the country in the first century, communicating their teachings and interpretations of Scripture. They did not hesitate to travel to the tiniest towns or the most remote parts of the land. Sometimes they conducted their classes in someone's home, under a tree, in the town center, or on the side of a hill. Jesus, one such sage, did this as the Gospels portray; his lifestyle was surprisingly not distinctive, but his driving purpose to redeem the world and bring the kingdom of God to earth was unique.

Relating to his day, Jesus used the Hellenistic[6] influences for good by forming them into something that could be used as teaching tools, points of understanding. He functioned in this belief, yet he never gave in to populist thinking. Nor did he live in a vacuum, out of touch with what was around him—it was quite the opposite. The world around him held great significance; there was no division to him of secular and sacred. Evangeline Paterson, originally an Irish poet, slowly discovered a fundamental and essential truth in this regard: "I was brought up in a Christian environment where, because God had to be given pre-eminence, nothing else was allowed to be important. I have broken through to the position that *because* God exists, everything has significance."[7]

The disciples were invited to join and follow Jesus. This implied that they would learn and be transformed by the behavior of the master and by serving him. There were certain aspects, certain subtleties that could only be learned in the context of walking with the sage and fully participating in his life.

It was common knowledge of the day that being a sage-follower was not a plush existence. People had to consider the cost of being a disciple, for it was extreme; it dictated how all of life was lived. This was not approached as a hobby, as a segment of life, a part-time job, or reserved for only the Sabbath. To a disciple, it was even more than a way of life—it defined the meaning of life itself. Spirituality without tangible daily obedience was not an option.

When Jesus looked for disciples at the start of his ministry as a sage, he did not approach the intellectual elite. Rather, he went to those who apparently had never been invited to study with a sage. These were most likely young men. When asked to follow a sage, these youth were astounded! Such an honor they could not pass up. Nor should we, for his invitation is to us as well as our children. We do not have to be prepared before we accept it; we simply need to run into it. Truly with him, the last shall be first, the poor and crippled in spirit shall be truly rich, and the meek—those who have thrown away their pride and cried out to God—shall inherit the earth.

In any given society, those who are considered "the least" are most of the children, yours and mine, and the estimated 132 million orphans in the world. We live in an age where countless women and children are plagued by discrimination. Disempowerment and poverty are rampant. Women and girls are disproportionately affected by the AIDS pandemic. Nearly half of the estimated 2 million orphans in Uganda alone are

orphaned due to AIDS, with the total expected to rise to 3.5 million by 2010. Many girls around the world are forced into child marriages, some before they are fifteen years old. Maternal mortality figures remain indefensibly high in many countries. In most places, women earn less than men for equal work. Millions of women and their children, specifically girls, suffer from physical and sexual violence, with little recourse to justice and protection.[8] History and our present time give proof of two lies that have catastrophic consequences for us all: (1) Men are superior to women, and (2) Adults are superior to children.

I am convinced that Jesus is deeply grieved over such lies of dishonor for they are the ways of evil, repression, and despair. He never desired this for his daughters and their children. In the days of Jesus, children as a whole—as well as their mothers—were forgotten members of the covenant community. They occupied the lowest rung in the social ladder. In fact, the term for *children* in that day meant also "slave" or "servant."[9]

Today our language is different, but the connotation is often the same. Instead of viewing children as having immense worth, eliciting our deep respect and the gift of being nurtured, they are viewed as commodities, consumers, or economic burdens. We think of them in terms of how much they will cost us, financially, emotionally, and even in regard to time. I have even read that in reproductive technology, high quality eggs and sperm from donors who are Harvard graduates, attractive, and physically fit cost more than donations from a regular Jane or Joe. Through much of my own early motherhood—and I confess in my most banal and exhausted moments still, although I was and am deeply committed to my children—I also saw them as threats to my own independence and upward mobility as a woman. I too have believed the tragic lie.

Even in wealthy US churches, children are on the outskirts of much of the vision and ministries—the worth of creating avenues for their learning is often measured only by their ability to draw their parents to the church. It seems that most leadership is really after the adults. This sense of limited priority is confirmed by research conducted by the Barna Research Group. From a random sample of senior pastors leading Protestant churches, only 24 percent mentioned ministry to children as being in their church's top ministry priorities. Less than 15 percent of their church's budget is devoted to the discipleship of children. Barna's research indicated "attention devoted to the children's ministry most frequently revolves around making sure there are children in place, rooms available, and a standardized, minimal curriculum with the same stories taught every year."[10] Children are not immune from this sense of separatism and afterthought. In this mentality, we push our children to grow up faster than they were designed to and rob them of a deep and shimmering foundation for faith as well as the celebration of childhood. We want less work, as we want to focus more on the development of our own personal adult identity.

As mothers, we have to evaluate with great and often painful honesty how we perceive our own children and from where we are seeking to derive our sense of identity and purpose. Are we hiding behind our roles as mothers, thereby avoiding certain growth as individual persons? On the other hand, are we not fully embracing our mothering role and avoiding the growth that happens within that synergy? These are questions that must be asked with great frequency.

It is a hard thing to pursue and engage our gifts, strengths, training, and growth while being devoted to the nurturing and training of our children. But it is possible, and necessary, if we

are committed to transformation. I believe God links the two, living simultaneously as a woman and a mother, in a manner more meaningful than most of us realize. A friend and fellow writer, Alison, a mother of three, wrote on her blog, "I work so hard to be a good provider for my children of all they need but what I have learned is they are actually God's provision to me."

Caring for children in the first century was a low status activity. Even Jesus' disciples seemed to think as much when they tried to keep children from Jesus. Perhaps the disciples were convinced that children would be a nuisance, especially as they could not possibly understand the true kingdom of God that Jesus spoke of and all its implications—children would never understand the importance of this man, the Messiah!

The truth is that children are models of entering the reign of God. As Jesus said, "Whoever does not receive the reign of God as a child will not enter it" (Mark 10:15). This is a dramatic claim, for nowhere in ancient literature are children put forth as models for adults. In the Greco-Roman cultural days of Jesus, comparison with children was highly insulting.[11]

Neil Postman's informing and alarming book *The Disappearance of Childhood* jaunts throughout history to see how people have struggled to acknowledge the meaning and worth of children. The tendency has always been to force children into early adulthood whether it is through language, dress, images, or behavior. In the Medieval world, personal childhood was invisible. In other centuries the idea did not even exist, as you can tell from the custom in the Middle Ages of identical names given to all siblings. It took ages for childhood to become a social and intellectual category; internationally the worth of a child still is not seen in our day and age.

Jesus was generationally counter-cultural. He had an entirely different view of children; he saw them as a precious new generation of disciples. To him, it was imperative that they join the current of God's reign among his people. Jesus said in effect that whoever wants to be first must be last of all and servant of all—in essence that those who serve in the most humble fashion truly have on them the beautiful, eternal mark of greatness.

Jesus redefined the care for children as a high and most intelligent holy calling. I believe that everything he deems as such has redemptive purposes for all involved. Imagine if humanity had heeded his blessing on children throughout all the ages. Stop and consider his blessing on your work, for his is the truest voice in the multitude all around you. Quiet yourself in the harried days and the wee hours of the night with this redefinition of your mothering practice. Center yourself on it. Fight for it. Renew it.

I remember rocking Anders in his first week of life—so fresh and utterly helpless. He did absolutely nothing to earn or deserve the words of blessing my husband and I spoke over him in awe and delight—he simply *was*. That is how Jesus looked on those children, looks on the millions of unborn children murdered yearly through the holocaust of abortion, and looks on each of us. We are all sacred.

In thinking of my own children, I observe how they are closer to a true sense of the kingdom than I was at their age—how much higher they are already standing due to all the discoveries I, my husband, and others have made in our awareness and appropriation of truth. It is my hope that they exceed all of our understandings, that their children exceed theirs, and that the kingdom will break forth with greater and greater power and authority.

How it causes me as a mother to stand among the unashamed to know that Jesus pronounces blessing on my own life! My little life, often so simple and without great earthly acclaim, taking daily delight in my sons, my husband, and my vocation of words. The gentle way I scratch Larsen's back on the couch while my husband, Ben, reads Narnia aloud, the chasing of Anders around the house for large blocks of time, the wiping of a nose and a bottom, the careful explanation of correct penmanship and ideas about scientific theory.

It all matters; it all counts—to Jesus. This is no small or mindless thing. Francis Schaeffer wrote,

> Love cannot be a banner that we carry around or a slogan that we repeat like a mantra. Love must be evident in practice. All truly great Christians have gentleness and a tenderness about them that is manifest in the delight they take in spending time with little children and the energy they gladly expend on "little people." Such love demonstrates that a believer truly has met with the Lord. For the Lord carries little children close to His heart. He does not break the "bruised reed" or quench the "smoldering wick." The Lord has time for every one of His people—no matter how insignificant they may seem to the Christian leader who has his own agenda in mind.[12]

In many ways, I do not know that I ever met Jesus until I met my own children.

The invitation to immerse ourselves in the lifestyle and attitudes of an apprentice of Jesus is clear. A relationship with God through the cross of Christ void of discipleship is meaningless; we rob our children and ourselves. We are to be willing to follow

Jesus relentlessly and entirely, into transformational, committed discipleship, especially while raising our children. If we truly confess Jesus, this is not optional. Our comforts, our quest for control over our own lives, power, and personal significance are surrendered. Regardless of where we have come from, of what our educational or professional status is, we have been chosen to be learners and followers of the Most High God.

Much of the rest of this book is devoted to working out all of this, for it is a lifestyle of relational practice, not perfection; a spirituality of immersion, not toe-dipping. Again, it is our practices as mothers, the ways in which we live our lives both in relation to our children and in spite of our relation to them, which will be transformational for them and us. Our assignments and those of our children will be varied throughout life, but our calling is the same: to live as disciples of the great Sage and Savior.[13]

RUNNING

Jesus, enable me to have the courage to discover the humanity of my own mother and father in their true contexts. Forgive me for a lack of grace. Speak to me about this. Let me receive and bless the children in my life, as you did, even if I was not received and blessed as a child. Forgive me for any lies I have adhered to that carry the connotation that my children are reducing my potential, instead of maximizing it. Give me a true picture of noble and strong womanhood and motherhood. Apply depth of intellect and emotion to my practice of mothering and to my continued growth. Let me not settle for any less, but call me higher and plunge me deeper. I pray for the millions of orphans around the world in need of nurturing parents. Convict me if you are calling me to mother the motherless. Raise up your people in

a giant rescue mission to capture the children of the world for your purposes. I call your attention to the millions of oppressed women whose basic human rights are not secured, who daily are exploited through rape, domestic violence, trafficking, and abortion. I know you weep for your daughters and for all the children who have been robbed of life. Bring justice and mercy! Small as I am, use me. Today I choose to run to you to be immersed in the lifestyle of your disciple. I choose to move beyond that of a mere God-acknowledger to that of a true Christ-follower. Teach me. Amen.

DEEPER IMMERSION

Over the next seven days read the Gospel of Matthew, four chapters per day. Rediscover the context and earthly life of Jesus. Ask him to enable you to listen to the words as far from your own perceptions as possible. Study, meditate, and take notes. Find the Jesus that you may have never met.

THE INDWELLING:
A PRACTICAL MYSTERY

Jesus stood and said in a loud voice, "If anyone is thirsty, let him come to me and drink. Whoever believes in me, as the Scripture has said, streams of living water will flow from within him." By this he meant the Spirit, whom those who believed in him were later to receive. John 7:37–39

SARAH SAT ON THE VINYL SEAT OF A RED FORD TRUCK
traveling down a dirt road. The stick shift bumped between her knees at every pothole as she sat between her parents on the way to hear her grandfather preach his first official sermon—he had entered the pastorate late in life. When she arrived, the familiar voice rose up through the small sanctuary in a new way. She was not expecting his words to be the sword to pierce her heart with her first sense of true hope. Feeling so dirty and in need of a cleaning and a trust she could not wrap her small mind around, she ran forward.

With tears streaming down her eight-year-old, freckled face, the little blonde from a small town in Minnesota ran hard. It was

a different run than the ones in which she was struggling against sexual abuse, the reason for her sense of inner filth. And it was different from running to the arms of her alcoholic father who never initiated any embrace of unconditional approval and full blessing every child needs. It was a run to hope pushed forward by the Spirit of God.

That was thirty-one years ago. Sarah never forgot that Sunday run, even when she lost her virginity at fifteen and her first baby to an abortion at sixteen. Married at eighteen to her aborted baby's father, she gave birth to her second child eight months later. Her sense of failure and rejection dictated her days; stealing much of the joy a young mother should possess. In hopes of erasing the turmoil, Sarah and her husband had another baby. After many good intentions but failed attempts, the marriage ended and she found herself alone.

Addiction comes when a soul is hungry for Father God's wild and abundant love to swallow up all pain, and Sarah was no different. Sex and alcohol became her less-wild lovers. As strange at it may sound, during many of those nights of drinking and one-night stands she had the sense of something pure and good, beyond her, hovering and beckoning to her.

It has been said that spiritual awareness knows no age barriers; the young child and the aged philosopher stand on level ground. So it is with one sensing the Spirit of God, be it a child, a teen, or an adult—the Spirit makes no age distinctions.

He did not with Sarah; his wooing continued. It went on through another marriage, another baby, and another divorce. At the age of twenty-seven she found herself a twice-divorced alcoholic with three children, two abortions, and dragged through two custody battles. Coming face to face with her mess, she made the hardest decision any mother could make: to surrender the

custody of two of her children. Still, the Spirit had not stopped whispering wisdom, for this decision could only come from a place of selflessness beyond her comprehension. If someone had talked to her of the Holy Spirit at the time, she would have been uncomfortable. Jesus, she remembered. God, she knew of, though the figure of a Father was painful. The Spirit, she was unsure about. In her mind, the Trinity remained separate entities, the whole of God too large to embrace.

As far as my limited understanding of the Holy Spirit went, I was also immensely suspicious. I was cautioned through the years in spoken and unspoken words to stay clear of those who lived and acted as though the Spirit was beyond the normalcy of daily living—those who believed that the Spirit had to be artificially manufactured with the use of the gradual elevation of emotion and intensity, of hype and excitement. As a child and a teen, the Spirit was a mystery. To stay in the comfort zone where the Spirit was kept in line—every movement already choreographed and predicted by the dogma—seemed safe, but deflating and devoid of abundance. The only alternative was to go in the end zone where the Spirit was throwing balls over the line as if it were a mad circus of entertainment, but the chaos was fearful and the unspoken warnings to stay away, too severe. I stayed in the middle, unengaged and certain that to look to the left or to the right would threaten and undo my own understandings of God.

I have come to believe that the Spirit is, much to my surprise, located within the very heart of daily living, not limited to either end of the spectrum. To live as daily followers of Jesus means waking and sleeping, quite literally inhabited by his Spirit. This Spirit is not an impersonal force in the universe, but the third, equal, and distinct *person* of the Trinity, literally our helper that

comes alongside us and within us, activating our dead spirits to life.

At the age of twenty-nine Sarah ran again. She ran when she heard that the Jesus she met as a girl had spoken to another woman long ago at a well about her own personal promiscuity (John 4). The woman of ancient Samaria was of the hated mixed race. Her race, social position, and list of sins were more than enough to keep away any respectable Jew of the day. Except Jesus. He drew near to her, not away. Jesus told this woman that he knew everything about her and that he would fill up her incessant ache. It was Sarah's story and Sarah's thirst. And it was Jesus who refused to treat her with rejection, never desiring perfection, simply repentance.

The person of the Spirit attuned Sarah to his message and she heard what no other sage of the first century or biblical writer had before said so clearly as Jesus. It was as if Jesus spoke directly to Sarah and said, "I esteem you because my Father God esteems you and I will relate to you in the way God does. I love you and I call you to love. I can cleanse, forgive, and satisfy your thirst." Running, Sarah threw herself down at the altar, crying out, "You have to take this life and make something of it because I've tried and I can't! Take my life! Fill me!" The Spirit rushed in on her, now unquenched, and began to heal every part of her ragged heart.

These were sweet times of drinking deeply of life as Sarah had never known it. She had her youngest child with her and her two oldest on the weekends. Rebuilding her relationships with them, they read the Bible together and played basketball. They watched her through times of weeping as she dealt with her brokenness; they saw her constant financial woes and witnessed her

practice of running to Jesus with all of her needs and listening for the Spirit's words of instruction.

Who is this one we call the Holy Spirit or the Holy Ghost? How does he affect our lives as disciples, our calling as mothers, and the spiritual development of our children? I have pondered such questions and the implications of the answers. I have found that to understand the Spirit more fully, we must, as the early Jews did, go back to the start of time, for his work in the world has been from the very beginning.

The Spirit has had a story flowing through time. After all, stories are not simply illustrations; they are golden invitations into a world where all the senses are involved, where the listener and eventual participant can enter in wholeness. More than for anything else, my children come to Ben and me for good and true stories—it is where we dwell best together.

Walter Wangerin commented that as a story is told repeatedly, it draws children into its cosmos. If the story cosmos accords with the child's experience of life to some extent, then when the child leaves the story it becomes the framework by which the child interprets the rest of the world. Everyday experiences for a child are often chaotic and lack the structure of a good story. Thus, stories have the potential to make daily experiences more comprehensible by offering that needed structure by which the child interprets life.[1]

I have never heard anyone, such as Sarah, recount steps of faith without narrative, without a story form with metaphors and imaging, whether the plot is simple or complex, laden with characters or not. Though certain elements of the events will be made more significant than others, we cannot, with any true validity and integrity, recount a story in bullet points.

When it comes to telling our children about the mystery of the Holy Spirit, we must tell the Spirit's story as we know it ourselves. We can tell it something like this.

The Holy Spirit is unified with God the Father and Jesus the Son in thoughts, emotions, and will. He is called the wind of God that moves with reason and purpose. Think of the wind—sometimes it is wild and rushing; other times it is gentle and soothing. We cannot control the measure and movement of the wind.

It is the same with the Spirit of the Living God. The Spirit was a part of creation. He participated with God and Jesus when the first trees took root and the first sunset filled the sky. He first filled people with skill to sew, build, and paint the Temple where God's presence lived among his people. (Artists are of special use to the Spirit!)

He moved through history as time went on, carrying words from God to the prophets and to other human authors of the Bible. He also enabled leaders like Moses, Joseph, and David to guide large masses of people. Think of the thousands of people they led and all the details involved. The Spirit also gave the kings of Israel leadership abilities and helped direct the hearts and souls of the people.

The characters of the Old Testament often dreamed and wrote about a day that would come when the Spirit of God would be more direct and his ministry more complete. They longed for this day—this day when Jesus would come and send the Spirit among his people in a new way. On the day

of Pentecost the Spirit was given to the church. He appeared like tongues of fire and a rushing wind that came on the disciples, giving them the ability to speak in other languages in order to proclaim the truth of Jesus.

Now, for those who believe in the truth of Jesus, the Spirit is immediately given as the seal of right standing before God. They are cleared of all guilt before God and start anew. The Holy Spirit now resides in us, literally. Our inner man, who we really are, has gone from death to life.[2]

Few women have displayed to me the Spirit's workings in their lives more than Sarah. The Spirit prepared her for another custody battle in which she would lose her youngest child and learn to find solace for her pain in the Word of God. The past nine years, during which time her children have not lived with her, have, ironically, been the best years of her mothering practice. When her children visited her they could see how God was becoming their mother's everything, the most precious relationship she had. She never had a curriculum to teach them, a ten-step program, or a theological education under her belt—only the water of Christ that filled her. Her Bible became tattered and dog-eared with every promise she found in it underlined repeatedly. She has slept with it under her pillow and held it to her heart through moonless nights of utter loneliness. "I do not know how I could have known the Spirit and his voice as I do today if it had not been for the pain, the need, and the desolation," she recently told me.

Yes, the Spirit both sustains and nourishes true spirituality. The Spirit is now the intimate pillar of cloud by day and fire by night in our own lives as we go forth on the great pilgrimage

we know as life. We have exited from slavery, become God's very own, and now we are moving forward into the Promised Land—into the final chapter when all God has created will be renewed. Sarah is sure of it.

The Spirit never leaves us where we are, never urges us to buy season tickets to our exact present position. His game is not religion or piety; it is the increase of awareness that in us dwells the fullness of the Godhead. He presses us to go further up and further in, empowering us to do so.

Jesus was empowered by the Holy Spirit after his baptism. He did not push and claw his way into his calling all those years. He did not begin his public ministry until he received the anointing and empowerment of the Spirit.[3] After his resurrection, Jesus told his disciples in Jerusalem that they were not permitted to begin their public ministry of fulfilling the Great Commission *until* the Holy Spirit indwelt and empowered them for the task (Acts 1:4–8).

It is the same with our motherhood. When my first son was born over eight years ago, as inadequate and naive as I felt as a mother, I sensed a power I had not known before. A surge grew in me as my child grew in me. Some call it natural instinct; I call it the empowerment of the Holy Spirit for the anointing of motherhood.

We have often gone ahead to all of the things that mothering entails when we should tarry. Rather than running ahead with our days, before our feet even hit the floor in the mornings, we should surrender and wait for the Spirit, ever existent within us and beside us, to take us over as we allow. How weary in body and soul I can become in my days when I forget the source of my energy! How much I have altered the peace in my own home!

We are called and divinely enabled, as frail as we are, to mother according to and within the Spirit. The words we speak to our children are best if they are words of the Spirit and not of the flesh. The Spirit does not beg and lecture, does not grow impatient and frenzied, does not obsess and demoralize, does not look at the externals and ignore the internals, and does not change with every mood and fashion. *I* do.

We can guilt our children into obedience; we can give up every earthly pleasure and necessity for their greater good and still not please God as women and mothers—not to mention exhaust ourselves. Our sacrifices may mean nothing eternally, for what really pleases him is walking by the Spirit, being led by the Spirit, and bearing the fruit of the Spirit (Galatians 5:22–25). Aside from marriage, I know no other way as consistent as the care of my children to drive me to the practice of walking in the Spirit, abiding in Christ. Brother Lawrence said it this way: "the practice of the presence of God," meaning to learn that Christ via the Holy Spirit is our companion, is our very life.[4]

Sarah's constant Companion eventually led her to a poor Central American country on a short-term mission trip, which was to be the beginning of many. She fell in love with the warm culture. More alive than she had ever felt in her whole life, it was there she saw little girls turned into pregnant teenagers (as she had once been), living in a place where resources were not nearly as readily available as in the States. Again, she sensed the Holy Spirit directing her heart toward them.

She dreams of and is in the process of opening a home in this third-world country for unwed, pregnant women. This home, which she plans to name after her first aborted baby, will be a place where unwed teenage mothers can come to be nurtured and loved, abortions prevented and options given. Sarah

imagines instilling in them the truth she had always longed to know—that they are daughters of the King with a hope and a future.

Being filled with the Spirit is not a proposal of perfection. The key is that we are no longer *slaves* to sin. A slave must do what his master bids—there is no sense of liberty, certainly no sense of re-creation, renewal, and hope. We, through Jesus, have been freed from the law of sin and death. We have been freed, not to pursue selfish ambition but pure love.[5] Just look at Sarah's life. Her children rise up and call her blessed and one filled with great love, because she is not driven by anything but the Spirit. We, through the Spirit, are being made perfect—literally, being made increasingly *full of the goodness of God.*[6]

RUNNING

Holy Spirit, I praise you for wooing me all of my life. Show me how you are doing the same with my children and others you have surrounded me with. Endow me with wisdom to collaborate with you in the work you are doing in their lives. I avail myself to you as your tool. Let me not turn away from seasons of loneliness and suffering in my own life, as these may be the very times I may most clearly discern your movement and my own need for you. Give me the treasures of darkness and riches stored in secret places (Isaiah 45:3). Function powerfully in my life as my teacher and counselor. Pour your anointing power on me to carry out my practice of mothering with bold authority and gentle wisdom. Move me out from what I have deemed comfortable and safe. I pray also for the single mothers and widows, my sisters, whom I encounter and for the fathers of their children. Keep me from turning a blind eye. Bring mighty provision, hope, purpose, and restitution to them. Use me to pour on them your refreshment. I

run to you, and in that run I confess that it is not by might, nor by strength, but by your power (Zechariah 4:6) in which I live and move and have my being (Acts 17:28). Amen.

DEEPER IMMERSION

Read Galatians 5:16–26. Often the Scriptures (Proverbs 11:30; John 15:1–17; Colossians 1:10; Psalm 1) speak of God's followers as being like fruit trees. What does this fruit consist of? Do you look for the fruit in your children's lives, or have you seen them as not bearing any fruit until they are adults? Also, read 1 Corinthians 2:10–15 and process where your source of wisdom to live and to mother really should originate. Who supplies the power for you to live in obedience; who is your energizer?

THE SCENT OF THE BODY:
THE SMELL OF DEATH OR LIFE?

Just as Christ loved the church and gave himself up for her to make her holy, cleansing her by the washing with water through the word, and to present her to himself as a radiant church, without stain or wrinkle or any other blemish, but holy and blameless. Ephesians 5:25–27

I GREW UP IN THE CHURCH. ITS RHYTHMS AND traditions were imparted to me as much as my blue eyes. The evangelical[1] church of my formative years—a rusty-colored brick building on a street corner—had been born out of the pioneering movement of my Scandinavian immigrant ancestors. Had you visited on a Sunday morning back in the 70s and early 80s, you would have seen a small slip of a girl sitting in the hard, honey-colored, rounded pews, the early light coming into the stained-glass fortress and dancing down on her in slivers of red, gold, and purple. As the rainbow of color ignited the tips of her skinny yellow braids, she was illuminated as a small firebrand there under the cathedral-like ceiling. Bathing in the light not only on her but

all around, she sensed she was a part of something bigger than herself, something divine, with purpose, hope, and a sense of eternity. The smells of all those ideas were sweet; they were the aroma of Christ, the fragrance of life.[2] If you were to ask her what church was, this is what she would have understood it to be.

Yes, this was my church, my family. I belonged. It was all I knew and it was home in the midst of all its own quirks. Wanting nothing more than to believe in all I heard and saw, I was aware of my deep spiritual thirst. Perhaps all children are, but they just cannot find the language to inquire about what it is they are sensing and seeking. So they sort of grope along as they are carried along.

Social scientists have known for years that by the age of nine, most of the spiritual and thus moral foundations of a child are in place. By the time a child reaches this age, it is more difficult to change an existing view than to form a new view.[3] It was these first foundational years of life on which I would go forth to build all of my more mature understandings. Yes, all of my heroes and boogey men, values and dislikes, were first encountered in the early environment of my little church community. In later years faces and places changed, but these were always set against the backdrop of the church of my earliest childhood.[4]

Growing older and entering the activities of youth group, I began to consciously build on the foundations laid in those younger years. In spite of all the noble intentions of my leaders, I was confused by the message I took away from it all: being a follower of Christ meant to reside in a prepackaged faith, reciting proper doctrine and indulging in safe alternatives. I did not accept those definitions. I wanted more. There must be more, and I knew I had to find it.

We all come to a place where we need to unravel and examine our lives, giving thought to the road behind us so we might know where we are heading. My need to unravel became crucial after the birth of my first child. It was upon his birth that I transitioned from being not only a learner but also a teacher.

These simultaneous realities—of being both a learner as a woman and a teacher as a mother on a daily basis whether I was up to it or not—contain within them the potential for an identity crisis. I have felt it rumble around within my own soul and heard the echoes in the sentiments of other mothers. The wonder of how to play both roles while not abandoning one or the other is often a mystery. The sensation of this new reality caused my soul to be famished in a way I had never known before: I *had* to know what it really meant to be a disciple and what it meant to live as a part of the church. I was passionate about passing the torch of faith to my children so that one day when I would step away from playing my life's piece, they would be able to sit down on the bench and continue playing the same song in a new style in such a way that where I left off and they began would be impossible to detect.

From all of my own study, I knew that influencing a person with focused purpose does result in the strategic impact on their thoughts and behaviors. Unsure of how to go about such intentional effort, my earliest notes for this book are traced back to midnight hours of rocking my sons while internally wrestling and scribbling my thoughts. I was thirsty for more of Jesus, crawling and falling, trying to run into the Water. My life-long thirst would prove again that God never ever denies the thirsty pure water. He has the divine ability to satisfy thirst with even more good thirst.

Unlike many of my generation, I never turned away from the church as an adult; instead, I turned into it. After Bible school, I spent years digging around, often quite intentionally and often unconsciously, in a quest to discover the larger face of Christ. I have been in almost every stream of Christian church including Wesleyan, Reformed, Baptist, Bible, Episcopal, Evangelical Free, Anglican, Catholic, Lutheran, Messianic Jewish, Nazarene, Presbyterian, Berean, Methodist, Mennonite, Brethren, Amish, Charismatic, Non-Denominational, and Pentecostal. Along with urban, traditional, country, emergent, and fundamental house churches. I have attended church plants in high schools and bars in Mexico, Guatemala, and Spain. I have sat through services in Japanese, Chinese, Greek, Hebrew, and Spanish. Witnessing every form of church government and small group, I have quietly thought through their implications, ideas, ideals, and visions. I have sat under the leadership of both men and women elders, deacons, worship and arts leaders, teachers, and pastors.

In my pursuit and observations, I have been both elated and invigorated as well as burned, wounded, bored, frustrated, perplexed, and deceived by those who call themselves members of God's family. Like many of my generation tantalized by emergent thought, I have scorned the underbelly of their tradition, gender-inequality, compromise, misplaced priorities, institutional-like organization, and seemingly huddled irrelevancy to the real needs of the real world. For some reason, we are more apt to keep score cards for those who call themselves believers than for those who do not. We are also apt not to see ourselves in their ranks. As Dietrich Bonheoffer wrote, "The serious Christian, set down for the first time in a Christian community, is likely to bring with him a very definite idea of what a Christian life together should be and try to realize it. God's grace speedily shatters such dreams. Just as surely as God desires to lead us to knowledge of

genuine Christian fellowship, so surely we must be overwhelmed by a great disillusionment with others, with Christians in general, and, if we are fortunate, with ourselves."[5]

I have been tempted to judge the character of God by the behavior of people. But I have discovered that as I relinquish bitter wounds, disappointments, and self-righteous expectations through confession and healing, I can search out the Christ who emerges from all those dialects and activities of faith. There are sharp, very sharp, give-and-takes within the community of humans we call the church that perhaps are there to serve as healthy irritants, lest we limit our growth and perceptions to our own ways of thinking and stick to people who share our own preferred style.[6] C.S. Lewis wrote, "The church is not a human society of people united by their natural affinities but the Body of Christ, in which all members, however different, must share the common life, complementing and helping one another precisely by their differences. . . . Heaven will display far more variety than hell."[7] In my wandering I found something of great value hiding behind all of the efforts of unity with diversity: hope.

The church is a living organism, not an organization or at worst, a country-club society. It must and will endure for the sake of the fame of God and his movement and reign on this earth. After emerging from my own period of solitary conceit and suspicion, I am convinced that my God loves and inhabits his imperfect church, his often-floundering people—such as myself—with great fervor. We *must* do no less. There is no time for less! After all, if the universal church driven by the Spirit of God cannot continue to clear the path for our children and the generations who are to come after us, radiating like a lighthouse in a dark sea, then nothing can.

The terrain of Christendom in a postmodern culture is entirely different from anything before; many now believe everything must change and be reinvented or repackaged. Some do this as if they are bored with God himself, when they might simply be disillusioned with form over function. Perhaps we have not apprehended the potency and aim of what it is to be the very body of Christ walking across the earth in massive union. If so, may God forgive us for our obsession with form where we should have had enthusiasm for his purposes.

The prelude to the birth of the church began with Jesus' first ministry goal: leading the disciples into full recognition of his person. It was Satan who tempted him and still tempts us to redeem the world and corrupt the church by power, prestige, and the distribution of material things with great philanthropic goodness. We are tempted to employ *anything* but the starting point and ending point of Christ alone, *anything* but the offensive cross! The truth is that the world cannot be redeemed apart from that beautiful bloody cross, and the church cannot exist without the confession of it.

It is after we stand alongside the disciple Peter and say the words "You are the Christ, the Son of the Living God" that the advancement of God's kingdom can occur and the real training and metamorphosis begin. This is the starting point with our own children. Their confession of the divine leadership, which only *they* can choose and declare, will open the door of their understanding and their own acceptance or rejection of the church as God intends.

My own eventual confession was nurtured in my earliest years by my family—as deficient and struggling as we were—who communicated that belonging to the church was crucial to our lives; it was the one constant where we all found refuge.

In those years I was encouraged to be not simply a spectator but a participant within the church, and my parents modeled this in front of me. I believe that a mother's involvement in the local church based on her developing relationship with Jesus is one of the greatest factors in influencing her children's immersion into him and their participation in spreading his kingdom. The powerful role of mothers in the spiritual development of their children cannot be overestimated.

Embedded within every gathering of my childhood church was firm biblical instruction as interpretation of life; I received the sieve through which I would sift everything for the rest of my days. The fact that my faith pilgrimage was a personal choice apart from my parents was strongly implied. I owned my pilgrimage by early puberty when many children sense a separation from their parents. At that point children move forward in their own faith or begin to stagnate or go down a path of rejecting their childhood beliefs.

Many older members of my faith community modeled their beliefs through teaching and kindness toward me. I still remember many who took personal interest in my life and my spiritual development. I am certain that although many of those Christ followers have now passed on, they form a great cloud of witnesses still cheering my race on.

These processes were all of great worth, but I am convinced that none of them would have made any mark in my impressionable soul had they contained no love.[8] We can teach the tenants of our beliefs to our children through every applicable innovation we can imagine, but as Christ followers, we are not about religion but a love relationship. Jesus taught that our beliefs are not subject to popular opinion, but our love for one another is.[9] Although I was longing to see more heart renovation, transparency, and

acts of social justice in the older believers I knew, if I had not sensed their genuine love in spite of these perceived omissions, I would have privatized my faith and completely turned my back on the church. The growing spiritual health, vision, and vigor of the adults within the faith community greatly impact children. Imagine if the church was known more for what it stood for than what it stood against.

Now that my children are growing, so is my concern for how their spiritual composition either progresses or regresses through connection with the local church body. If the church makes its focus the child—which is rare—the parents grieve for their neglected spirituality and long for their sense of unique autonomy. Yet, if the body of believers neglects the children, the mothers falter for vision, feeling that Christ's community cares not for the coming generations and that the weight of being their children's sole teacher is too heavy and daunting.

After all, spiritually speaking, at any age, we were never meant to keep to ourselves. Perhaps we can attain better balance and attention to these needs when we understand that our growth into Christ's likeness is the interactive relationship between two variables: *experiencing* and *knowing*.[10] Granted, the experiential and sensual elements of modern worship can be a pursuit out of proportion, but in good balance with knowledge and teaching, it can actually accentuate all the elements of our understanding and worship of God. God made us all with senses and various learning and relating styles.

John Wilson wrote this about the ways we experience God, "What could be more eloquent, more blessedly superfluous, than Creation itself? All those beetles, those unseen creatures of the deep, those galaxies upon galaxies—unnecessary. Shakespeare was unnecessary. My new grandson Gus was unnecessary. Let us

forswear false dichotomies. We are not faced with a choice between savoring eloquence and serving our brothers and sisters, or between eloquence and truth."[11]

There need not be a choice between experience and knowledge when it comes to the spiritual formation of our children—there must be a peaceful inclusion in our churches and in our homes. Let us not merely teach facts about God but experience what it means to walk with him on a daily basis through some of the practices this book will describe.

In a world that now is very accessible through travel and information, we have the advantage of being exposed to the intercultural church. The gospel is one, but it finds expression in a variety of cultural forms. There can be no part of the global church that is exclusively independent of the others. Our own immersion is made more complete by learning from other cultural expressions of the faith. These different expressions must be in conversation with one another.[12] Staggering growth is taking place in Asia, Africa, and Latin America. The church's new geographical center is sub-Saharan Africa, home to over ninety million followers of Christ, desperately in need of increased discipleship.[13]

As a girl, I met many missionaries from around the world. My parents would occasionally invite them over for a Sunday casserole of rice, chicken, and broccoli. After I ate, I would slink down under the table so they would believe I was gone. My interest and incessant love for the nations was stirred up in those moments of eavesdropping. It was the only way I could hear first-hand the news and ways of worlds beyond my small one. It fed my inborn desire to travel. My view of the world to this day cannot help but be intertwined with my idea of the church. Our children's love for the church can be bolstered when they begin

to perceive how vast and rich is the movement of God and how beautiful are all its expressions. It will serve to clarify and deepen their own theological beliefs and worship practices as they grow older and begin to unravel the details of their own spiritual and cultural heritages.

No matter what your story is within or without the church, the truth is we cannot truly love God without loving his body, just as we cannot love the souls of our children but find their physical appearance despicable, refusing to embrace their small, growing bodies. We cannot despise a floundering and broken body anymore than we can a newborn, for we know the glories tucked away in such a small package, yet to be revealed.

We cannot stay on the fringes, holding ourselves or our children back out of fear, disdain, or pain. If we do, we leave them and ourselves in a state of poverty. Women, our generation is doing this as no other, especially in developed countries—we are restless and annoyed with how things have been, how religion has been oppressive and bland. Some are tired of what a friend of mine has termed *social Christianity*, that is, hopping from one study and small group to another instead of simply living out what they already know of what it means to be immersed in Jesus. I have spoken to many women who feel an obligation and a certain comfort in remaining in the church of their childhood though it refuses to move forward in growth. Still others, me included, have church shopped out of thirst for something we expected the church to quench and out of dissatisfaction that it could not deliver. Perhaps we should *be* the church we envision. It matters to us as women and to our children if we are committed to the building of a redemptive community. We cannot call ourselves true disciples while living out an individualistic church mentality.

I find after all my wanderlust within professed Christendom that I am back where I started. I am simply a little girl in that honey-colored pew, thirsty to love well, know deeper, and live out the person and teachings of Jesus in a lush way for the fame of God and with the fuel of his Spirit. He is not finished with me yet, as he is not with you. He neglects not the care of his very body. The world is ever awaiting all of us pilgrims to get off our long rabbit trails and onto the path that leads to revolution, grabbing those along the way to climb with us into life eternal.

Jesus said, "Go and make disciples of all nations, baptizing them in the name of the Father, the Son and the Holy Spirit, teaching them to observe all I have commanded you" (Matthew 28:19). He went on to speak of the signs that would accompany those who would believe: they will, through his power, cast out demons and lay hands on the sick, and they will recover. His followers are called to imitate him by joining in the ministry of reconciliation, preaching good news to the poor, binding up the brokenhearted, and proclaiming liberty to the captive.[14] The signs will flow out from the body of Christ, but our love for all that he loves, even our distain for that which he will not tolerate, must be put forth or the wonders will not come in our lives or the lives of others. Let us not be perceived by those who are truly thirsty to carry the stench of death when we, immersed into the fullness of God, were meant to exude the aroma of life everlasting.

RUNNING

Father God, I come to you through your son Jesus Christ and enabled by the power of your Holy Spirit. Help me to un-ravel the road behind me as it relates to the church and ask the hard and honest questions. Keep me from playing church, and keep me from dismissing the church, which, in spite of all its

shortcomings, you see as a thing of exquisite beauty. Enable me to re-examine my expectations and to bring my wounds to you for healing, forgiveness, and restoration. Create in me a true vision of your universal body, and give me zeal to be an active part within it. If we turn away, we will lose the present Church; if our children turn away, we will lose the future church. I choose to stand against this and bring forth the depth and beauty of an apprenticeship relationship with you into their lives. Let them see the transparency and truth of their elders within the church living their faith. I pray that churches will value integrity, vulnerability, discernment, and creativity. Wake those that are asleep, and take the critical spirit away from those that have stayed away in hurt and judgment. Forgive the church for the sins we have committed against you, the seekers, and the members. Forgive us also our great omissions. Give me more glimpses of what is happening with my brothers and sisters around the world and a hunger to see your global church grow out from a dry and weary land. Allow me to experience first hand what you are doing outside of my own culture and denomination. Let me be unafraid to do so. Give me the heart of a learner and a contributor, marked with love. I choose to run to you, by running to your people, your very body.

DEEPER IMMERSION

Jesus' prayer for the church in John 17 gives evidence to the six things that should characterize his church. What are these marks? Ephesians 4:12–16 shows how these are fueled inwardly through community, teaching, worship, and the sacraments of baptism and communion. All of this is meant to thrust believers outward. Overall, according to John 13:34–35, what should be the basis and hallmark of the church's mission? Why is this so important in the lives of your children?

A BRAVE NEW WORLDVIEW:
UNSEEN REALITIES

"Where is your faith?" he asked his disciples. In fear and amazement, they asked one another, "Who is this? He commands even the winds and the water, and they obey him." Luke 8:25

A SOPHISTICATED, GREY-HAIRED DOCTOR IN A TIE AND a lab coat sat across from a female doctor, eating chicken salad in the cafeteria of a prestigious Florida hospital. While prodding my youngest to eat something besides spoonfuls of ketchup and my oldest to use his napkin and not his right shoulder sleeve, I eavesdropped. Their voices intense and the topic very pointed, it was difficult not to hear their words.

"What has been most fascinating to me as a physician all these years is dissecting my patients' intangible belief systems, even as I dissect their tangible bodies. Every one of them believes in something. They all have a system of values, even if it is reduced to simplistic wishes and sentimental antidotes. Humans crave to believe and never as much as when they are faced with their own mortality."

They continued their dialogue: "A friend of mine studied Christianity for three years. At the end of this time he converted to Hinduism because he was convinced there was a disconnect between a Christian's beliefs and daily behavior. Authenticity and what worked better for him were more worthy of adherence than if a system made the best sense, theologically speaking. I confess, I must agree with him. Our beliefs have to resonate with our personal and cultural makeup. We all have to find what works for who we are and go with it, respecting that in the end we are all looking for the same thing."

At that point, while I was busy scribbling their sentiments on a napkin with a dying pen, Larsen, in realization that we had not thanked God for the provision of food, grabbed my hands and began to pray quite loudly. At the conclusion of his prayer, I looked up to see the eyes of the doctors hard on us. Their conversation quickly was reduced to mere small talk in a lower volume.

By this time into the reading of this book, you may have grasped more fully the truth in your life and that of your children of a humble God and are more aware of your thirst to live out a Spirit-filled allegiance to Jesus. You may see that as a member of the church—being created in God's communal image—you are community first and an individual second. I hope by now you call yourself a disciple, a broken one made whole only by the life, death, and resurrection of Jesus.

However, when the difficulties of life hit you and your family like a head-on collision, it may seem that all of this dries up and that none of these theological standpoints are valid in carrying you through the moments of adversity, or even the simple routines. I have been there. Much of our lives are lived in the simple, unseen tasks of existence.

How does your immersion into God really matter, when, as a friend cried on the phone to me this morning, your husband says he does not love you anymore and he believes he never did? What about when your children are screaming in the backseat of the car at the top of their lungs while you are lost in an unfamiliar city, exhausted and hungry? What is the significance of your life and beliefs as you are crying on your bed, realizing that at the end of the day, you feel you have no control over the choices your older children make that tear your heart apart? Does it all apply when the biopsy report is positive, when the tumor is malignant, when the rent was due weeks ago, when the work of daily relationships is messier than you ever signed up for? How about when rebels' burn your village, your immigrant status is despised, your identity is stolen, your child works against a learning disability, or your baby dies in the womb before you ever get a chance to hold their hands and look into their eyes?

We all have our high hills and deep valleys as well as persistent struggles; none of us is immune. Jesus promised in this life that we would have trouble; it should come as no great astonishment to find broken things in a world that has been cracked. The minutes turn into hours and then into days, months, years, and you wonder, what is the point of it all? How do you gather up everything, all of the effects of this shattered world, all of your own sins and wounds, all the disadvantages of life and redeem them, even allowing God to put them to good use?

I am convinced that to redeem anything we have to live according to the worldview of God. A worldview is an intricate web of beliefs, rather like a pair of glasses, through which we see and interpret our experiences and what we perceive to be true reality. I think that the simplest common denominator of all religious and philosophical worldviews is the belief that something is

wrong with the world and there is, there must be, some way to fix it.

In God's worldview humanity is sinful and alienated from him as well as from true relationship with each other. This estrangement from him and others exposes us to the certainty of God's wrath, for the severity of our sin against a holy God cannot be overestimated. Salvation from God's wrath is found only in the sacrifice of the innocent Christ, God's sent Son, in place of the guilty sinners. Christ's death pays the penalty of sin (satisfying God's justice) and reconciles the sinner to God and others (extending God's mercy).[1] Every story in the world is based on this motif of estrangement and reconciliation, lostness and salvation, and every person in the world is living it out.

Those who believe this story of God's redemption hold that the natural world is a deliberate, orderly creation of God over which his sovereignty continues to extend. There are spiritual and moral implications to every choice made. Absolute moral truths exist. God is the all-powerful and the all-knowing creator of the universe and still rules today. We all need personal salvation and it can be obtained only through the cross of Christ. Satan is real. The Bible is accurate in all of its teachings including its demanding ethic to love and express to others this love of God through Jesus Christ. In all of this, humans ultimately exist to give God glory. In this worldview, what we *know* is intimately related to how we ought to *act*. Knowledge is so tied to ethics that knowing the good and doing the good are the same.[2]

We who profess a biblical worldview are accountable to love; such love is the artery to the very heart of the gospel. Recapturing the idea of biblical humanism, we are commanded to build our homes and relationships around the recognition that we are all created in God's image and therefore have intrinsic value. This

concept is excruciatingly difficult to honor unless empowered by something apart from ourselves. When we find nothing in others to love, then we must love them fully because of their creator. This is more than enough reason.

Dostoevsky observed, "To love a person means to see him as God intended him to be."[3] We relate to each other in esteeming, forgiving actions in the same way we want God to relate to us. This code of honor is a thread through all of Jesus' sayings. God gives value not only to select individuals, but his mercy extends to all. This is where we can base the values of love, honor, and mercy in our own homes. To relate to our children in this way as mothers is powerful and completely God-like.

After all, we are not preparing our children for an exam about God, but a relationship with him and others. We all crave the impersonal to become personal. That is perhaps why you are reading this—not simply to hold bound paper with strange black marks on it, but to digest the words they carry, which may *mean* something to you, which may *name* something that you have sensed but could not articulate. This is the work of words.

The graven images cannot contain God and the skies cannot adequately proclaim him. Yet the pursuit to find a personal God is endless, and the need is universal. Those in high society cry out to be touched and held, just as the beggars on their cardboard sheets simply want to be valued and esteemed. We all issue silent cries to the God who is there and have silent longings for the God who is personal. The clamor of it all would be deafening if we had ears that could hear human thoughts. We could not bear the thunderous, cumulative wail. It is astounding that God has not become deaf with our noise coming at him from all the generations simultaneously, as he knows no time or space. It is a wonder he distinguishes the sound of my thoughts and your

thoughts and our children's thoughts from all the others, this discerning God with incredible hearing.

This unseen world of this personal God is very real, and children never even need to be told this. They grasp that they live in two dimensions—they have a natural sense of the "other." I remember knowing this as a child, especially in the late evening. Dusk came, and a peculiar yet consoling glow settled over the trees, sinking down between the dark branches. I have always loved the evening sky and the bareness of branches because they were my first setting to the sense of the "other." They became my windows to the understanding that I live in two realms. We all need settings in which we have room to have nourishing experiences with God. We need settings that give room for the work of the Holy Spirit. How important it is to create space and time for our children—and us—to not only know facts about God but also experience him.

In the awareness of the discovery of the two spiritual realms that we live in, the seen and the unseen, we must not be naive. Jesus spoke of hell more than anyone else in the Bible. He never downplayed eternal separation from God. His justice demands punishment, just as his mercy seeks to save us from it. Heaven, hell, and eternity were real to Jesus, as they need to be to us, whether we are comfortable with these concepts or not. We are not naturalists, but rather super naturalists. The whole spirit world—God, good angels, and fallen angels with Satan as their chief—interact among themselves and with human and natural life. Those who deny or minimize these realities have an incomplete and insubstantial worldview and are open to misinterpreting facts, events, and experiences.[4]

Personally, I was not aware of the biblical intensity of this until I took an evening college course on spiritual warfare.

Week after week, taking notes through all the lectures, it was as if scales were falling off my eyes. How could I have missed so much for so many years, as if none of it affected my personal life and the world all around me? The Bible is clear that two unseen armies carry on a great battle that surpasses human thought and affects the lives of individuals and nations.[5] The biblical imagery of the supernatural realm is one of warfare, and our faith demands that we be proactive in this ancient battle through prayer, awareness, and the renewing of our minds with all that is true. Satan, a creature of terrifying magnificence, is bent on spreading a philosophy throughout all cultures that is creature-centered rather than God-centered. He spreads its corrupting themes by implanting false worldviews in the arts, medicine, media, and religion. Posing as an angel of light, Satan seeks to alter, however subtly, the biblical worldview. He is a master of deception.[6] Jesus told his followers that he was sending them out "like sheep among wolves," therefore they must be as "shrewd as snakes and as innocent as doves" (Matthew 10:16).

The god of this world also opposes and condemns followers of Christ relentlessly, stealing life and joy and speaking lies. This stalking lion with a network of millions, seeks you and yours. It is spiritual ignorance and immaturity to pretend that we do not live in a war zone and that we can walk through it all without spiritual armor or wisdom. We are not immune to its wearing effects; we hear the talk in our ears all day long and assume much of it must be our own negative and flesh-driven self-talk, when it very well could be a voice of the enemy.

We must grow increasingly in our sensitivity to discerning what aligns with God's worldview and what does not. Otherwise, we will tread among it all, tricked and lulled, unable to give a reason for the hope we profess. As a mother, I know how easily

this can happen during times of great weariness and busyness, the enemy preying on our weaknesses and vulnerabilities.

A worldview that holds a prominent space for love and the reality of good and evil would be incomplete without detailing our purpose in it all and our human desire for significance. As one who has always aspired to do great things, the desire for true significance has been both a drive and a desperate, anxious burden to me. I spent my twenties wrestling through this, often failing miserably and coming to the place where I had to recognize that my near-frenzied obsession was a deeper cry not simply to make a noble impact but to control the outcome of my life and prove to God I was worthy and capable of doing something for him. I was living as if I believed my salvation was anything but a gift; it was a pursuit of payback and an effort to control. I was an evangelical girl toiling hard and doing all the right things, but only getting deeper into the despair that stems from constant striving, accompanied by a low dose of grace. There was within me a subliminal belief that doing some kind of Christian work or ministering in a particular way was equivalent to pursuing God. It was slapping the face of a Creator who simply wants to immerse me in all he is and rush me with his love—a powerful love that so changes me that all I do is simply because I am his beloved.

Your call and mine is not to be ever doing to create significance. The gauge of significance in this world fluctuates almost daily, leaving our brittleness more delicate with every rise and fall. We simply cannot keep up, which the relentless media adores because stress and its insecurity sell. There is always a more noble cause, an injustice that needs our attention, a beauty product that is more effective, a nation with a better plan for healthcare, a room that could be more stylish, a child better

behaved, a ministry more fruitful and fulfilling, and a setting offering greater opportunities. In all of this, I have learned that I cannot locate and dwell within contentment until I first rest in the fact that Jesus alone is my significance. All else is secondary.

Many women I have spoken with over the years have told me of their frustration at not being able to use and develop their gifts, strengths, and interests during and in combination with the practice of motherhood. They alternate between delight in caring for their children and resentment toward the daily role, which they feel guilty giving voice to. They see the needs outside of their homes and they feel at a loss to meet any of them. Depression, anxiety, discouragement, anger, and stagnancy have come as a result of what they have termed an *identity crisis* or an attempt to create an identity from random scraps of their girlhood and recent adult experiences and education. Some even have taken to living vicariously through the achievements of their husbands, their children, or worse, the drama and gossip of celebrities. Women with a passion for the nations, living and working overseas, have burned out or returned to home base as a result of such nagging feelings and struggles.

All this frustration has little to do with what we are not doing, but rather with what we have not understood. Nothing we can do will make us any more significant to God than who we are in this moment. We are entirely loved by the God of the universe. We are completely forgiven through Jesus. We have been created so we might be counted precious in God's sight. Our salvation is for his pleasure. We have nothing to prove. We are souls at rest.

If you believe this is true, and it has seeped into every fiber of your being, then it follows that your purpose is to increase God's honor, dignity, and fame.[7] This happens when we allow him to change us inwardly and guide us in being his instrument in the

world. All through Scripture I see how he actually prefers to work with the weak and the limited because then it is more obvious that the power is from him (1 Corinthians 1:26–31). Ironically enough, when I am in this posture of belief and weakness, the creativity he has placed within me is truly unleashed.

When our gifts, strengths, interests, and talents are trained and used in combination with competence, character, and the intent to honor God, then the inner desperation and anxiety is cast out because there is simply no room for it. Our children and mothering are no longer a means for gaining credibility and worth. Our time devoted to things apart from mothering no longer becomes a pursuit to make something of ourselves, but rather to pursue the natural bend God has created within us. I learn to trust in myself less and in God more. I am at peace with speaking less about what I can do, who I am, and what I own. I am compelled to speak in increasing measure about all that God can do, all he is, and all he owns, as his reputation and honor become more important than mine.

In God's worldview nothing is to be duty driven, but love driven. His view works; all others leave us dry and exhausted. To live not as self-centered and self-empowered as but Christ-centered and Christ-empowered is the truth that sets us free. As John Piper expressed it, "God created us to live with a single passion: to joyfully display His supreme excellence in all spheres of life. The wasted life is the life without passion. God calls us to pray and think and dream and plan and work, not to be made much of, but to make much of Him in every part of our lives."[8]

RUNNING

Father God, I reclaim your worldview, which is the ultimate reality. I believe that humanity is sinful and alienated from you

and each other. I confess that redemption is only through the death and resurrection of Jesus Christ. Thank you for providing reconciliation. Satan is real and our battle is ongoing, but we are promised victory when we use the weapons you have provided. Let me not fight unaware or in spiritual laziness. Let me be equipped and proud to fight as a woman. Your Word is accurate, and you are my capacity to endure.[9] Fill me with love so I may look at and esteem others the way you do. I cannot do this apart from you. Let my quest for significance find its rest in you. Grant me a contented spirit as I base my identity in you and embrace how you have created me. Let me point to you in all I do. I choose to come out of hiding and grow into all you have dreamed I would be. Your Word says that perfect love casts out all fear (1 John 4:18). Fill me to the brim so that all fear, anxiety, desperation, and false sense of condemnation are simply shoved out. Let me and all the women who function as mothers not see our lives, our ministries, our jobs, our strengths, and our desires as wasted or on hold. I stand against this lie as I run from a self-centered life to a God-centered one. Take my life, and let it make much of you. Amen.

DEEPER IMMERSION

With singular focus on the unseen battle that we are in daily, read John 10:10; Ephesians 6:10–18; 1 Peter 5:8–9; and James 4:7. Note the agenda of Satan and the believer's equipment. Are you putting this on your children? Yourself?

PART 2:

PRACTICES

PRACTICING CONTEMPLATION:
THE PAPRIKA MAN

As the deer pants for streams of water, so my soul pants for you, O God. My soul thirsts for God, for the living God. Psalm 42:1–2

JUST A BIT AFTER THREE O'CLOCK IN THE MORNING, a man in a Roman haircut and a flowing tunic that seemed as if it was cut from silk paprika stood in glistening white high-tops outside our five-story, grimy hostel. We learned the reason our online reservation was so cheap; our hostel was in the red-light district of Madrid, Spain. Our family of four stayed for three nights and four days in a room measuring ten feet by twelve feet with only one wilted double mattress. We used a communal bathroom down the hall, sharing it with travelers who poured in from all parts of Europe. The accommodations were rough, most likely just the sort of place where Jesus would have been found had he lived in Madrid.

Our family had just come down a dimly lit elevator two at a time, because it was tiny and rickety. Having an early flight to Amsterdam, we needed to catch a cab to the airport. Billowing silk, eyes staring straight ahead, hands clasped in prayer-like

fashion, the paprika man stood as if he were a living statue on the otherwise deserted street. Under the stiff moon and the hazy streetlights, I recognized within me neither alarm nor calm. The sight of this strange lone figure was symbolic of that which I observed in Spain: the disappearance of children and the low desire to even mother them. Spain, in likeness to other parts of Europe, has one of the lowest birthrates in the world. The death of motherhood leads to the death of the nations.[1]

Journalist Mark Steyn suggested, "Much of what we loosely call the Western world will not survive this century, and much of it will effectively disappear within our lifetimes, including many, if not most, western European countries. There'll probably still be a geographical area on the map marked as Italy or the Netherlands—probably."[2] Holding my baby boy in my arms, I grieved this and prayed against this demonic, deathly agenda, this ensuing lie that to be all we can be as women is to be childfree. Shocked back into the circumstances by the snappy predawn air, I followed my little family forward.

Ben pulled our luggage train with one hand and held onto Lars with the other hand, setting out toward the main street. I stopped for a moment, turning to look back at the paprika man, with the eerie feeling that in doing so I might turn Anders and myself into pillars of salt. His position had not moved, but sensing my momentary stare, he turned his head to meet my gaze. Looking down at Anders, he nodded toward Ben and Lars as if instructing me to quickly follow. My look indicated agreement into his matte-blue eyes, and I walked on.

I still think about the man in silk paprika. What was he doing there in the watches of the night? Who was he? An eccentric nut, an aesthetic, or Eastern monk? Perhaps even an angel from God in strange garb? Regardless, something stationed him there at

the time before dawn, staring at a seedy hostel as if it was worth more thought than met the eye, as if it could be a place worthy of concentrated meditation.

Contemplative meditation for a follower of Jesus is a gift. It seems people the world over are born with a deep need to meditate, and this need points to the eternity that is set in our hearts. Novelist Nathaniel Hawthorne insisted, "Our creator would never have made such lovely days, and given us deep hearts to enjoy them, above and beyond all thought, unless we were meant to be immortal."[3] We are not machines, wooden, entirely programmable, only capable of left-brained thinking. Isaac, the first person in the Bible to be mentioned in correlation with the idea of meditation (Genesis 24:63), was from the Eastern mindset. This mindset is often foreign to us in the West. It is a way of right-brain thinking, which involves music, art, awareness, reflective living, pondering, imagination, dreams, and visions.

There is great value in reclaiming the lost art of meditation, in this sense of musing pensively, as a gift from God. When we reflect we can peer closer at a particular thing from a slow-motioned perspective. Things become wondrous. It has a strange, mysterious way of making ready our hearts as a farmer prepares and churns up rich soil so something of worth may be dropped into it and take strong root. As Isaac was perhaps preparing for Rebekah in the field during his time of meditation, contemplation prepares us for a more meaningful interaction with God and life around us.

During meditation, we are leaning in and listening to what the Spirit may desire to clarify or indicate where he is leading us. Clues will come when we hold out our hands to see what it is God desires to spell within them. A truer intimacy is cultivated when we take a walk out to a field and stop, wonder, and think.

To live a life of wonder, beauty, and imagination is not frivolous. As Ravi Zacharias observed, "Wonder has a direct bearing on hopelessness and evil. Loss of wonder sets the stage for evil, until truth itself dies at the altar of a desecrated imagination. If we are to understand wonder, we must see that the first chronological destroyer of wonder is anything that takes away the legitimate mystery of life and living."[4] I believe that if we can teach our children how to wonder, imagine, and think, we can teach them what it is to be alive. And a person fully alive glorifies God.

In the Psalms, a grand collection of meditative poetry, David spoke of it. Much of the meaning for his usage of the word *meditate* implies more of the murmuring, muttering, roaring, speaking, and uttering, yet still involves the pondering and the imagining aspect. He seemed to know what it was to rest in God's presence. His famous words "May the words of my mouth and the meditation of my heart be pleasing in your sight"[5] express a desire for his words and his thoughts to be on par. Without the practice of contemplative meditation, our words as well may be hollow and weak.

Joshua, in leading the nation Israel into the Promised Land, urged the people to rise up in strength and courage to receive their inheritance. He reminded them to obey the law given to them through Moses, staying straight upon it, unswervingly. He commanded them not to let the law depart from them but to *meditate* on it day and night, in order that they may follow it with conscientious carefulness (Joshua 1:8).

There is even the sort of meditation that requires us to develop and use the gifts we have been entrusted with.[6] Meditation walks the mind back and forth over previously given truth, laying deep personal tracks for us to easily slip into, so what we believe and how we live our daily lives fall into sync. Obedience can

start only where meditation has first been. All Eastern forms of meditation stress the need to become detached from the world.

As a woman in my harried days, I have discovered that if I do not take moments of meditation throughout the day, I may follow through on the impulse to toss my children and all my work out the window. Who of us has not been there? One way of stilling my soul is simply to read a few lines of Scripture, letting them drip down into my quintessential self, leaving their marks of conviction and potency; or I can say out loud with deep breaths, "My Father deeply loves me." These remind me I do not keep the moon in orbit. Even examining the veins in a leaf or the colors on a stone or listening to the comical sound of a bird with my children calms and sensitizes me again.

When we read Scripture (or great literature) to our children, we can have them close their eyes and imagine they are within the scene. I often ask my boys what they hear, see, smell, taste, and feel within the setting. They come to enter into the words, and the fact that the word is living and active is then no surprise to them. They see the deer that pants for water, and they taste the cool liquid startling their tongues. They become one of the Israelites with bags packed full and sandals tied, waiting for the walk of liberation. They hear the water being poured over the feet of the disciples, and they come to believe they can imitate Jesus.

Observe children and you will see that they have no qualms about meditation. Rare is a child with an internal checklist who, as they stare in wonder or play, is conscious of the moments that slip away repeatedly like a million grains of sand at the seashore. They receive all the delight around them.

The word *child* actually appears 482 times in Scripture. A large number of these occurrences do not refer to persons under

the age of twelve, but to persons in a relationship with God. Children are a key metaphor picturing our relationship with God.[7] I want to remember to be like my sons, peering down at the ants, mindfully digging holes, and studying a shell like it is one of the great wonders of the world.

There is something in the human mind that some researchers have termed the *transitional space*.[8] In adults this space is the part in our brains where we go to play around with our perceptions of material, relational, and spiritual reality to discover meaning. For young children this is where they actually live and play—in their fantasy and imagination. This is where they create all the unseen wild creatures and make-believe places. Their image of God is formed in this place, and they attach feelings to him, even as he defies all human psychoanalytic studies and proves to be the creator who is anything but a transitional object. Meditation on truth is crucial for their imaginations, which is one reason I am so careful regarding what is allowed to enter this space.

As crucial as our oversight is of our children's lives, we cannot take credit for giving them their sole understanding of God. It is God himself, lodged in their sacred space. Our boys go to church every Sunday with their own God, so to speak. I do not want this image to be tossed aside when they get a little older, as they will someday lose interest in their beloved stuffed animals I will store in my cedar chest. That true image of God must be reshaped and renovated with each stage of their development, based on the Word.

We mothers do have a strong part to play in what our children are encouraged to meditate on. There has been a rising interest and activism regarding the effects of consumerism and technology on the formation of children. Enola Aird, founder

of the Motherhood Project, wrote to the American culture at large:

> Our nemesis is not the marketplace. We agree that economic freedom is one of the foundations of democracy. Our nemesis is the value system that your advertising and marketing increasingly foster in our children. We mean the value system that promotes self-indulgence, assaults the idea of restraint, degrades human sexuality, promotes the notion that our identity is determined by what we buy, and forces us constantly to scale down our sensitivity to vulgarity, ugliness, and violence. With so much money to be made from our children, you are constantly trying to find new ways to reach them. Your probing into our children's minds, feelings, and sensibilities is becoming more invasive, and your strategies are increasingly coercive.[9]

Women are the number one nurturers in the lives of their children. Out of this nurturing spirit has arisen a concerned movement to rally against such value systems and targeted marketing. How much could meditation in your life and contemplation of Christ and the rich truths in Scripture deflect these very values and tendencies? Is not the relational aspect of our practices as followers of Jesus our greatest response to the world all around us? Imagine the free market of a nation changed simply because an entire generation of women are no longer thirsty for the things they fear are damaging their children. We must address our own thirst first before we seek to lead our children to pure water.

If a silent man in silken paprika can stand in a contemplative posture in one of the most degenerate districts of Madrid,

then perhaps you and I can stand firm in meditative response, detached from all that is against us and our children, securely attached and absorbed in the God who is victoriously redeeming empty practices and lost people.

RUNNING

Father, I pause before you from the whir of my days. I acknowledge that imagination, creativity, beauty, wonder, and times of pondering are gifts from you. I have wrongly associated them with immaturity, and parts of me have died. My soul has become wooden and stale. Enliven me! Bring new sight to my seeing; let my soul stand on edge, again enthused to live fully in my role as a mother. Show me how to live a more reflective life. Teach me how read the Scriptures not only in an inductive and expository manner but also in a meditative and slow way. I want to foster the creativity and dreams you have given me. I choose to accept the courage you provide in order to do this. I want my children to see that I value calm, peace, creativity, and solitude. Give me ideas to teach them this, ideas of how to create sacred space in my days, in my home. Let me not get so caught up in the stimulating culture all around me. Instead, I choose to erect intentional boundaries so that I will love all that you love and distain all that you disdain. Train the thirst of women so that what we long for is what we want our children to long for. We choose to see our imaginations as holy and our wonder as necessary. We want to see the power and beauty in your words, and we want our souls to be inhabited by them. I run to you and the words you have given. Amen.

DEEPER IMMERSION

The experience of giving birth to my second son was nothing short of worship. The difference between his birth and my oldest son's was my growing understanding of prayer and meditation. With the snow falling all around and the cold moon shining into my hospital room, I endured labor contractions with my husband at my side, while internally I repeated and inhabited the words, "For you have been my hope, O Sovereign LORD, my confidence since my youth. From birth I have relied on you; you brought me forth from my mother's womb. I will ever praise you" (Psalm 71:5–6). Spend time in meditation on this Scripture and in prayer for the women and mothers of Europe.

PRACTICING PRAYER:
INTO GOLDEN BOWLS

Since we have confidence to enter the Most Holy Place by the blood of Jesus, by a new and living way opened for us through the curtain, that is his body, and since we have a great priest over the house of God, let us draw near to God with a sincere heart in full assurance of faith, having our bodies washed with pure water. Let us hold unswervingly to the hope we profess, for he who promised is faithful. Hebrews 10:19–23

AFTER A SWIM AT DUSK, MY FAMILY AND I PERCHED ON the edge of a hotel bed to witness history in the making—the 2008 Olympic games. Larsen, who had just turned eight the day the summer games began, was not accustomed to the conscious sense of seeing events of such importance that they would be recorded in the history books. He seemed to feel the moment, the good anxiety of not knowing what the close future held, coupled with the hope that it just might contain something extraordinary.

It was the men's hundred-meter butterfly race. Not a person in the world yet knew the outcome. The whistle shrilled, the men dove in as underwater bullets. We watched as US swimmer Michael Phelps snatched the victory, by one-hundredth of a second, over Serbia's Milorad Cavic. Phelps pounded the water in triumph, shouting with glee when he realized the magnitude of his achievement. With his arms stretched forward, the particular length of his limbs meant more than he could have ever imagined—he had won by a fingertip.

We slapped each other on the back and retold the new story, something within each of us leaping out in recharged belief that we too could hit the edge of the pools in our lives with our fingertips. Perhaps there is some sort of empirical data in our own lives that bears witness to our outcome, some quality in us that can be validated by more than human opinion. We all have this great hope.

I fell asleep in the tight clean sheets reflecting on the race. None of the swimmers swam in a haphazard and uncommitted way, for they knew where they were going. Each had a purpose and a possible end result. Phelps reached as if his soul was rooted and grounded in the truth of his created calling. In that one-hundredth of a second, he was living out loud exactly what his race was supposed to be. The rest is history, the standard now put forth, in the smallest measure of time, for the generations to refer to and emulate.

This was the draw and wonder of athletics I sensed as a tomboy in my girlhood. The ageless and universal metaphor of the race and the inevitable prerequisite of training are made tangible. We can see it lived out before our eyes, and it evokes the fresh resurrection of the truth we all know deep within: every one of us was created for a race. We were made to follow, to train,

to become fit to go forward and make history, clearing the way for the generations. When we lose this focus and swim around the pool in nonsensical ways, something within us slowly dies. We live as though we have no vision, as though our unique race is too small and too short to mean anything. The apostle Paul alluded to the fact that our maturity is based on our understanding of these concepts by appropriating them through "forgetting what is behind, and straining toward what is ahead, pressing on toward the goal to win the prize for which God has called me heavenward in Christ Jesus" (Philippians 3:13–14).

Your race holds great gravity; your minuscule pinpoint on the timeline of human history means something to the One who thrust you forth for such a time as this.[1] It means something to those he planted you in the midst of and for the history of those to follow.

All throughout the Bible there is the prevailing sense of the creation and preservation of the righteous generations because of the love and fame of God. The individual is significant, but even more significant is everyone's place and role in the timeline of the generations and in the composition of world history itself.

How many of us long for what we typify as breakthroughs in our own personal, familial, communal, and national lives? We desire much and our intentions are often excellent; however, we cannot break through and run our race the way that Phelps swam until we comprehend what is at stake. The prize of our race—Christ and his kingdom coming here on earth as it is in heaven—is not a personal trophy for us alone. There is a much bigger picture than our small, yet powerful, part. We are called to advance the generations for the fame of God and the continuation of his kingdom purposes. Your choices and investments of radical discipleship affect not only you personally,

your spouse, and your children but those who come after you. David acknowledged this when he penned, "Since my youth, O God, you have taught me, and to this day I declare your marvelous deeds. Even when I am old and gray, do not forsake me, O God, till I declare your power to the next generation, your might to all who are to come" (Psalm 71:17–18).

Our moments are eternal deposits. They must not be wasted. When you come to prayer with this reorientation of your mind, you can form your walk with Jesus with your intellect and the extent of your experiences in the world. You will find that God *can* illuminate your life in all of its complexity and passion and imperfections. You will discover that your part in all of this glorious intricacy is actually quite simply profound: prayer.

The practice and the training of prayer begins when you stretch out your fingers to lay hold of this truth. It will enable you to begin to understand that your prayers matter. When you pray, heaven will respond, for your prayers are the channels through which the movement of God will flow.

The greatest thing you can do for your children is to bring them into the throne room and lay them down at the feet of Jesus, through prayer. When Larsen was young, the Spirit revealed this to me in a powerful way one spring afternoon. In Brennan Manning's book *A Ruthless Trust*,[2] he wrote about how relatively easy it is to say that we love God, but how much more difficult it is to say that we trust him. Something in his words chafed up against something tender within me. I recalled the trusting prayers of my little boy, faithfully asking God for a brother. He was unaware of my struggles with secondary infertility and the anxiety it bred. To one who has not walked through this, it may seem small; but at the time, it was very big to Ben and

me. Through the words of another writer, the Spirit asked me if I trusted him with my son, with my desires. I did not.

In Daniel 5 we read of the holy golden goblets designed for temple use, which the irreverent king brought into pagan festivities. My children and yours are golden goblets, straight from the mind of God himself. Anything we recognize to be from God and hand back to him becomes set apart. We had better be careful how we steward these souls entrusted to our care. They are not to enhance and further our own personal agendas. Material rewards should never motivate our care of them, nor should we treat them as if they were our personal property. We are not their ultimate rescuer or shield; we are not the one who controls. Even over all of our visions, plans, expectations, and necessary daily details of mothering, these golden goblets in the form of our children are created for a much larger purpose. If we cannot lay them on the altar in trust, as Abraham laid his son Isaac, then we bypass our own purification. What is really within us will stay buried, never brought to the surface for refinement. We will never know what it is to be free from fear when it comes to our children and our mothering practice.

That day I went into the room where my little boy was sleeping and laid my hands on his head. My prayer was simple: "I choose to trust you with my son and partner with you in the work you choose to do in and through him. I release my expectations for what I think will benefit him in his formative years. I give you permission to work in our family to grow us by whatever means you see fit. I will trust you."

Behind the only words I knew to use was something of great beauty. If I could paint that intimate moment spent in prayer, you might see the image of a young woman shedding the wrappings of grave clothes and waving the white flag, one more time. I was

dying again to self and all its entrapments and bowing before a path much better and more mysterious than the one I had been walking. This is the walk of faith, not sight, and the ceasing of my scramble to find a light for myself or for my child. Aside from this trust, I walked torchless.[3]

This is accomplished in the greatest of prayers—a fresh intimacy with Jesus, our advocate, so that we do not simply say words to him but we inhabit them, and we come again to see that life is much truer when it is not reduced to only our small pleas.

Most of us understand prayer to mean speaking to God in order to make a request or to commune or fellowship with him. The majority of us do that to some degree. Intercession, however, is a unique type of prayer. It literally means "a prayer offered to God on behalf of others."[4] Intercession is the act of standing in the gap between the need we see and the provision of God that we long to see.[5]

In the year 1722, a crowd of several hundred young people began gathering on the German estate of a wealthy count named Zinzendorf. Years later they sensed a movement of the Spirit leading them into a movement of prayer. They prayed in creative ways, and they prayed in shifts around the clock. Their prayers led them to see the poor as God sees them and have a passion for those who have never heard of Jesus. This prayer meeting went on for a hundred twenty-five years; it was the longest prayer meeting recorded in history. The book *Red Moon Rising* details how this meeting nearly three hundred years ago has reflamed into organized continuous prayer that is happening globally as you read these words.[6] It is awakening the hearts of our generation all over the world in radical ways. Without prayers of intercession we will miss the heart of God and the purposes he longs

to bring forth in our children, in our homes, in our churches, in our cities, and in our nations.

We lived in Mexico City for a short season, and the upper floor of our apartment had large windows that overlooked the valley of thirty-three million inhabitants. Each afternoon I would pass in front of the windows and stare at the layers of naked cement dwellings and the people that moved out from them like ants. The weight of the souls in the smog-filled city would overwhelm me, and I wondered if this was how Jesus felt looking down on the city of Jerusalem. I wanted to gather them all up and hold them close to my heart. I know now that the great weight I sensed was the burden that the Spirit had for these people, for this beloved country. He was sharing it with me so that I would come to him in those afternoon hours on behalf of that massive city. I was beckoned to intercede. Without understanding what these deep waters of sensitivity are that rise and fall for no apparent reason, we may very well come to believe that we are depressed or mad, rather than pursued to pray. There are times when we are allowed to share the intensity God has toward the nations, and we would do well to embrace this as an honor—those rare moments when our lifeblood pulses in harmony with his.

I believe most mothers and fathers would understand this in their love toward their children. It is more than the parent-child bond; it is the burden to intercede, which was pressed on you at their conception. You go to God on your children's behalf, when they, in their smallness, know not what to go to him for. You run ahead, rushing to the throne with them in your arms for Jesus to bless and nurture their inner spirits. You watch as he places his shield around them and pours truth down to the depths of their understanding. You observe as he feeds and waters them or hands you the food and water so you can. When your words

are weary, you thank God that others value your children to such an extent that they too intercede for them. There are times when you will be called on to carry another mother's children to Jesus. Do not hesitate. I do not know where I would be today if not for the radical prayers of my own parents and so many others on my behalf. Someday the trail may be made visible. In faith, I trust in the power of prayer.

All these prayers are never in vain; they mysteriously accomplish much (James 5:16)! I envision them to be like tiny slips of paper that are tossed into gleaming golden bowls, set aflame and handed up to Jesus, then passed on to the Father, who delights in their sweet and persistent aroma to the point where to not respond in sovereign wisdom would be to not be God.[7]

Our prayers are not only to be the "now" prayers but the "then" prayers. Through intercession, we can reach far into the generations that will trail ours, making spiritual, eternal accumulations. As Jennifer Dean has written,

> We can be a present conduit through which the future power of God can flow. We can release His power to accomplish His purposes. We can leave behind for our descendents a spiritual trust that can never be stolen, squandered, or lost. Prayer is deathless and limitless; once we have submitted our prayers to heaven they live on in the spiritual realm. The answers to the prayers you pray today will be answered in the lives of your descendents at the right time. Those answers will be working in their lives as if you had just prayed them. Your prayers will put spiritual riches on deposit for them.[8]

Pray for your children as they grow that you may be aware of where they are in their spiritual, cognitive, emotional, and relational development. Ask God to raise your awareness in

these areas so you may be effective and intentional in your role. Intercede over them daily, often aloud, in growing power and fervency, so in hearing your prayers they may learn to be intercessors themselves.

Pray that your children will feel loved and accepted, that they will discern their life purpose early and be equipped to fulfill it, that they will honor their parents and resist rebellion, that they will follow truth and reject lies, and that they will live in health, wholeness, and abundant creativity. Ask that their sexuality be protected and they would flee from immorality, that they would be free from fear, and that they have a sound mind as well as a passion and capacity to learn. Pray that they would be enabled to avoid addictions and if they are to marry, to be led to a mate that will help them grow and teach them great love and grace. Pray that they practice forgiveness, walk in repentance, seek wisdom and discernment, live radically as a passionate disciple of Christ, and seek him all their days. Ask God to do much of the same within you.

Declare your children's freedom from the sins and destructive tendencies of the past generations. Ask that they speak life-giving words of mercy, have the ability to determine truth from error, and be influential in bringing fame to God.[9] Pray that your children, and you, would have zeal and love for the nations. Ask God for divine equipping in order that they will be instruments of justice and hope to the poor and the oppressed, being part of God's response to suffering. Above all, pray that your child's life would be one that gives God glory, as they become all he envisions for them.

Prayer recognizes our human limits and throws faith on God. I pray for my boys because I know that the world they have been brought into through my womb is a place full of glory, but also full of enemies—the world that seeks to conform them,

their flesh that seeks to condemn them, and Satan who seeks to compromise them. All the issues of civil rights, welfare reform, the war on terror, poverty, the need for clean water, AIDS, environmental issues, abortion, human trafficking, a despairing economy, international political affairs, and much more compose the landscape of our lives and much of what our children will walk into, but with a greater intensity than we realize. Our struggles and enemies are real and our war is incessant. Prayer is the truest and most effective weapon I can fight with, no matter the hour or the place.

A friend of mine who recently has come out of a two-year period where she battled cancer, an international move, sending her first son off to college, and a fierce struggle with depression said to me over tea at a local coffee shop, "All that can be shaken will be shaken in our children's lives, more than we have ever experienced, I am convinced. We will not model perfection for our kids nor are we expected to; we as women must model the pressing in. God does require our constant return to him. This pressing into the Lord, through prayer and deed when all around us is in disarray is vital for us and for them. If anything, I want my kids to know that I pressed in and that they must do it even more." Her words are exactly what this running, this immersion, is all about.

Jesus' whole ministry was saturated with prayer, and he commands that we do no less in our race. Let your prayers, propelled by training, push you and those in your wake forward into the only source of power that can shake the very generations.

RUNNING

Jesus, I thank you that you are our advocate before God the Father. You make a way for us to go into the holy of holies. You

call us your golden goblets! Give me the vision to see my life as a race, my run to you as paramount not only for my children and me but also for the generations to come. Enlarge my thinking, and thank you for placing me in this world for such a time as this. I choose to be a woman of prayer, welcoming all you are passionate about to become my heartbeat. I choose to release myself and my children fully into your care and for your purposes. Let my life and my children's lives grow into all that you have dreamed they would be. Burden me with circumstances in my immediate realm and those within my nation and the world for which you need intercessory prayer. Increase my thirst and understanding of interceding on behalf of others. I will be a watchman on the wall in the night; I will pound the courts of heaven and come against the gates of hell in bold confidence. I call on you, in the authority of the blood of Jesus Christ, to release your power to accomplish more than we could ever ask or imagine. Amen.

DEEPER IMMERSION

A lifestyle of continual prayer is costly. It will change you and those around you. Read Nehemiah 1:5–6; Psalm 134:1; Isaiah 62; Luke 2:36–37; and 1 Thessalonians 5:17. Will you devote your life to being, as Jesus was, a radical intercessor? In many ways, world history belongs to the intercessors. Will you be one?

PRACTICING FASTING:
TRAINING DESIRE

They all ate the same spiritual food and drank the same spiritual drink; for they drank from the spiritual rock that accompanied them, and that rock was Christ. I Corinthians 10:3

IT WAS AN UNUSUALLY WINDY AUGUST DAY AS I FOUND my son's hand and we stood on the purple porch of our rented, one-hundred-three-year-old house. Ben soon pulled up and we drove to the Title & Transfer Company. Signing the papers, we were handed the keys to our new little, yellow two-story house. That week we asked God to make this humble dwelling a spiritual refuge and house of prayer for us and any who would visit or live there after us. It was God's house and we were simply offering it back to him. We learned long ago—be it ever so small and as unimpressive as an old house right by the highway—that something or someone dedicated to him becomes much more impressive than it may seem.

When we left that house to enter the next chapter in our lives through a job offer, the house stood vacant, unloved, and

even abused for many months until a missionary family from Eastern Europe, needing a home for a year, occupied it. It was just as we had prayed.

It stands empty again like many other houses with the wolf of foreclosure at the door. We could not have anticipated the burden any more than many of you in such economically troubled times as these. So last week we declared a day of prayer and fasting for those who wished to join us. We believe that selling or renting a house is not too large or small of a thing for God to show forth his fame.

That day I could see again the quiet validity of the practice of fasting. It was my sons and I in the middle of the day, bowing down and admitting that our only deliverance would come by the intervention of God. It was Ben and a handful of others pausing in their day to intercede, desiring more for God's hand to respond than fill their stomachs with food. It was more than just about a house. We were, we are, powerless left to our selves and our own means. Fasting reminds us of this and alerts us to what it is we actually desire.

We usually try to quench the incessant ache of our desires through the vehicles of lust, envy, covetousness, and ambition. Speeding around, we occasionally drive to God, but usually to beg for what is in his hands without every gazing on his face. We pull out like a crazy driver, full of anger and annoyance while God simply wants to show us that his arms are empty so that he might embrace us. I wonder if for God to part the waters before us so we can walk through on dry ground, he first must part the waters within us so he can walk through, free and clear, declaring his dominion.

In New Testament times fasting was a central component in worship.[1] Not only can fasting mark our humble repentance,

it can also transform our prayers, resulting in a personal re-
vival. It stuns us out of our busyness into the remembrance
that bread alone is not enough for our well-being. Fasting
reminds us of who is behind physical nourishment and just
how hungry our inner selves may be for God—if we can stand
to feel it.

The Bible teaches us that when worshipful fasting is coupled
with prayer, its outcomes are immense. Done in secret before
God in the midst of our normal daily routine, it can bring great
revelation and discernment from the Holy Spirit.[2] It is not to be
a Gandhi-like hunger strike to prove a point or even raise funds
for a worthy cause, nor is it obligatory or meritorious. Unlike
the Muslims' yearly Ramadan in which they have only one meal
per day before dawn for the whole month of September, biblical
fasting is not compulsory. This fasting arises purely from the
heart, as urged by the Spirit. I think of it as a necessary spiritual
retreat from some of the daily routine and as a time of intense
conversation between my creator and me.

The Old Testament tells of Israel fasting before approach-
ing calamity. This would focus their attention and demonstrate
their fresh alertness to God and his heart.[3] It was a wake-up call
in many ways. Instead of doing something to fix the problem
before them, they would simply stop and acknowledge that God
is God and they were not. The account in Ezra 8 shows fasting
taking place in the context of having immense practical needs
and crying out to God for help and provision. The paths for
healing and provision are so often cleared through the practice
of prayer and fasting.

Men and women have fasted for mental and spiritual clar-
ity, for deliverance, for understanding and wisdom, for a greater
endowment of power, purpose, and vision, and to prepare for the

good burden God wants to place in their lives. In a culture where the bodies and health of women and their children are at times put on a level of idolatry, how good it is for us to sometimes take a step back and get down to the truth that our bodies are for service to God and not for our own vain use.

Desire is something every human was born with, and, too often in Christendom, we have not differentiated between holy desires and unholy ones. We have simply thrown them all out, which may be the reason our faith has become so drab and shabby. The world tells us that we must either be dead to what we truly desire or be a slave to it. The gospel tells us that to be alive is to be thirsty, and fasting has the power to liven us to a holy thirst, to holy desires.

As with our bodies and minds, our desires must be trained. Fasting can be a tool of this training as it exposes our desires, thoughts, and the lies we have held on to. Christ said that the truth would set us free, and this includes the freedom to be a slave to all that is good and true. Fasting can help free us to realign our thoughts with biblical truth and our desires with holy deeds. This is what it means to work out our salvation with fear and trembling, for God is working in us to desire and act according to his good purposes (Philippians 2:12–13).

We are our children's constant trainers, gently guiding their desires, much as biblical fasting trains our desires. As our children begin to grow, they see that the Spirit is not tethered to us and that the way to God is through Jesus, not through us. Catherine Stonehouse wrote, "To say that children are spiritual beings does not assume that they are ready for spiritual disciplines (such as fasting) or that they can be expected to consider what pleases God in all their interactions. Often children experience God in fleeting moments of awareness and may not be fully conscious of the encounter. Such glimpses of God, however, are real, and

the joy, peace, and insight of those glimpses germinate within the child and someday may come into the full bloom conscious love for God."[4]

Our little yellow house is still standing unoccupied. It is clean and waiting for the next manifestation of what God's desires may be. The fasting and prayer have not been in vain. Heaven will respond . . . in due time, as time is his invention, not his master.

RUNNING

My God, my Savior, my Teacher, I thank you for the mysterious gift of fasting that reminds me that I do not only live by all that I see but also by all that I cannot. Teach me to listen when you are leading me into a time of fasting for whatever reason. I will listen and respond. I will come in repentance and in expectancy that you intend to do a work through it. Show me the root of all my desires. Even awaken my desires and let them find their rest in you and be trained by all that you hope. Enable me to uncover my children's desires, meeting them and steering them as necessary. You value what we are thirsty for, so let me value my children's thirst and not shut it down. I recognize the holy discontent within my own soul, as you have set eternity in my heart. I praise you for giving that which can fill my dry soul and the gift of never losing that thirst, so that I never stop running to you to fill it. Amen.

DEEPER IMMERSION

Consider Psalm 145:16,19. What is it that you desire? Read Romans 8:22–25 and Hebrews 11:13–16, and notice the sojourning heart that depicts a follower of Christ. Can you live with this? Might the Spirit of God be nudging you to a time of prayer and fasting to repent, to listen, to prepare, to move the mind of God?[5]

PRACTICING STUDY:
RECITATION OF THE MIND

Oh God, you are my God, earnestly I seek you; my soul thirsts for you, my body longs for you, in a dry and weary land where there is no water. Psalm 63:1

"CLOSE YOUR EYES," I ANNOUNCED TO ANDERS. HE squealed with excitement, immediately plopped down, squeezed his eyes shut, and held out his hands. I had gathered some preschool supplies and had been giving him one a day for the first two weeks of Larsen's school year. Today it was a new puzzle game—matching photographed baby animals with their mothers by fitting the pieces together. When he came to the photo of baby chicks, he was unsure if they belonged to the mother chicken or duck. He tried to fit the chicks with the duck, just when Lars walked over to observe. Anders realized his pieces did not fit, and he looked up at his knowing brother. Realizing he had the wrong pieces, he threw both down to bury his head in my lap. He was finished playing. I lifted up his small head of blond fluff so I might see what was in his eyes.

They were overflowing with shame. I knew it well and I held him close. If I would have had a sword, gleaming and sharp, I would have sliced the throat of that beast named shame and watched to make sure it was dead so that this ancient enemy would never erupt through the heart of my son again.

There is a correlation between shame and learning. That strange and distressing phenomenon that swells up from a sense of being exposed has a firm grasp on how we explore and embrace the world in which we find ourselves. Exposure means revealing our vulnerabilities and deficiencies. Having nothing to do with moral failure, it involves something deeper and more essential to the self. The child who feels shame experiences an exposure to others in which a deficiency in being, an inadequacy intrinsic to self, is on display. Its twin brother, doubt, often emerges next.[1] If ignored, shame becomes the ornate throne on which the dictator of fear reigns, forcing us to bow to its false authority. We run and hide, becoming less than all we were created to be—all in attempt of avoiding shame at any cost.

Every woman I have met, from every corner of the world, has spent time in this throne room. Who of us has not been held captive by our familial backgrounds, the unspoken or spoken rules, or the realities of bodies that were too bony or too plump? What about the thinness of our wallets, the erratic behavior of our loved ones, and the humility of our dwelling places? What about our lack of competence or education, the limits of our own personalities, and the sins we have committed? How it wrenches our hearts to detect these glimmers in the eyes of our children! Yes, shame has become the most evil of motivators and the most relentless of dictators. Still we, who profess to be set free from the weight of accusation, walk around heavy with its chains.

Ironically enough, I have discovered that shame leads not to humility but to pride—the worst kind of self-pity and arrogance that deceives all those around us as we try to prove we are worthy to somebody, to anybody. Shame robs us of having a teachable spirit that is outstretched to the world like a cup waiting to be filled to overflowing with all the good it encounters. It pulls our cups back from the fluid glory of everything, including the hard discipline and attentiveness all good learning demands. It keeps us from being subject to the subject matter. It shuts down our minds. Arrogance and a teachable heart are mutually exclusive.[2] There is no courage where shame dwells, and learning demands volumes of courage.

Perhaps the most devastating effect of shame is the resistance it creates against the renewal of our minds. An arena of the mind dictated by shame is one that is set on fear, not on the things of the Spirit. Shame grips us in self-worship rather than in God-worship, quenching the very activity of the Spirit. One of the greatest agendas of the Spirit is to adjust the very posture of our minds and give us eyes to survey the wondrous love of Jesus and the magnificent intricacies of the world he crafted so that we can grow, going from glory to glory.

Such a demeanor of the mind gives us courage to be exposed as learners, not immediate masters. It willingly submits to training and technique. It acknowledges that there is not a disconnect between personal holiness and the life of the mind.[3] The truth is that if we are all truly human, created in the very image of God, then we all are called to a life of the mind. To create, reason, synthesize—none of these is a hindrance to our faith, but rather the greatest aid.

I lament for the robbing effects of shame in my own life. Perhaps some of the groans of Jesus on the cross were for the

coat of freedom he knew he would hold out to me all of these years, longing that it would become my very skin. This has nothing to do with the American dream brought on by my hard work, self-reliance, and belief in myself. Those burdensome externals do not address the universal sense of shame; they do not liberate my soul in the darkness of the night when I am alone and aware of my own inadequacies. Our confidence to learn and grow and that of our children must be rooted in more than our persons or it will not endure; it must be based on what the cross of Christ accomplished and the new identity he gives us with that coat of holy confidence. Depending on God and pursuing him with a renewed mind bring the only true freedom.

It is only as an adult staring into the eyes of my own sons that I can see Adam's reflection and weep for all the years I have worn the shame chains for whatever reason. The gift I can give to my children is to be a woman unchained with my cup outstretched to the wondrous world, seeking to fill it with all the fluid glory around me and then pour it over them. One of our greatest callings as mothers is to unleash freedom on our children, leading them to that holy coat rack so they may engage the world around them with wisdom and awe and courage, as God intended.

When Larsen was small, we discovered a delightful set of books, now out of print, called *Henry the Explorer*. They were stories of a little boy and his dog, Angus, who explored the world around them, marking their discoveries by leaving a trail of small flags with a letter H on them. My son and I were so inspired by these stories that we took small wooden skewers and taped bright, square pieces of construction paper to them and wrote a big L in permanent marker. I placed Lars in the bike trailer; the flags were piled on his lap, and we rode off into the morning air. At every place that meant something to him, he yelled for

me to stop so he could stake out his delight with his tiny flag. The town was littered with those flags by the end of the day: the park on the edge of the river where he fed the ducks, the front of the neighborhood bakery, the best place to pick up pebbles, the edge of the highest sand dune, and the base of the fence that surrounded the historic orange caboose. We claimed all of his joys and made them wave in praise. It was the method of study for a four-year old, the best way he could bear witness to knowledge and study of his world. Knowledge and belief are on the same team. Knowledge in the biblical sense is very different than mere knowing. It is seeing what is implied and then acting on it. Knowledge, like obedience, must move us. It must become transformational or it is only mere information, never amounting to wisdom.

We need study, the type that leads us beyond meditation to analysis and critical thought. Alan Wolfe wrote, "Of all American religious traditions, evangelical Protestantism ranks dead last in intellectual stature."[4] It was not always so—but we have grown terribly lazy on many fronts. Sadly enough, from the reading I have done, this fact points its finger mostly at mothers; particularly mothers who have chosen to stay home with their children. This ought to grieve us and have some sort of impact on what we feed our minds and the diet we present to our children. Is it rich and hearty or filled with only the sugar of passing fads? Theologian John Stott has rightfully said, "The kind of food our minds devour will determine the kind of person we become."[5] A.W. Tozer wrote, "The things you read will fashion you by slowly conditioning your mind."[6]

What are we reading, watching, investigating, and learning? Are we students of all that is around us—books, art, cultures, sciences, relationships, nature, experiences? Do we milk every

ounce out of them or live unreflective, unintentional lives, the fruit of untrained minds? What a terrible witness to the magnificence of the Creator! As Charles Malik stated in his address at the Billy Graham Center, "The problem is not only to win souls, but to save minds. If you win the whole world and lose the mind of the world, you will discover you have not won the world. Indeed, it may turn out you have actually lost the world."[7] Indeed, if we can reach the thoughts of the generations, we can reach the influence of nations and change the landscape of the times.

In the Hebrew language the heart is the center of human thought and spiritual life.[8] The heart is not only emotive, but also deeply thoughtful. Many ancient cultures seem to have believed that the heart was the seat of all intelligence. Western culture tends to separate the intellect from emotions, with various dialects of Christendom elevating one over the other. In the time of Jesus, study was actually considered the highest form of worship. When you look at the words of Jesus, they carry with them an assumption that his audience knows what he is talking about because they have made themselves familiar with the Scriptures.

Old Testament Scriptures stress the richness of living this life to the full, not in some burdensome, guilt-ridden law keeping but in relationship with God himself. In the book of Hosea, God is recorded as saying, "I desired mercy, not sacrifice; and knowledge of God more than burnt offerings."[9] This knowledge of God was found in the written words of God available at that time and in the laws and sacrificial system that pointed to the character of God and the sacrificing Servant Messiah to come.

In the New Testament God's people are admonished, "Since, then, you have been raised with Christ, set your hearts on things above, where Christ is seated at the right hand of God. Set your minds on things above, not on earthly things. For you died, and

your life is now hidden with Christ in God" (Colossians 3:1–3). Things above are those things that have a rich eternalness to them, a daily significance. Paul reminded us that we are not given a spirit of fear, but of love, power, and a sound mind (2 Timothy 1:7, kjv). Again, heart versus head is a false choice as the spirit of truth is also the spirit of love and of power—these strengths are not pitted against each other.[10]

My most frequent prayer for my children is that they be filled with love, power, and a sound mind to the utmost degree, having a hunger and thirst for the teachings of the living God and finding great delight in learning and applying them to their daily lives. Children naturally are attracted to the teachings of Jesus; they listen and receive. They have an innate ability to understand and be thoughtful about the teachings of Christ.

Robert Coles, a psychiatrist and professor at Harvard University and an amazing life-long scholar of children, noted this in one of his own case studies. Many of the children he interviewed emphasized the childhood of Jesus and the similar struggles he must have had. One boy in particular, a twelve-year-old from the hills of Tennessee, stressed the teaching capacities of Jesus. He said, "He's a teacher whose word is good! He taught everyone to love. Jesus knew how to teach—you can tell by what the Bible says. People knew He was special, very special, and they waited for Him to tell them things. If a teacher does not get your interest, it does not make any difference if he has a good idea or not! No one is listening. Jesus gets to you even now, and He's been gone all those years. You can hear Him talking. You can see Him. He's looking at you, and you don't want Him to leave, ever. He's the only one who's going to save you. He's that kind of teacher!"[11]

I must address the caliber of the minds of women and moth-
ers. Studies on current gender equality substantiate the impor-
tance of women developing their minds not only for their own
sakes but also for their children's sakes.[12] This current struggle is
no different than it has been for centuries. Throughout history
women have rarely been in the forefront of public life or given
a voice to express their opinions and thoughts. Ancient Hebrew
writings have express mixed views on women. Some refer to
women as "good, tenderhearted, possesed great intuition and
discernemnt and had strong faith"; others refer to women as
"greedy, eavesdroppers, lazy and jealous" as well as "theives and
gadabouts."[13]

In spite of the fickle opinions that prevailed in the world
into which Jesus came, there is *no* recorded instance where Jesus
disgraced, belittled, reproached, or stereotyped a woman. He
does not appear to have propogated the idea that women were
being victimized nor that Judaism was negative in totality toward
women. Rather, he simply and naturally did what was righteous
in each narrative involving women. He treated them with dignity
and respect, repeatedly liberating and affirming them—just as he
did with men and children alike. He sought unity.

Since the days of Moses, Jewish women were not permitted to
even brush their fingers across the Scriptures. There was debate
in the Midrash over the eduation of women, some rabbis con-
sidering women appropriate candidates for schooling. Overall,
women were instructed how to regulate their lives according to
the teachings of the Torah, but they could not personally study it.
Women were given instructions in domestic duties such as food
preparation, spinning, weaving, medicine, and midwifery. While
men were required to attend prayer services, women stayed
home to care for the house and children. They certainly were not

allowed to read the Torah aloud in the public congregation—this would bring "shame" and "harm the dignity of the reading."[14] No rabbi or sage instructed a woman in the Torah.

Until Jesus.

My heart burns within me every time I read the familiar account of his visit with Mary and Martha (Luke 10:38–42). Instead of joining Martha in meal preperations, Mary sat at the feet of Jesus, listening to his teaching. Not only did he commend Mary for her choice but he also admitted her, a woman, into his "class." Spirituality was not an issue of gender with Jesus. He saw that we are all the same in our need for teaching and transformation; we do not live in separate parallel worlds.

I have often thought of this when I prefer to be in the study rather than the kitchen. The Sage invites you and me, his apprentices, into his class where, as we listen, we are eating spiritual food needed for spiritual beings. We do not live on bread alone, but on every word that comes forth from God. Spirituality for a woman or a man void of full engagement of the intellect is not spirituality as Christ intended it to be.

Perhaps many of us women lack the knowledge or time to nourish our intellects. Our thinking is characteristically relational and contextual. We respond to the needs and demands of relationships with a strong, almost compulsive, ethic of responsibilty and care.[15] I think Jesus understood this in his response to Mary. He reacted to her in a way she could understand, and he was releasing her from what can often become bondage of obligation. And perhaps, he was releasing her from the chains of fear and shame that held her back from the freedom to learn and grow.

Look at this passage and discern the implications. The Word, its fullness hidden from women for generations, was now made

flesh and opened before Mary, and she was affirmed in her desire to enter. She followed her inner initiative, and Jesus responded with a warm invitation. The days of exclusion were past with the breaking forth of the kingdom of God.

So, there Mary sat, at the feet of Jesus. The ancient Old Testament custom of falling voluntary at another's feet was taken as a mark of reverence. By the time of the New Testament, sitting at someone's feet was considered an act of submission and teachability.[16] Now Mary, the first female student of the Word-made-flesh, could touch, hear, and belong as a disciple of the great sage Jesus. What liberation. Such liberation we cannot take for granted as women. Enter in! And bring your children into the Word so that the fullness of God's reign in their lives can be now, for the kingdom is now.

Does it not establish more firmly our own sense of dignity as women, as followers of the great sage, to know that Jesus allowed women to be learners of him? He gave them validation in their hungry desire to learn. He received women into his inner circle; he treated them as disciples on a par with male disciples. He had close relationships with several women, and it was Mary Magdalene who was the first witness of the resurrection in John's Gospel (John 20). Jesus' own mother was a leader in the apostolic community (Acts 1:13–14).

The evidence is there, and it continues throughout the New Testament and into the present. I saw a documentary last year on the secret desire of Muslim women to learn. One woman, so heavily veiled you could barely hear her whisper, said, "I have heard of Jesus and his great teachings in the Christian Bible. One of my dreams is that someday I can read his words for myself and learn what he really did say. There is so much I want to learn."

I have never forgotten the desperate longing in her timid tone. I reflected on my own pile of books and Bibles on my night stand. My pillow was wet that night, wet with tears for all women worldwide who longingly still stand, like bleating and anxious sheep in a pen, waiting to be freed. They still wait, held back by inner shame or outer oppression, when, in all truth, the gate was burst open with violent force and the King, the Word-made-flesh, led them out,[17] led us all out over two thousand years ago.

Let us live in the freedom of a mind open to learn. As mothers, we do not have time *not* to! Recite over and over the good deeds of God in your life and in the subject matter before you; center your concentration on it, comprehending to the fullest what it is you are learning or want to learn, and reflect on the significance of it. Walk away changed, invigorated, freed, and renewed, and thus truly blessed.

RUNNING

God of my heart, soul, and mind, I praise you that you have set us apart from the animals in our desire to know things and apply our knowledge. I confess that shame, fear, and pride have been obstacles to my learning and my full embrace of all you have designed me to be. Fill me with your love, power, and a sound mind in all things. Let me learn and study and risk courageously and, in doing so, be to my children a living epistle of your glorious freedom, showing them how to engage the world around them. Let all that I learn become a part of who I am. I choose to fill my mind with the best, not the cheapest, of foods. Enable me to be thoughtful and discerning with what I put into my mind. Thank you that you have never seen women as less than capable of learning and that you made a way for us to

enter into all of your fullness. I pray for the millions of women who hunger to learn and aquire more skill, understanding, and education. Open a way for them and their children. Provide the schools, the finances, and the help. Let me not take learning and education for granted, but let me share all that I have been given. Let the water you have poured into me be poured out on the thirsty. Let my mind be your designated space, always only for you, my King. Amen.

DEEPER IMMERSION

Read 2 Corinthians 10:5 where Paul speaks about taking every thought captive. Take note that he is referring to the battle of our minds and hearts that goes on daily, challenging our devotion to God. In what ways have you allowed your devotion to be compromised by what you fill or do not fill your mind with? Are you a learner or one still hiding in shame and fear? Have you believed that you must forfeit personal learning for the sake of your children? Make a list of subjects, experiences, relationships, books, and so forth that you would like to become a student of. How do you want to grow in loving God with your mind?

PRACTICING REST:
SABBATH THEOLOGY

The Lord is my shepherd; I shall not be in want. He makes me lie down in green pastures, he leads me beside quiet waters, he restores my soul. Psalm 23:1–2

BEFORE DAWN BROKE ONE MORNING BACK IN THE 1990s, Annie was shaken awake and urged to dress. She assented and piled into a small car with her fellow teachers. They whizzed through the Japanese countryside with the fresh splendor all around them peeking out through the sleepy fog. Their intent was to get to Miharu, Fukushima, as soon as possible. Word had spread that the Takizakura tree was ready to bloom. To witness the wispy pink petals open their eyes as the new day wakes them from the slumber of the winter was apparently significant. This was not just any tree; Takizakura was a waterfall cherry tree, well over one thousand years old. It was named a national treasure in 1922.

Guarded by a fence, its ancient crooked arms jut up and out to hold the thousands of flowers. Similar trees nearby in the hilly

land are believed to be this tree's offspring. Annie described how she made her way to the tree, camera in hand, and then paused. She noticed thick wooden beams, perhaps ten or so, driven into the ground under most of the heavy branches. Each beam held up the weight of a branch so it could continue receiving life from the roots and trunk. The supportive strength of those beams ensured the yearly bloom of the branches.

I think of that picture often now and how you and I are given a similar provision in God, to ensure our blooming. I have never met a woman who has not deeply desired that her life leave a legacy like that of the thousand-year-old tree. We are told by our culture that to accomplish this we are to dedicate ourselves to productivity with quantifiable, documented results. Our exhaustion testifies to this reality. Whether we are wired to be task- or people-oriented, most of us fear living insignificant lives. We carry anxiety about missing out on divine opportunities that will change our lives and those around us. The subliminal Protestant work ethic is our ever-present taskmaster. North American culture promotes the belief that if you work hard enough you can do anything and be anything—our effort being what is ultimately responsible for our achievements. Self-sufficiency, we are told, is the true sign of success.

According to author Judith Warner, most women in Britain put in at least one hundred hours of work a week in the field of mothering, and this forms the "hardest working profession" in Europe today.[1] Business leaders may scoff at the idea that doing the laundry, the school run, and the vacuuming constitutes real work, but most mothers would disagree, pointing out that such labor is often physical, relentless, goes unnoticed, and is unpaid. Many mothers also work part-time outside the home. Research among 1,035 mothers found that for nearly 40 percent of them

the day did not end until nine o'clock at night on a regular basis, and a third slept fewer than six hours a night. For those in London, seven hours a week were devoted to school runs alone. Many believe that the underlying reason many women live in such busy, quiet desperation is due partly to the tax system. Is it really? Are the nebulous forces outside of us as followers of Christ much stronger than the will of God that should rise up within us?

Paradoxically, in spite of all these lies and programming, the best provision for our mothering is *rest*. It is spoken of and commanded over and over in Scripture. Our immersion into God must redefine not only our womanhood but also our motherhood.

You are not like any other woman. If your spirit is alive in Christ, you have great beams supporting you. The needs of your soul and your body ultimately have their dependence in Christ the Vine, not in yourself. You are a branch that is connected to the Vine (John 15:5). As Andrew Murray wrote, "The branch grows out of the vine or tree, and in due time it bears fruit. It has no responsibility except to receive from the root and stem its nourishment through the sap. The branch is at rest."[2] Your labor has an end; yours is not an uninterrupted, self-sustaining life. Your God provides you time, space, and a mode of thinking that enables you to keep life in perspective and avoid burnout and breakdown. He refers to this as the *Sabbath*. And this Sabbath rest is meant to be a practical reality.

Rest is not a luxury for the wealthy or those who have two weeks of yearly paid vacation; Sabbath was established at creation.[3] Incessant work without a respite goes against the grain of the created order. The Old Testament prophet Isaiah pointed the finger at the people of God for letting the Sabbath deteriorate.[4]

The accusation seems to underscore how easy it is to fall into this neglect and how much it means to God and to his people to observe a Sabbath rest. The true biblical understanding of *rest* is not to relax or rejuvenate, but to cease or desist from exertion.[5] God, the author of rest, has no need to relax or rejuvenate as a weary body or soul. Thus, there must be a deeper implication for the meaning of *rest* if he himself enters into it and becomes rest to us.

Since Adam and Eve's fall and the death of their spirits, people have been obsessed with survival. God's rest calls us out of this frenzy and into an acknowledgment that our existence does not depend on us. Just as he beckoned the wandering Israelites back into this trust by providing them a double portion of manna on the sixth day,[6] so he beckons us. He demands that our rest not be based on all we have done, but on all he has done and shall do. It demands faith to allow God to be our provider. Our lifestyle of Sabbath living is an opportunity to exhibit this truth. And it allows us to better discern what God's part is and what is ours in carrying forth the work of his kingdom, the bearing of fruit on earth with a more lucid, interdependent viewpoint.

Spiritual rest follows the labor of faith, the work of being sure of what we hope for and certain of what we do not see (Hebrews 11:1). We cannot stand for a lazy, easy faith anymore than we were saved by a cheap grace. The Bible always depicts faith as a fight, an intense battle that will bring revelation.[7] There is no rest without such labor.

This work of faith can be represented by the process of giving birth. A woman in labor often sweats and groans through hours of strain demanding every ounce of her physical and mental strength. She is sure she will see the child she hoped for all those months, certain of the baby's existence though she has

yet to see him or her face-to-face. Finally, every vestige of labor ends as the baby slips out into the world. What the woman was seeking has found her. Holding her baby on her chest, she closes her eyes in contented rest. Her new little one must depend on her for nurturance, just as we must trust that God will nurture us. Her rest was not one of relaxation or rejuvenation. No, it was much sweeter and more unforgettable. It was a ceasing of her nine months of specific exertion. It was the contented grandeur of taking a part in God's created order and holding what she had hoped for, what she was certain would come to be. The baby is the fruit of her labor.

This is a picture of the wrestling of our faith and our work and of God's rest. It is the rhythm of life here on earth as we constantly battle the flesh's natural desire for independence. The process cumulates in a taste of what our eternal rest will be composed of. But for now we are gifted with just a whiff and are invited to inhabit it, inhabit God in whom we live, move, and have our being. There are no constricted movements within him; we move in fluid activity. It is not we who invite him into our lives; it is he who invites us into his. We find a place, a reward to satisfy our strivings. In him we cease our exertions and we find the truest rest. Unbelief in God's promises and in his ability to be our all in all will steal our rest (Hebrews 3:18–19), snatching it away with such a pull that we will walk around ever weary. Belief—in essence, rest—in who he is and what he has said he will do changes the posture of our hearts, where we discover that life is all about desire for Jesus and knowledge of the Holy One, attributing all fame to him.[8]

A friend of mine who has wrestled for years with driving perfectionism finally understood that her pursuit to excel was a way in which her flesh was responding in what the world would

consider a "positive" manner. Her confident and competent self believed that she had all the resources within to keep things under control. She must. The conviction that everything would fall apart without her administration left her in a state of people pleasing and overtiredness, all in attempt to meet the expectations she felt. What other alternative could there be? She began to see the stress that her frenzy put on her children. It was the opposite of trusting God in undesirable circumstances and leaving the outcome up to him. It was contradictory to radiating a calm sense of peace and having a soul, mind, will, and emotions at home in God in an imperfect world. She was not attached to the vine, so her life was full of work but void of fruit. She cheated herself from entering God's rest because of her misplaced trust.

As women and mothers we cannot do it all. We must trust that the breath of God breathed into us through the Spirit will be more than enough to cover all our needs and recall to us the truth that God urges us not to be afraid, for he is our shield and our "exceeding great reward" (Genesis 15:1, KJV). This is not mere philosophy or ideological thinking. Rather, it is intended to be personal, daily, and highly practical as we are gradually renewed and give up trusting in our own strength.

I must believe that if being immersed into Christ redefines every aspect of our living, then it must also redefine our acts of attempted rest and leisure. We must examine our modes of stress relief. Spa treatments, aromatherapy, or drinking a cup of hot tea before bed—as good as they are—cannot be ends in themselves. We have to ask what it is we are seeking to alleviate or fill. If we are bypassing the work of faith and the true meaning of rest to simply relax, then we will always find ourselves returning to empty, and our souls will always feel parched. Relaxation becomes an idol when it takes the place of abiding in the Vine.

Spiritual immaturity considers Jesus a helper. Maturity knows him to be life itself.[9] I will find rest and all I need when I slip into his life and let him move through me. This is usually played out by knowing what it is he has directed me to do and doing it well, utterly dependent on him for the outcome and to meet my needs and desires.

I wonder what it would look like if we taught ourselves and our children to find their leisure in rich and creation-affirming ways? How does turning off our minds in front of a mindless television show or escaping reality through easy reads add depth, joy, and texture to our minds? Does our chosen entertainment give our souls a sense of divine rest? We are letting others open up the world to us instead of doing it ourselves with thoughtful discernment and awakened creativity.

Too many possibilities presented to us and our children kills the delight each was intended to bring. Crowding little lives does not build options, but, in effect, kills the wonder in all options.[10] Often when we seek rest for our children, they profess lack of interest because of their conditioning in our over-stimulating culture. Something is wrong with this. Is the presence of God through the intricacies of creation not stimulating enough? When we turn our backs to him and choose cheap substitutes, our joy—the by-product of true rest—is depleted.

We have been called as a holy priesthood, a people unto God. Does our leisure attest to this? In Genesis 2:2 we see that after God established his creation, he rested. It is no small thing that God ceased to create on the seventh day and called all he had made good, pronouncing the first blessing. He controlled his work; it did not control him. Finding our home in the person and work of Christ and ceasing from our work reminds us of the divine perspective of labor we should maintain and the

gratitude for the fruit we are honored to bear. Genesis 3:8–9 indicates that God would spend time walking in his garden, enjoying his relationship with the people he had made. How might he want to engage with you and your children in your specific times of Sabbath?

How good it is to participate in God's intention to bestow his *Shalom* peace on all of creation, and how deeply influential— perhaps as ever-blooming as a thousand-year-old Japanese cherry tree. We are held up and supported by the provision of the eternal rest of God.

RUNNING

Father God, I would like to be known as a person of rest, as a branch who abides on the true vine. My family needs this; I need it. Give me a bold endurance to wrestle and fight through the labor of faith in my life now, for I am sure of what I hope for, certain of what I cannot see. I choose to believe you and not allow unbelief to steal my rest. I choose to live a lifestyle of active Sabbath as I acknowledge that you are ultimately my sustainer and provider. I want to enjoy you and allow you to nurture me through prayer, creativity, community, and laughter. I want to deepen my soul through that which challenges my thinking and deposits rich truth about you and your world. Give me ideas of how to lead my children into these things. I pray for all of the tired mothers here and around the world—shake us and enable us to have the boldness to evaluate how we are choosing to live. Show us your way and how to receive all that you offer. May my daily obsession be not striving, but utter dependence on you and the breaking forth of your kingdom. Let these be more than words—but a new reality as I continue to immerse myself in you and allow you to redefine my living. Amen.

The Israelites were promised rest in the Promised Land; we are promised rest in the work of Christ (Hebrews 4). He bore the weight of toil and striving. Mediate on his words in Matthew 11:28–30. Note that the typical nature of a yoked young ox is to try to run ahead of the more mature and learned ox it is yoked to. But all it gets for its efforts is a sore neck. Consider the quote of Hannah Whitall Smith in your own life, "The Lord's servants are not in obligation to do everything. He has his own special work for each special workman. In a well-regulated household this is how it is done!"[11] As you meditate on Psalm 127:2 and Isaiah 63:14, consider recapturing the spirit of Sabbath rest in your own home and your own way of thinking.

CHAPTER 11

PRACTICING SIMPLICITY:
ONE TRUE WORD

The mouth of the righteous is a fountain of life. Proverbs 10:11

The words of a man's mouth are like deep waters, but the
fountain of wisdom is a bubbling brook. Proverbs 18:4

ERNEST HEMINGWAY ADVISED, "WRITE ONE TRUE word.
Write the truest sentence that you know."[1] In reflecting on this
often as I write, I think also of spoken words. Our immersion
into Christ as his followers must transform even our speech. God
bestowed language on humans as a means of communication
with him and each other. He originated the spoken word with
the creation process. We forget, doubt, and question his word
because we are often so fickle with our own.

When my words become capricious and I need to be stunned
by the voice of God and set back in my place as the creature,
I turn to Job. This book delves into the transforming crisis in
the life of a noble man who lived in ancient times. Job endures
great suffering and his friends are unable to resist spouting off

their own assessments. Words dash everywhere, hurled from every incorrect angle as his friends take less time to listen than to speak.[2] They all insist on fitting what happened to Job into their personal frameworks concerning God and how he relates to his creation (Do we all not tend to do this?). In their structures his friends make the calamity intelligible, as humans have the relentless need to make all tragedy understandable.

Job, after enduring all the false interpretations of his troubles, speaks to God. I pause there because this act begs us to imitate; we can speak to God too. Imagine a clay pot rising up and speaking to its potter or a desk turning to speak to its craftsman! We are the created who have been given actual communicative breath to relate to our Creator and others he has created.

Job uses his breath, and in the midst of noting God's majesty, wisdom, and mystery, he questions and laments that God does not hear him, is punishing him, and allows the wicked to prosper. God finally interrupts Job's agony by speaking to him out of a storm and asking some questions of his own. All of God's questions declare his supreme knowledge and control over all his created order. He declines to be held accountable for pain to Job or anyone else. The reader cannot help but be stunned and humbled at the sheer magnitude of these truths.

I still shudder when I read the very words God uses in his reply to Job: "Brace yourself like a man; I will question you, and you shall answer me. Would you discredit my justice? Would you condemn me to justify yourself? Do you have an arm like God's and can your voice thunder like his?" (Job 40:7–9).

Job responds with humility, repenting of his attitude and acknowledging God's great justice and power. He chooses to trust God with all he cannot understand. No simple act. Without the spoken word, no such exchange could have happened. Words have meaning—irrevocable and eternal meaning.

Anders, my youngest son, has had difficulty with his words. I have spent many hours with him at speech therapy, training him to use his tongue, mouth formation, and airflow to communicate more clearly. We work at home, and every week is a new victory, his frustration level becoming less pronounced as he more effectively communicates. We have marveled at the little thoughts he has held inside that now he can release.

In coming alongside him in his journey of apt communication, I have often likened it to our journey in learning to use our mouths as followers of Christ, retraining them to be not merely the means of narcissistic, opinionated self-expression, but of true service to others. C.S. Lewis wrote, "The greatest cause of verbicide is the fact that most people are obviously more anxious to express their approval and disapproval of things than to describe them. Hence, there is a tendency of words to become less descriptive and more evaluative."[3] If we are to serve others with our communication, our objective is that we listen to understand others, not just spout off so that we are certain others understand us.

Some of our evaluative language is gossip. The Hebrew word for this term actually means "evil tongue."[4] It is defined as defaming a person by revealing negative details about him or her to others. Slander is speaking lies about another person. Jesus and his entire Jewish community frowned on this habit. They equally despised any talk that was simply pointing at something in order to criticize it. There is a fine line between critical thinking and being a habitual critic. Not only do activities of gossip, slander, and constant criticism point to an evil tongue but also to lazy language skills.

We are not entitled to shooting off our mouths or indulging others while they do so, feeling the satisfaction of acting out

our primal sinfulness. Solomon in the book of Ecclesiastes said, "Do not be rash with your mouth, and let not your heart utter anything hastily before the Lord. For God is in heaven, and you are on earth; therefore let your words be few. As a dream comes when there are many cares, so the speech of a fool when there are many words" (Ecclesiastes 5:2).

Our standard is to be much higher, as we must be women of few but powerful and true words, especially in light of the fact that we are constant teachers to our children. This is one of my greatest struggles and perhaps one of yours. But the resurrected life must include the pursuit of resurrected language, or it is a mere shadow of all the abundance Christ died to claim.

If we are to use our words to communicate out of a heart of service, then our listening to others should be in the same vein. Listening in our culture is considered a mere mental activity. In the Bible, with a few exceptions, every place we see the word *listen* or *hear*, it means to obey. When Jesus said quite adamantly, "He who has ears, let him hear!" (Matthew 11:15) he did not mean for us to just listen to all his words and have them memorized until we dull to them, but to put his words into fierce action. Hebrew thinking always emphasizes the idea that we have never truly taken something into our hearts until it transforms our very lives.[5] We must be careful of what we take in then, for no one is immune to influence, and our lives will eventually bear witness. The external will always follow the internal; thoughts are first, words are second, and actions are the outcome.

The real battle is always first in the thought world. If we have not developed a rich thought life from listening to wisdom, our words will be bland or harmful. As Ravi Zacharias observed, "If you have spoken but not listened, you have spent without income

and sooner or later an expenditure of words without an income of ideas will lead to conceptual bankruptcy."[6]

I never knew as a child that I could be discerning about what I gathered from all the sounds around me. I deduced that we were all at the mercy of the vicious flux of emotions that all words caused. No one seemed to know of another way to clarify my emotions. I wanted another way, but the words I trapped within my heart became the framework of the stick-built house of my personhood.

As mothers, we need to remember that communication is not only the ability to talk but to listen. Perhaps the finest art in communication is not in learning how to properly express our thoughts to our children, but learning how to draw out their thoughts. We need to understand what is going on inside them and try to see the world through their eyes. Make listening and talking about everything and anything a normal part of your days with them. Once your children see your genuine interest, they will naturally ramble about their interior lives.

It is then that we can help them discern what words are filling their minds, driving their choices, values, and beliefs. We can help our children separate what is from God, from Satan, or from them. Conversing with our children in the context of their very concrete and literal thinking, we can challenge them to think beyond themselves as much as they are cognitively able. Our language is to convey that behavior is an indication of what is going on in the heart, what words and ideas are aligned in their thinking.[7] The stewardship of our words and our listening should be modeled so that our children see their expenditure of words as just as important as the family's monetary budget. Jesus spoke about this outgoing expenditure of words. He said that "the good man brings good things out of the good stored up inside his

heart, and the evil man brings evil out of the evil stored up in his heart. For out of the overflow of the heart the mouth speaks" (Matthew 12:34–35).

There is an inexplicable staying power in our words—the power of life and death (Proverbs 18:21). We can all testify to the sour aftertaste of bitter words left on the palates of our minds and emotions—what we wish we had or had not said, what were really the words behind the words, what words we felt forced to say in compromise. We cannot say that careless words affect only the few and far between; that is a lie too many people believe. Many of us walk around with arrows sticking into our flesh—big, gaping, bleeding wounds that pin our arms down, keep our eyes lowered, and our feet slowed. We are all wounded by words.

We must measure our words as women and as mothers again by Jesus' demanding ethic of love. To love means that we show honor. Honor speaks to the highest, not the lowest in a person. To dishonor someone means to treat him or her as common and ordinary, rather than weighty, precious, and having great value. People tend to believe what they are told and how they are treated. We all grow in the likeness of what we are shown and what words are spoken over us. That is how God relates to his children; he tells us who we really are so we can become, according to his enablement, all that we were designed to be. Can you imagine how speaking words of blessing and not cursing and argument has the potential to literally change the lives of women globally?

A friend of mine in Africa lives near a town where twenty thousand widows live! In some African cultures, after the husband dies, the family of the husband comes and snatches away all the possessions the couple has gathered through the years. The house is stripped bare, and the woman and children are left

destitute and become the untouchables in their communities. Because well-meaning people there do not have the ability to help these widows, they would rather not deal with the sense of guilt, and they avoid them altogether.[8]

Along these lines of dishonoring treatment is a recent article in a prominent Mexico newspaper that reported the murders of fourteen million women this past year who died from aggressive domestic physical violence. In that *machismo* society the Mexican government has yet to put into effect public policies to ensure the basic human rights of women. This is another example of the demonically inspired war against women and thus against the endurance of the human race.

I wonder what would happen if the people in Uganda and Mexico simply began to bless and honor women and their children with encouraging words. What doors might that open? What sense of hope and courage might that bring?

Someday you and I will hear the language and tone of the awesome voice that does bestow blessing and honor on us. I have heard it through the years in certain measures, but someday we will hear it as we have never heard it. And the sound of the voice that brings things into existence will leave us without need for any more words, except praise.

RUNNING

Father God, thank you for giving me the ability of communication to relate to you and others. I ask that you would do a deeper work within me of retraining my language and my listening to be of true service to others and honoring to you. Forgive me for my judgmental words that have attacked the character of others, rather than lovingly addressing behavior. When I hear your Spirit, let me listen to obey. Through language, give me

the ability to clarify the thoughts and emotions of my children. I choose to use my words to honor others, speaking words to them that I think you would speak. Fill my home with honor. Guard my lips and let my mouth utter nothing but wisdom and speak what is just. Embolden me to speak up in society when I need to defend the essentials of the faith, to empower the voiceless excluded from public discourse, to expose wrongdoing when direct confrontation has failed, and to repair the wrongly damaged reputations of others.[9] I bless the women and children around the world whom others have deemed unworthy of honor, encouragement, and hope. I speak words of life over them and ask that they might see and hear your goodness in the land of the living (Psalm 27:13–14). Amen.

DEEPER IMMERSION

The Bible teaches us that life and death are in the power of the tongue. It also teaches us to protect others from shame by talking less and acting more. Listen to your children more than you lecture. When you correct your children be careful and gentle with your words. Read and copy James 1:19–27 as well as 3:1–12. Also, if you want to continue to learn what the Bible says about our words, go through the book of Proverbs and make note of every place in which the tongue, mouth, words, and listening are mentioned. Begin replacing words of complaint, arguing, and complaining (Philippians 2:14) with words of gratitude.

PRACTICING BEAUTY:
INTENTIONAL SUBMISSION

The Lord will guide you always; he will satisfy your needs in a sun-scorched land and will strengthen your frame. You will be well-watered, like a spring whose waters never fail. Isaiah 58:11

I HAVE LONG BELIEVED THAT WHEN SOMETHING IS beautiful, it is good and true and stirs within us a certain ache—a yearning not only to look upon it, but further to possess it or inhabit it. We visit places or people of beauty and struggle in the need to end the experience. We feel the impulse to claim all this beauty as ours because it seems that the power of ownership of all that is wondrous can quench our determination to become one with it. Dictionaries cumulatively define beauty in terms of the quality that gives pleasure to the mind or senses and is associated with such properties as harmony of form or color, excellence of artistry, truthfulness, and originality. This idea surpasses sappiness or glossy amusement; rather it defines itself in the experience of what we might call glory. What a gift to be able to respond to such beauty all around us! The writer George

Eliot penned, "It seems we can never give up longing and wishing while we are alive. There are certain things we feel to be beautiful and good, and we must hunger for them."[1] Immersion into Christ and beauty intersect. They are meant to be reconciled to each other or our immersion is too small, our swim to shallow.

A couple of summers ago my younger sister Elisabeth and I watched a television show that attempted to do the work of defining such beauty. The show was about a supermodel transforming a hard-working, well-deserving woman who had forgotten her own innate beauty. With the help of a host of fashion and beauty experts, the woman was readied for her very own photo shoot. It implied what we all sense: neglect and ugliness weigh us down. Very early in this show, the favorite vocabularies of these human restorers became obvious—"hot" and "sexy" were used over and over, while the words denoting *beautiful* were almost never used. The real intent was there—human beauty and all of its descriptive synonyms mean nothing in this culture. They are exchanged for the much-desired social and cultural labels of hot and sexy. Feminine beauty is reduced to the power of lust and the worship of sex appeal.

Without a doubt, obsession with body and health are distinctive of social life, particularly in Western culture. The media subtly and overtly send us messages that the most important thing in life is to possess sexual attractiveness; if you have this, you can get whatever you want. Life is all about the individual gaining power to manipulate others. Again, the essence of beauty has nothing to do with all of this.

Like me, you have probably had moments while standing in front of a full-length mirror in a dressing room when you despaired over the perceived inadequacies of your own body. I do not think we can say that our outer appearance does not matter to

us, because it does. But can it be that when we cease to embrace the true definition of beauty, we call ugly what God has created as good and we disregard the fact that those who truly love us do not choose to do so because of our appearance? Those around us who speak love and truth into our lives do so because they have discerned the beauty of God with and on us. Our beauty is to transcend our individuality, and the beauty we admire is to stir the pining we have for eternity, for the true beauty of Jesus and what he has prepared for his own.

Betty Blake Churchill explained, "The truth is we haven't seen or experienced real beauty . . . because no one has seen God, no one can begin to imagine the depth and mystery of infinite beauty. Our sense of beauty is just a taste, really, of what is beautiful—God himself. The value of beauty lies in the fact that it is a reflection of him. He created us in his image and as a means of pointing people to himself. The value is short-changed when beauty becomes an end to itself."[2]

Our bodies have never been the problem. It is sin and eventual death that has been the dilemma since Adam and Eve paved the way for such in their choice to rebel against God. Being embodied, walking around encapsulated in mysterious flesh and bone is good—good since God formed them and gave them life.

Author Dallas Willard highlights this idea in his writings. He reminds us that our bodies, if we profess to be followers of Christ, are holy, yet they are not our own.[3] As disciples, we have the command to release our bodies back to God and allow him complete authority. Secondly, we are no longer to idolize our bodies, making them a primary concern. Finally, we are not to use our bodies to dominate, control, or manipulate others or as simply a source of sexual gratification.

To present our bodies to the world to elicit sexual thoughts, feelings, and actions from others is a form of dumbing down our intended beauty. In doing so, we show very little honor toward others or ourselves. How we use our bodies is integrally part of how we develop our souls.[4] When refinement happens internally, our bodies have the honor of displaying that externally. Scripture reveals that our very countenance will speak of what is internal.[5] However, it all begins with the Holy Spirit ruling our souls after they are activated to life through the grace of Christ.

Women who have chosen to immerse themselves into Christ do not lose the desire to feel and be beautiful in their femininity. On the contrary, we should be the leaders in this area! We do, however, reject the cultural notion implying that the way to soul transformation is through bodily transformation (Matthew 23:25–28). Instead, we run to true beauty; we pursue God.

The ancient Israelite women who had just come out from an Egyptian culture, which was almost obsessed with body care, donated their mirrors for use in the building of the temple of God (Exodus 38:8). I can imagine how difficult it must have been to give such a gift. Perhaps it was a testimony that their image was now reflected in God's and that to stand at the entrance of where he dwelt now satisfied their underlying quest for beauty, love, and acceptance. What if we took all of our mirrors—the mirrors of culture that tell us what the latest passing fad is, what the best new beauty product is, which clothes we have that are now out of season, which weight we should be—and give them in a great pile to God? It seems we need to throw them off in order to run into him, as I had tossed away my watch and keys to run into Lake Michigan that sundown with my son.

Our calling as followers of Christ gives radical redefinition to our view on bodies, health, and beauty. We acknowledge the

beauty of the form and function of our bodies, and we see them as literal members of Christ and temples of the Holy Spirit. We are the dwelling place of God, and we submit our bodies primarily to this purpose. We have given over the authority of our bodies to God—he has the right to govern, lead, and rule them. This is not a surrender that steals joy. We do not necessarily have to give up our personal styles and preferences—it is not an oppressive dictatorship. Those expressions are another branch of God-given creativity and celebration of beauty. Instead, it is an understanding that submission to God enhances our beauty as nothing else can. Our reason for nurturing and enjoying our feminine bodies is radically different from that of the world around us. It is all done to show our worship and delight and to draw deeper into the beauty of God through the beauty he has bestowed on us, for we cannot grow tired of the shattering implications that we "are not our own, we were bought for a price. Therefore, honor God with your body" (1 Corinthians 6:19–20).

What if we tended to the care and health of our bodies not because of our fear of wrinkles and varicose veins but because we desired to live long and strong to be Christ's instruments to advance his kingdom? The body holds much power. We could nurture our bodies for the service of others, not for the medals of flattery or from fears of appearing to be anti-fashion and anti-sex. Every motivation must come down to serving Christ and serving others, rather than originating from competition, power, a quest for the constant state of youth, or to keep up with the current fads.

I have this notion that to be able to rest in submission personally and train our children to submit, we first must be willing to surrender our bodies to Christ in all the ways he intends. I question a woman's full immersion into the fullness of God if she

refuses to acknowledge and hand over kingship of her physical body, for she is holding back the only hand that can bring forth her full glory.

If the heart and body are not in mutual submission to God, there is a disconnect. It is our bodies that provide the testimony in our mannerisms, countenance, care, and communication that Jesus has done something profound to rescue and renovate our souls. Bodily submission is simply another way of challenging us in our thinking and practices about what or whom we have chosen to honor, trust, and follow. There is something about giving our bodies and our souls to Christ that enables us to come alive and respond more fully to the beauty he has created all around us and the glory he is bringing forth through us.

RUNNING

My God, I praise you for the ability to long for and appreciate beauty. I praise you for creating my feminine body to display your glory. My body is good. Forgive me for ways I have given it over to anything or anyone instead of you and all you intend. Cleanse me from the ways my body has been taken advantage of and the ways I have sought to have ultimate authority over it. Thank you that you make all things new, even my bodily beauty. I choose to submit it to you as your dwelling place and delight in the care and enjoyment of it, not out of obsession or to win the approval of others, but to be a mirror of your beauty. Forgive me for the times I have wanted the attention of others in a dishonoring way and forgive me for the times I have not even taken any care to enhance my appearance or tend to my health. Show me how to care for my physical body so that I might have more effective service to you and others. I will come under your authority in all areas so that my children might learn how to submit to your wise

instruction, discipline, and extravagant love in their own lives. I pray for the women and children whose bodies are not respected and, as a result, they have grown to hate the physical containers you have given them. I am grieved over their violations, and I ask that as they run to you, your Spirit would so dwell in their bodies that they would shine in all of your glory and delight in the fact that you have intentionally made them beautiful. Amen.

DEEPER IMMERSION

The idea of submission, honoring another above ourselves, is paramount to having the proper perspective on our health and our bodies. We desire our children to obey and submit when we may be living in bodily rebellion. Search the following Scriptures and see what you glean from the idea of true submission: Romans 13:1; 1 Corinthians 6:12–19; Ephesians 5:21; and James 4:7.

PRACTICING SERVICE:
PONDERING ME LESS

The poor and needy search for water, but there is none; their tongues are parched with thirst. But I, the Lord will answer them; I, the God of Israel will not forsake them. I will make rivers flow on barren heights, and springs within the valleys. I will turn the desert into pools of water, and the parched ground into springs. Isaiah 41:17–18

"You call me 'Teacher' and 'Lord,' and rightly so, for that is what I am. Now that I, your Lord and Teacher, have washed your feet, you should also wash one another's feet. I have set an example that you should do as I have done for you." John 13:13–15

WE HAD DRIVEN TO CHICAGO FOR THE WEEKEND TO visit some dear friends and were heading back to Michigan, where we lived at the time. The season of road construction in and around Chicago is like eternity: no end and no beginning. It took us hours to inch our way through the traffic lines, and it was late when we finally reached Indiana. With our four-year-old boy

sleeping in his car seat in the back of our little, black two-door car, we sped on through the night in stiff silence. Earlier, there had been sharp words flung between Ben and me, and now we both were feeling the sting, annoyance, and regret. We were in a place again where it seemed our plans lay like crushed glass all around us and we had no capability to put them together again. The poverty of our pockets and tactics left us feeling thin and shabby. It was not the first time. We had married young and we were growing up together. Wading through the world with few tools and rustic faith was hard on both of us. The drive through the sleepy night felt like our lives: we could not see what anything was until we came upon it; there was no preparing, simply the act of moving forward.

It was then that our little car jolted and clanked, hissed and growled as Ben turned off to take the nearest exit. He calmly pushed it into an obnoxiously bright truck stop. Lars awoke just as Ben was beginning his usual response in such situations: prayer. He asked that God would send help and give us a place to sleep for the night, as we had no money for a hotel. Lars awoke energized, as he always has loved to see what astonishing order God will bring out of such messes.

God's order this time brought us to the warmth of a turquoise living room in the middle of the night, fed and shown just where there was room for us to sleep. The family was from Ben's boyhood and they had been glad to come to our rescue, even at midnight. We stayed up into the early morning, chatting with this endearing young couple while our little children slept. It all came out, tumbling off our perplexed hearts and into the room. They listened, hospitable with both their home and their hearts, and accounted to us bits of their own story.

For five years, Ken worked at a soup kitchen and eventually became the food pantry coordinator in a downtown, north side Chicago parish. With two small children, they knew this would likely not be a permanent position. They were living out the questions too, of what it is to be young with young while striving to live out their faith in Christ with boldness and consistency. They spoke with fervor about their convictions of serving the least among us. They had not meant to, but their words jolted us out of our world. It was a good awakening. When I think of the practice of service, I go back to this couple, these true servant leaders. For theirs is not a faith caught merely in the classrooms of theological education or religious self-promotion, it is the simplicity that loving Christ means serving others and giving up some comfort for the sake of the kingdom.

Josie may not know it, but her life is countercultural. In the common worldview of secular materialism, a woman's identity is not based on the intrinsic worth of being made in the image of God, but rather on her position in the workplace. In this worldview women like Josie who earn no money in a job are not perceived as productive members of society. But if someone stole motherhood away, all society would soon dissolve into anarchy and poverty. We already know that eighty-three countries are now below the replacement fertility level. This encompasses 2.7 billion people, 44% of the world's population. Apparently, a woman who has children and raises them to serve others has a small brain and is of little value to society![1]

Josie stood against this lie every day that she took her oldest daughter in a sling through the nights' events at the downtown soup kitchen. Countless dirty stuffed animals were bestowed on her, as well as pieces of linty gum and books from the public library that Josie would later return herself. As her daughter

grew bigger, she would sit in the kitchen's big industrial sinks, babbling and waving to the guests.

Small children draw others to them, for they consider all to be simply people—their understandings have no room for categories or pecking orders; thus all are put at ease in their presence. As mothers, to give our best often means sharing our children with others in this way, rather than holding them to us as though they are for our own personal delight and blessing. Their very presence in the lives of others is their best service, and we must not deny the world this gift.

Ken spoke about Dorothy Day, a woman radically devoted to the idea of helping the poor. He quoted her: "As for ourselves, yes, we must be meek, bear injustice, malice, and rash judgment. We must turn the other cheek, give up our cloak, and go a second mile." The examples of St. Francis and St. Theresa of Avila also spoke volumes to them both. Josie mentioned her own parents, missionaries to Central America, who served and persevered no matter the cost, without whimpers of complaint or inconvenience.

We are often the hands and feet of our God who does not demean the least among us. No matter what our need is—material, emotional, physical, or spiritual—we are still needy. Serving others means does not mean showing them that *we are* water for their thirsty souls, but that *we have found* where the water is.

An immersion into Christ is meaningless without the action of social justice, the concept that God's justice should be brought to every aspect of society. Women like Josie are longing to get beyond the shrill rhetoric of the often too-huddled Christian subculture, crashing out to meet the real needs around them. We need to remember that no person among us

is common and no one is unclean. We walk among those made in the image of God.

Many of us who grew up within strictly right-wing evangelical churches were cautiously warned in our formative years about a liberal social gospel, regarding it as a threat that could undo the firmness of being justified through Christ on the basis of faith alone. It was a reaction against liberation theology that—instead of addressing our individual standing as a sinful person before God—speaks mainly against the social and political consequences of sin. Streams of this approach focus on the liberation of the marginalized, especially the injustice done to minorities. It is a view that seeks to create an earthly utopia with equality and justice for all. We must not forget that the early church not only preached the gospel of true salvation—the life, death, and resurrection of Jesus Christ—but also practiced doing away with social distinctions by giving to anyone who had need.[2] The two must go together, for they have the power to meet the needs of the eternal soul and the human experience. This approach alone values the sacredness of the whole person and draws others into a true immersion into God.

There is a joy of coming into relationship with those we seek to serve, for they often have just as much to give us as we think we have to impart to them. God's idea of advancing social justice in a sin-shattered world is to multiply the number of those who pursue justice in their own social relationships because they have been created in Christ Jesus to do good works, which God prepared in advance for them to do (Ephesians 2:10).

Josie, now a mother of four, all under age six, recently and so rightfully stated to me, "I think that we as humans forget that the poor and all of the injustices of this world are not the most important thing—Christ is. We serve others and fight for justice

because in doing so we are serving him. We can easily elevate service for the sake of service as though it is the savior and our gospel. It will redeem neither them nor us, and it is not about whom we serve. It is all about Jesus. We serve in order to turn faces to him, not to our sociological triumphs. My hope is that my kids will grow up and serve God with their whole being. I do not care what they do or where they do it. They may touch millions or just one person. It really doesn't matter to me as long as they are able to mirror the true face of Jesus."

Josie believes that the best way to train this vision into her children is in teaching them to serve one another within their home—to serve not out of feelings but out of choice. Josie is teaching her children how to live out Jesus' new command to love one another as he has loved us (John 13:34). When we serve others—whether it be through interceding for them, babysitting for them, preparing a meal for them, the words you can write or speak to them, the picture you can paint, the song you can sing, the toilet you can fix, the law you help pass, the freedom you can fight for, the healing you can bring, the counsel you can give, the little teeth you brush, the debt you forgive, the time you can spend, the bed you share, the floor you can scrub—it is then, and perhaps only then, that we begin to love them.

Love for others is often followed by the choice to serve and honor God. To think like Christ is to act like Christ, which is to live a life in service to others.[3] It is also to receive another's service to you, not with entitlement or greed, but with joy that you can sometimes be the receiving Christ and at times the giving Christ. It is difficult to give unless you first learn how to truly receive.

I look back now at that return drive from Chicago, at what seemed to us to be another hitch in our already pot-holed road.

I see now it was the Spirit running out to meet us in the faces and tender ears of Ken and Josie and their children. They had simply made themselves available, giving what had been given to them, allowing their convenience and plans not to be the king in their home. Now, Josie tells me, they are in the process of signing up with the state of Indiana Senior Foster Care. The children are looking forward to having an old person come and live with them, adopting a grandparent and learning to serve in new ways that esteems the elderly among us in a quietly drastic way. They are learning that their first community is within their own family—that their house is not to be a barrier to service, but a bridge.

Ronald Sider, author and president of Evangelicals for Social Action, wrote:

> History has proven that the effects of sinful societal injustice can be conquered. In my lifetime, I have watched Solidarity's Polish workers defying what seemed like an impenetrable Soviet system, helping to contribute to the collapse of the Soviet Union. I have watched courageous non-violent Filipinos that lay down in front of tanks to overthrow a vicious dictator. I have watched, even played a tiny role, as a global coalition of activists helped to bring down the system of apartheid in South America. A longer historical perspective underlines the fact that there is nothing inevitable and unchangeable about widespread justice. William Wilberforce and his small gang of supporters who worked within and without the British Parliament for more than thirty years—eventually abolished the slave trade in the British Empire. At the time when my ancestors, the

16-century Anabaptists, stood for religious freedom and were executed by the thousands for their beliefs, they could not foresee that two and a half centuries later, the writers of the American Constitution would make religious freedom the center of their grand experiment and that over the course of the next two hundred years, religious freedom would become the norm rather than the exception around the world.[4]

God must be pleased to witness and fuel such triumphs over wickedness and injustice. But if all the glory goes to people and not Christ, then these victories have no eternal significance. They are bankrupt and are a tribute to mere humans and our instinct to survive. We must remember as followers of Christ that our service to conquer evil is not motivated by a sense of human decency or a desire to create a utopia, but out of love for Christ and a desire to express his love to the world.

RUNNING

God of heaven and earth, I praise you for being ahead of my road. I thank you that your ways are better than mine and that though I can plan my steps, you are the one to direct my path. I want to seek your agenda rather than mine. I want to care for my children and my family out of service based on my love and gratitude for you, rather than out of stingy duty and rolling feelings. I choose to practice hospitality and service as I have opportunity. Let my life be all about you. Open my eyes to the needs in my own community, nation, and the world. Fill me with a drive to educate and equip myself and be aware. Pull my head out of the sand so I can both empathize and react with strong action to the concerns facing our world today. You are the divine initiator

for the good works you have for me. Let me hear what these are and join you there. Give me a daily plan and a yearly vision to be a part of your mission to bind up the broken hearted, preach good news to the poor, proclaim freedom for the captives, and release from darkness the prisoners. Use me to comfort those who mourn and to provide for those who grieve. Use my hands to bestow on others a crown of beauty instead of ashes, the oil of gladness instead of mourning, and a garment of praise instead of despair. Then, they and I will be called oaks of righteousness, a planting of the Lord for the display of your splendor. I run to you to be filled, and I ask that you send me out to pull others into your wild and sustaining waters. Amen.

DEEPER IMMERSION

Our commitment to God lacks authenticity if it must be prodded and forced to reach out to others. Our service is to go beyond our own individual benefit and growth. Study Isaiah 58. It speaks of the nation Israel seeking God for wisdom and guidance through prayer and fasting, but God rebukes them for the sins of their societal injustices. Have your prayers and your seeking gone unanswered because of your sins in these areas? In what ways do you need to rise up? Are you walking in the good works that have been planned for you since the foundations of the world, or are you like Israel in Isaiah 58?

PRACTICING CONFESSION:
TRUE DECLARATIONS

"I will sprinkle clean water on you, and you will be clean: I will cleanse you from all your impurities and from all your idols. I will give you a new heart and put a new spirit in you; I will remove from you your heart of stone and give you a heart of flesh. And I will put my Spirit in you and move you to follow my decrees and be careful to keep my laws." Ezekiel 36:25–27

OVER SEVEN YEARS AGO, AFTER MIDNIGHT WHILE THE last winds of winter curled around our house, the phone rang. It was my mother; my grandfather had died. She came to pick me up and we drove in silence through the unlit, empty roads to the nursing home with the white cinder block rooms. I thought of the year 1910 and the day my grandfather was born and how his family and friends most likely traveled and walked through halls to get to the room that held his new life, his mother proudly cuddling him. Now his granddaughter, whom none of them had ever heard of, was walking through corridors to meet his death,

his only child, my father, weeping at his side. I felt again the wrongness of death.

My grandfather lay there in his nightgown, hands folded on his belly, as he always liked to sleep, a thin white sheet up to his waist. My parents left me alone with him and suddenly in that room, staring into the face of death, any fear I had of it dissipated. I sat on his bed with him and lay my hand on his and tried to close his open mouth. Like the shed skin of a snake, my grandfather had performed the greatest act of magic; he had grabbed his soul and slipped out in the dark of night. I wept not for his leaving, but for the living that he had finished.

Impressed with the fact that my grandfather was more alive than I had ever known him to be, I held on to his worn-out hand that was as dead as it ever could be. In those moments, all the meaning of life washed over me like a flood bringing up all the dirt at the bottom of my soul. It was Jesus, and all that mattered was Jesus and his wild work of grace and redemption. I always had known that, but now I saw more clearly that everything in life that did not point to him paled so drastically. The light of Christ in and all around me was all I craved. All the rest held no significance.

I had never anticipated a dead body being my confessional booth, but it became one—something holy, a place to lay down all that I had been carrying for too long. My grandfather's body became the sponge that absorbed all my tears with its cold death so I could more fully immerse into life. Familial memories of what was and what I thought should have been, of all the spoken and unspoken words, all the actions I made no sense of, all the emotions that were never clarified, the controlling factors with all of their disappointments, failures, bondage, and all the fear and anger of a child who felt good intentions

had not been enough now came to a head in woman who had become judgmental and self-protective in unrealistic expectations. There had never been perfection; there had only been life and all of its damaged complexity.

It all broke out of me as if my body of life were heavier than my grandfather's body of death. I weighted down his with all my burdens, stuffed them into his vacant mouth and carved-out soul. It all belonged there with death, not with me anymore. I rushed out of the room and down to the end of the hall where my parents stood. The first light of dawn was sneaking in through the windows. I wept and they thought I was weeping with grief, but I was weeping with life. "I choose to forgive you!" I said as I looked into their eyes, with a new resolve. "All that was shall not be any longer, it all stops here. Jesus is too immense; his mercy is too full toward us." None of us could go back and detail the *all*, for it was too much, the kind that had slipped into days and patterns, no set incident, just the nagging feeling that everyone's best had never been enough, had always fallen short, and had been misinterpreted anyway. All of us have fallen short. All of our intentions have been misunderstood. None of our efforts have ever been enough. All of us need the gracious Jesus.

Confession cleared me that day. It was the declaration of all that was good and true and all that was not. Confession draws the line of separation. It brings out all I have been harboring into the light of day. When I give refuge to it, all I sense is condemnation; but when I admit it, I sense a release. It is the process of sanctification. Charles Williams wrote, "It is often easier to forgive than to be forgiven; yet it is fatal to be willing to be forgiven by God and to be reluctant to be forgiven by men."[1]

I had always thought since I was young that after I finished college I would attend graduate school and then work toward a

doctorate. God has been good enough to me to not allow all of that, *yet*—in the formal sense of the word. The world does not recognize it, but I have been in school. You have been in school. The workload has been enormous, for marriage and mothering have been our schools of sanctification—our living, daily confessional booths for coming to terms with all we are not and all Christ is. Though this world believes that mothering—especially those of us who choose to stay home with our children—is less than intellectually stimulating, I believe we are unquantifiably educated.[2] Our mothering practice can be the most intellectually and spiritually demanding environment we experience.

On a trip up north, I recently visited my friend Ava, who holds this type of education and desires to get more in the formal sense. With her newest little baby sleeping in her arms, she said with her quiet voice, "I need confession. It opens up the gates of heaven and takes away the enemy's foothold of guilt and shame in my own life. It is God's gift. It gives me more of a heart for him." She described how her first response to her own sin is usually defensiveness, as her perfectionist self is sorely disappointed in her presentation. She senses God's holiness and the great gap between all he is and the actual performance of her life.

Every woman I have spoken to connects exactness to godliness in their own lives and those of their children. They believe that filling this holiness gap is what God requires of them and their children. They work so hard training and instructing their children in order to shorten the distance to faultless performance. This exhausting effort makes mothers feel as though they are doing a decent job.

God never wanted or expected us to be like him in these ways—all-powerful, all-knowing, and all-sustaining. Instead, he wants to be those things for us in intimate relationship with us.

Satan tempted Eve to try to become like God, ultimate perfection. At the core, this renunciation of God's gracious provision for us wreaks havoc on our days and on our behavior. It steals the restored relationships with God and others for which we were created. If we were able to bridge the gap to attain these relationships, we would not need Jesus.

Ava gave examples of how emotionally, spiritually, and physically her own marriage and relationship with her children are closer and deeper after a period of mutual confession. The admittance restores relationship and gives progressive growth a chance. Sin isolates; confession connects. No relationship of substance is meaningful without the practice of confession, the embrace of our humanity. Confession opens up the opportunity for God to work on a deeper level. Improvement is not redemption. C.S. Lewis wrote, "I cannot, by direct moral effort, give myself new motives. After the first few steps in the Christian life we realize that everything which really needs to be done in our souls can be done only by God."[3]

If I avoid all confrontation and humble admittance, I enter into the habit of blaming others for my own sin. I live on the defense and am easily offended, standing up for my rights. The less I confess, the more I control and believe that everything around me is alive and thriving because of my direction and service. I shut down others around me, burying them deep in a silent hole. I become an unsafe place for others to gather around, as nothing about me reflects a teachable, emerging life. One of the most needed and natural parts of relationship is stifled.

What can often hinder our true confession is our deep-rooted anger—anger that says I am owed something, I was cheated out of what I deserved. Stubborn anger holds on until the wrong is made right. Before I laid my stack of grief, unforgiveness, and

anger (essentially, my pride) on top of my grandfather's pile of vessels and bones, I was captive to it all. I was in effect saying that the offense was bigger and of more importance than relationships and too enormous for even the cross. I was an angry woman, an angry mother, and an angry wife. My pride caused my bondage and my broken relationships and shut down my heart. Yes, so much of my heart was given away to unforgiveness. There are times when I still give bits of my heart away to this. I have realized that forgiveness comes not so much in single moments but in waves that go deeper through the years.

My journals will testify to the debates I had with God about the validity of mercy and grace, and they will bear witness to the Holy Spirit breaking through all of that to speak to me. It was as if the Spirit was saying to me, "Be still, for the Lord is on your side. I know you have been wronged. I know your pain is true. However, wounds and disappointments are not treasures to keep and shine up. You cannot expect to be repaid; you cannot allow me to make all things new when your heart is so severe."

The gift of enduring novelists is that they often have the disturbing ability to understand the psyche of this controlling sin and addiction, this cycle of emotional pain. The great ones comprehend freedom from it as well, often weaving the redemption of Jesus into their tales. They offer us mirrors made of words. Nathaniel Hawthorne penned in reference to his character Hester in *A Scarlet Letter*, "She had not known the weight, until she felt the freedom."[4]

It is confession, the admittance of what is true, that often ushers in such freedom. The repentance that follows gives validity to our confession and steers us in a new direction. Chosen forgiveness—the hard choosing to accept the consequences caused by the sins of others and our own sins and to relinquish

all forms of vindication—is the crowning glory of this practice. We can walk our children through steps of confession, forgiveness (Ephesians 4:32), and blessing (1 Peter 3:9) by modeling it for them when we sin against them and others. This habit establishes a good life-long practice of keeping short accounts. And it will keep their hearts alive with the truth that it is not only sin that God forgives, but us.

Confession changes the world around us in the sense of not only admitting our sin but also declaring truth. For example, first-wave feminism confessed that women be judged as fully human regardless of their race or social status and fully valuable for their roles in the family and larger community. These reformers fought in the United States for women and children to get out of the sweatshops and back into the homes. These women battled for their children's education and for decent working wages for their husbands. They led the movement against abortion, declaring it was a sin against any woman. Globally, men and women who share this mindset have worked against child prostitution, foot binding, and widow burning.

Second-wave feminism fought for gender equality, fighting for women to have the same social, political, legal, and economic rights that men have. It also declared that womanhood needed to be less about others and more about self. Feminism became defined by reaching your full potential, even if it meant leaving your husband and children behind. Many women demanded that they be assessed by a masculine standard.

Margaret Sanger, the founder of Planned Parenthood, brought forth this movement with her link between sex and poverty.[5] Sex, according to Sigmund Freud, is simply a part of psychological health, morality not being a significant factor. Women and men alike must be free to satisfy this need, but

without proper protection they become victims of poverty through numerous unwanted pregnancies. This wave was a false confession that did not lead to freedom. Instead, it led to the literal death of millions of unborn children and the devaluing of sex, marriage, and motherhood.

Whereas first- and second-wave feminism were largely confined to industrialized nations, current or emergent third-wave feminism is globally minded, focusing less on activism and more on the personal power of women. Many proponents of this simply reject any differences between men and women, believing the body reveals nothing and femininity is a not a cause for celebration, as there are no differences to celebrate. We are left to construct our own sexuality and our own roles and callings as we please.[6] Again, this false creature-centered declaration has not brought a sense of peace and freedom.

I challenge you as a woman and a mother to confess all that is true about who you are and who you are not. The volumes written on both are vast, as this is an issue that causes confusion and concern for all women in every generation. Let us simply declare that women need to use and grow in their gifts unhindered, out of loving service to God and others, the motivation of their hearts being pure. This looks different in the life of each woman. Let us celebrate, not devalue a woman's feminine body! We must declare blessings on women globally, enabling them to train, nurture, and instruct their children without the pressure of poverty and the accusation that they are intellectually inept or stagnant. This would be a confession leading to action that could transform the nations, affect the generations, and reflect God's own tenderness toward women. I long for this.

We must practice confession and declaration in our own lives. "It is for freedom that Christ has set us free. Stand firm,

then, and do not let yourselves be burdened again by a yoke of slavery" (Galatians 5:1).

RUNNING

My Holy God, show me if I have unforgiveness, resentment, and bitterness in my own heart as the result of sin I have done or the sin done against me, intentionally or not. Show me if I lack mercy in my determination to pursue justice. I declare the truth that in you, Jesus, I am accepted and redeemed from all my sins and that the sins done against me no longer hold any power over me. I am secure, free from condemnation, and hidden in Christ. I am significant, chosen, and appointed to bear fruit in my life and as a minister of peace. I am free. Convict me when I need to come to you and go to others in confession; break down my defenses. Educate me more on what the societal trends and agendas are toward and against women. I pray that women would rise up not out of a need to prove or protest, but out of a determination to embrace the wonder of who you have made them to be and how you have designed them to serve. For all the mothers who desire to have more nurturing time with their children, silence the lie culture throws at them that their mothering is not thoughtful and necessary. Raise women up to not stand for the lie that to be a mother is to be stagnant, unintentional, and unaware of the greater world around them. I ask that this generation of women and mothers will shake the nations with freedom, intellect, and generous forgiveness. Amen.

DEEPER IMMERSION

Read Psalm 103. On a piece of paper, make a list of anything you need to confess, both of sin and of declaration of truth. Bring these to God. On the paper listing your sins, color over them

with a red marker and then burn them. Also, meditate through Proverbs 28:13; Romans 10:9; 2 Corinthians 9:13; James 5:16; 1 John 1:9.

CHAPTER 15

PRACTICING GUIDANCE:
WHERE WISDOM RIDES

By wisdom the Lord laid the earth's foundations, by understanding he set the heavens in place; by his knowledge the deeps were divided, and the clouds let drop the dew.
Proverbs 3:19–20

WHEN I WAS A CHILD ALONE UNDER MY COVERS AFTER my mother tucked me in, I prayed for Wisdom. It was tall, white, gleaming, and so fast that I had to leap off a tree to catch it. I pictured the day I would settle on its back and ride it down through the streets, come upon the Great Lake, and go crashing along the waves of the white sand beach. Perhaps we would ride straight into the water together. I could almost feel the wind breathing through my hair and Wisdom's kicked-up heels splashing water onto my back. I was under the odd impression that wisdom was something you should ask for boldly[1] and that it was a horse. As far back as I can remember, I asked God for it, especially around my birthday and Christmas.

I was not sure where I would put Wisdom, as my mother was not fond of animals, and I was certain my father would not build a barn. I never told anyone because I had heard somewhere the verse about praying silently alone in your closet so no one would think you were loud and arrogant in your piety. Wisdom never did gallop by my house, and soon I grew older and stopped asking altogether.

I know now that wisdom is not a horse, nor is it a quality limited to the Gandalf- and the Aslan-type creatures of the world; it is a hands-on word of utmost sensibility. It serves as a guide to our days, putting into practice not only knowing the right thing but also doing it. It is an essential element to our immersion into Christ as his followers. The Hebrew meaning for wisdom describes the ability to function successfully in life, whether it is by having the right approach to a difficult situation or the ability to weave cloth. It is practical and applicable to this world, not just otherworldly. Judaism, the context of Jesus' life, held manual labor in high regard, rather than distaining it as unspiritual. Carpenters and craftsmen were actually on the same social level as revered rabbis of the day.[2]

I look at the women who maneuver life, multitasking through their days with determination, flow, and creativity, and I learn from their wisdom. I observe my husband creating beautiful pieces out of rough wood stock he hand-mills himself, and I am in awe at the wisdom he has been endowed with. I listen to the mentors in my life as they detail how they handled a rough work or family situation with peaceable wisdom, and I glean from their diplomatic virtues. It makes us wealthy to be surrounded by people who live life well, with proficiency, creativity, counsel, and intellect from God. The women I know who are wonderfully immersed in Christ are some of the wisest people I know. Their

souls are filled with books of wisdom that I take delight in draw-
ing out of them in order that their wealth is dispersed into the
greater world.

Taylor is one such woman. She and her husband have been
married eight years and have moved four times—from the
States to the Ukraine to Nigeria to the Netherlands, and now
they have lived in Uganda for two years. With each decision
they have made and with each new move, they have desperately
needed wisdom and guidance. For them, as for most of us, the
two elements are intertwined.

In our eleven years of marriage, Ben and I have had to make
major life decisions at least twice a year. Before marriage, we
never expected such a thing. We have gone through the mo-
tions of agonizing over lists of pros and cons, reading books
together about decision making and the will of God, and seek-
ing counsel from a variety of people. In many cases, we were
assumed to be immature because we did not possess an innate
sense of private guidance, as if individualism were the highest
level of spiritual maturity.

We have come to see, as Taylor recounted to me, that not all
counselors are wise. She has learned that you must receive guid-
ance from others who have shown they live by the Spirit, who
seek to speak out of the Spirit instead of human opinion, who
exhibit the biblical meaning of wisdom and are like-minded in
understanding your ultimate goals. Not every confessed follower
of Jesus will display these particulars. Taylor and her husband
have chosen not to pay heed to others who speak more of their
security than their obedience. But they listen to those who have
openness to the ways that they have chosen to live out their faith:
living among the Ugandan people, being willing to go to any de-
gree to serve others and to speak of the kingdom, the power, and

the salvation of Jesus. They take seriously the hard questions, counsel, and discernment of these people in their lives. This does not mean that their every decision as a family must be presented to others for approval, but rather it is the understanding that as followers of Christ we live in community and are accountable to our community.

Richard Foster, in his best-selling book entitled *Celebration of Discipline*, highlights the need for greater corporate guidance: "God led the children of Israel out of bondage *as a people* . . . under the theocratic rule of God." After the period of ministry of the prophets and the reign of kings for God's people, Jesus, the promised Messiah, came. Foster writes, "Once again a people were gathered who lived under the immediate, theocratic rule of the Spirit. . . . [Jesus] taught them that they, too, could hear the heaven-sent voice and most clearly when together. 'If two of you agree on earth about anything they ask, it will be done for them by my Father in heaven. For where two or three are gathered in my name, there am I in the midst of them'"[3] (Matthew 18:19–20).

This practice is missing in many of our churches and in many of our lives. We need to fast and pray and worship together until we discern the mind of God. In the early church, missionaries (people today like Taylor and her husband) were chosen and sent out.[4] This was not the work of a mission agency; it was the work of the community of Christ followers. More powerful wisdom and guidance will arise in and through our lives when we learn to listen and act in this way.

Hannah Whitall Smith, a Quaker born in 1832, wrote, "We must believe that we will receive Divine guidance when we ask for it. God may guide you in paths where he knows great blessings are awaiting you, but which to the short-sighted human eyes around you seem to result in confusion and loss. Guidance

will never be apart from the love and honor of others." She advised there are four special ways God speaks, "By the voice of Scripture, the voice of the inward impressions of the Holy Spirit, the voice of our own higher judgment, and the voice of providential circumstances. Where these four harmonize, it is safe to say, God speaks."[5]

Taylor has navigated through these waters. Having a great desire to start a family, she and her husband were grieved to learn that they could not have their own children. To her this seemed to spell only confusion and loss. She said there have been, "many tearful and angry chats with God about this pain, longing, and sorrow." God began to impart to her and her husband a passion for orphans. They moved forward with the US-based adoption process, and three years ago were ecstatic to bring home their new little daughter, celebrating that her skin color was considerably different from their own. It was after her adoption that they prepared to move to Uganda and came face-to-face with the enormous number of children who desperately need homes.

In Uganda one in five children is a full orphan and one in four families cares for a child orphaned by AIDS. People who take in orphans, relatives and pastors included, tend to treat them like slaves and neglect them. Taylor could not escape these cold facts as she and her husband began to visit AIDS orphanages to help care for and hold the babies. They began to inquire if there were any children that were candidates for foster care or adoption. Praying that one would be chosen that would be God's best for their family, there was one baby, Samuel, who urgently needed a home. His mother had recently died of AIDS, and his father could not raise him. Taylor and her husband sought out wisdom and guidance from God and decided to go through the

rigorous process of adopting Samuel. The in-depth procedure in accordance with the cultural customs and courts in Uganda demanded wisdom.

Samuel is now two years old and a beloved member of the family. They are thankful he is not HIV positive, and they rejoice at the prospect of his long life. Many times people have stopped the "crazy white people with two black children" to tell them that their hearts must be different, as they could never take in someone else's children and treat them like their own. Taylor recounted, "They thank us with tears in their eyes. God has revealed to us that our family is a walking testimony to his adoption of all of us—that we are all, without coming to the Father through Jesus Christ, essentially orphans. We have had so many opportunities to tell of the miracles of how God has given us children, which we have received as our very own. It is a story more powerful than we ever planned."

Taylor lives her days as a mother to their two young children. They demand her energy and time. She feeds and clothes them, teaching them and loving on them in the presence of all of her Ugandan neighbors who marvel that a white woman would come and live among them and take black children to be her own. When her neighbors are hungry, she shares vegetables from her garden. When they are sick, she gives them medicine. She visits all the people throughout their town, chatting and praying with them. She does not consider her life to display any particular grand wisdom or marvelous sense of guidance. She dislikes the notion of others thinking that her life is saint-like. The truth is her immersion into Christ is anything but ordinary and her wisdom is as strong, wild, and pure as a white horse.

RUNNING

Father, I come to you through the sacrifice of Jesus and the power of the Holy Spirit. I choose to accept your words and store up your commands within me. I will turn my ear toward wisdom and apply my heart to understanding. I know that if I am a woman who calls out for insight and cries aloud for understanding—looking for it as silver and searching for it as for hidden treasure—then I will understand what it means to stand in awe and reverent fear of you. For you give wisdom, that ability to have good use of knowledge. From your mouth comes knowledge and understanding. I know that you hold victory in store for the upright and you are a shield to those whose walk is blameless. You guard the course of the just, and you protect the way of your faithful ones. Let wisdom ride into my heart. Let all of its knowledge be pleasant to my soul, enabling me to live with skill as a woman and a mother. Bring to me those who walk in wisdom to counsel me, and let me hear from you, as I need for your guidance. I want to listen to your Spirit and obey, whether it is in big things or the smallest details of my life. Thank you that you are the One who guides the nations of the earth (Psalm 67). Amen.

DEEPER IMMERSION

The book of Proverbs depicts wisdom as being a woman. Study Proverbs 2 and 3, and note the benefits of walking in wisdom. For more insight into the wisdom of God, read Isaiah 11:2; Romans 11:33; and Colossians 2:2–3.

PRACTICING WORSHIP:
A CHOSEN RESPONSE

Deep calls to deep in the roar of your waterfalls; all your waves and breakers have swept over me. By day the Lord directs his love, in the night his song is with me—a prayer to the God of my life. Psalm 42:7–8

THERE ARE TIMES IN LIFE WHEN IT SEEMS AS IF WE LOSE a golden chance, that a treasure that was to be ours has been stolen. The totality of the experience, the good and the bad, will never be. This is how we felt during the experience of our miscarriage. I was four months along in my pregnancy when we lost our first child. Our baby—all he or she would grow to be and all we might know of this child—slipped away one day, an invisible death occurring in my body while I moved through my day, oblivious to the final departing.

I witnessed my husband weep bitterly, as much as if he had lost a teenage child. There were no memories associated with this life, but the raw fact of losing our very offspring, a member

of our family, could not be brushed over. We would never know what would have been, so we grieved the loss of a life never realized and the impact such a life would have made on ours. This sorrow matured our perception of life.

In the midst of the deep lament, I was surprised to be confronted with the proposal of worship—not in an effort to put on a forged smile and pretend all was well, but in a choice to incorporate lament into my response to God. I was reminded of the ancient Israelites, slaves for over four hundred years in Egypt. Before they were set free, Scripture says, "And when they heard that the Lord was concerned about them and had seen their misery they bowed down and worshiped" (Exodus 3:7; 4:31). They did not demand their freedom before worshiping. Simply knowing that the God of the universe was compassionate toward them moved their hearts, and they could not help but bow, knowing his gaze was on them.

To know that the tears of God shared in my tears and that he heard my honest questions and even anger was enough for me, and there was no better place to bring my sorrow and suffering. My faith grew more honest as my lament became more profound. I began to see this concept of lament all through Scripture, this fact that all creation is groaning in anticipation and longing for full restoration to God. As I entered into my grief and allowed it to do its work in me, I became more immersed in not only how just and merciful is the face of God but how deep his compassion and tenderness runs. I came to understand that my best sacrifice of worship to God is my brokenness.

Dan Allender wrote:

> A person who laments may sound like a grumbler—
> both vocalize anguish, anger, and confusion. But
> a lament involves even deeper emotion because

a lament is truly asking, seeking, and knocking to comprehend the heart of God. A lament involves the energy to search, not to shut down the quest for truth. It is passion to ask, rather than to rant and rave with already reached conclusions. A lament uses the language of pain, anger, and confusion and moves toward God. . . .

Worship truly involves bringing every dimension of our lives to him, not forsaking the struggles of life to worship, but worshiping in the midst of our struggles. . . .

Lament is not an end in itself. There should be no question that God does not want us to sing lament as the staple of our worship, nor should it be our internal hymn of choice. But lament opens the heart to wrestle with a God who knows that sorrow leads to comfort and lament moves to praise as sure as the crucifixion gave way to resurrection.[1]

Immersion into Jesus, even in and because of our brokenness, releases us to worship, and through worship God communicates his presence to us. It is the kind of worship that not only is the balm for our troubled hearts but also penetrates our daily routines, making our actions more than boring work. Worship makes folding laundry, wiping counters, scrubbing toilets, paying bills, and planning meals all acts of eternal significance. Life takes on a holy dimension; even in the most mundane of tasks, we have the opportunity for intimate fellowship with the God of the universe. We can paint a picture, construct a building, write a poem, or plant a garden as a chosen response in reflection of our God. Our need to get further education or educate our children can be an act of worship, for as Abraham Heschel said of those

in biblical times, "Greeks study in order to understand while the Hebrews study in order to revere."[2] We work with the hands and minds God has given us, we use the goods he has given us to work with, and we use the talents and skills he has instilled within us to perform work and serve others with that work. All of these are acts of worship.

Service to God is worship of God. If we are set free from thinking that we are working for anything or anyone but God, then we are worshiping. The apostle Paul taught that all life is God's domain; there are no so-called secular areas of life. Every detail of life must be understood as sacred—set apart to God. This is why he exclaimed, "So whether you eat or drink or whatever you do, do it all for the glory of God" (1 Corinthians 10:31). The truest freedom is that which occurs in our hearts when we come to the place where we realize that in Christ we have been set free. When we are free within, nothing externally can enslave us internally. Worship is defiance against darkness; it is drawing deep into the heart of God. It proclaims to all who will listen, "Since we are receiving a kingdom that cannot be shaken, let us be thankful, and so worship God acceptably with reverence and awe, for our God is a consuming fire" (Hebrews 12:28–29).

When I think of this, I am reminded of my father-in-law, who has devoted his life to teaching and leading a movement of worship through music in Central America. He believes that missions begins and ends with worship. I have heard of the women's choirs he has directed and how he has written songs with words that have discipled these women so thirsty for truth. He has not known many of their backgrounds or familial lives, but—realizing the statistics of domestic violence done against women in Central America—he has no doubt that some come from environments of abuse and have reasons to lament. These

women gather to bring their suffering and offer it up in worship, the gift of music giving them a medium to express their reverent awe and gratitude to the God who is concerned about them and has seen their misery. If ever there were worship leaders, these women—and all the women who choose worship in their grief and in their joy—are mine.

RUNNING

God, my soul finds rest in you alone; my salvation comes from you. You are my rock and my salvation. You are my fortress, and I will never be shaken (Psalm 62). Better is one day in your presence than a thousand elsewhere (Psalm 84). I bring my own sorrow and brokenness to you, and I thank you for your compassion. I praise you that you free us to worship and that you bring meaning to our work, be it large or small. Worship frees me from fear and anxiety as it acknowledges your kingship. Meet me in my private worship, and meet me in my corporate worship. I desire more of your presence in my life as I follow you. I choose to worship. Amen.

DEEPER IMMERSION

Read Psalm 148 and Ecclesiastes 5:18–20 every morning for a week. Walk in the redefinition of all your work being done in the gaze of God, your service of worship to him.

PRACTICING CELEBRATION:
BREATHING IS THE OCCASION

He has shown kindness by giving you rain from heaven and crops in their seasons; he provides you with plenty of food and fills your heart with joy. Acts 14:17

MY HUSBAND SPENT HIS FORMATIVE YEARS IN CENTRAL America. He has recounted to me some of his most poignant boyhood memories—their gifts penetrating through his own worldview into mine. Ben quieted the angst of many questions and doubts of a sin-laden world long ago with an uncomplicated acceptance, which many of us find difficult to attain. Most mothers work hard to ensure that their children have an idyllic childhood, keeping them in a mythical land of lollipops and rainbows for as long as possible. The ironic truth is that within our good intentions, we can often cross the line and steal from our children their spiritual growth charts, as if shielding them from the practice of faith enables them to be more faithful.

The gifts that led to his appreciation of life were, strangely enough, none that we would ever choose to bestow as mothers.

Ben was pulled out of kindergarten one day and told that something had happened to his mother and that he should go home right away. Left with no information, he questioned if she was alive or dead. An hour later, he was to find her sitting in a living room chair, still in shock from being held-up at gunpoint after the morning's market shopping. She had escaped by putting her car in reverse and flooring the gas pedal.

He remembers the sight of a tank rolling down his street in Guatemala City and soldiers stationing themselves on rooftops to position their machine guns. As his family sat huddled in a bedroom on the second floor, they listened as soldiers ran across their roof. Governments had been taken over by force before, and they would be again—this time, perhaps, while he and his family were witnesses. Instead, that day he watched the tank stop, turn, and drive straight into a house across the street, a few doors down. His family later learned that the targeted house was the base of operations of a prominent drug dealer.

Guerillas—he had seen them leaping out from bushes along the roads and advancing toward his family. Poverty—he had walked among some of the worst. Robbery—it was a matter of when, not if, for missionaries. Corruption and manipulation— these were weekly happenings, and he never grew desensitized to the severity of the injustices all around him. Near-death experiences—his first was before the age of eleven when his entire family was struck in a head-on collision on a mountainous highway and he suffered a fractured skull.

"Evil and suffering and daily inconveniences of life were real; these I knew and plainly accepted as a young boy," Ben has told me. "I never lived with any sense of idealism; though I felt a great sense of security in my family and in the God we lived for. I never thought about the causes of all those stories or assigned blame.

What is the use of that? I knew God had a firm hand upon me, and in this, I was and am immoveable. My times are in his hands. There were no hysterics in my home because of such situations and obvious injustices. Instead, a profound gratitude for life and all of its goodness and even fun," my husband said.

And it is true. Ben is one of the most celebratory people I have ever met. Not in the birthday-holiday sort of way, but in the daily joy kind of way. Ironically enough, I believe it was the gift of what he witnessed and could bear testimony to as a child that created this deep-rooted joy.

A grateful life releases joy and creates a celebratory life. There is no room for fearful stinginess, anxious covetousness, and lazy self-pity. Those who can sense the gift in simply breathing can establish homes where joy and laughter are daily occurrences. Perhaps it is this that makes up a good childhood and, for that matter, the breeding ground for growth for us all: truth of the world's realities and the response of resolved gratitude.

As a woman of the twenty-first century, I sense a growing urgency to evaluate the world around me—all the issues, trends, and concerns that might push me toward or away from gratitude. Jesus urges us to not be so caught up in our own business that we neglect being careful students of the times.[1] He invites us to see the world through his perspective and then think and act with intentional power. Ezekiel 38–39 prophesies of a time coming, sooner every day, when the world as we know it will be taken by storm—a time when what we have experienced will sallow in comparison of what will be. Writer and communications specialist Joel Rosenberg, a disciple of Christ converted from Judaism, who has worked for some of the world's most influential and provocative leaders, wrote of the days before Christ's return:

It will make the devastation caused by the Asian

tsunami and Hurricane Katrina pale. In the run-up to World War III, a wave of fear will sweep through the earth as a nuclear cataclysm draws near. We will see our leaders feverishly trying to negotiate a peaceful solution that will never come. We may very well see the American military mobilized as a defensive posture against Russian, Iranian, and other Islamic forces streaming toward Israel. At the same time, we will most likely experience unprecedented price shocks at the pump as oil and gas prices reach new record heights. At the very least, the markets will be traumatized with the prospect of World War III in the oil-rich region. We may also see terrorist attacks increase here and at home. When the war itself begins, the world will experience the great earthquake, which Ezekiel referred to. Pandemic diseases will sweep through Russia, the Middle East, central Asia, North Africa, and southern Europe, putting the entire world at risk of such pestilence and plagues.[2]

Rosenberg continues to write of the global trauma that will come, taking his cues from the Bible. Much has happened and could continue to happen in our lifetime in terms of the actual fulfillment of biblical prophecy. How bizarre it may seem to you that I place these prophecies in a chapter about celebration! This is not a book about how women may better polish their furniture; this is about the gravity of running hard into God as women, as mothers in the times in which we find ourselves.

We, as ones immersed in Christ, are to celebrate because we know the One who sustains our moments. If we cannot derive a sense of joy that supersedes all happiness when we surrender to

this, then we may never find ourselves bound to true gratitude. Days are coming when the solidity of our immersion will demand every muscle we are working now to exercise. We cannot go limp. Our pruning now will determine our fruit later in a time when we really will need it—in a time when there will be absolutely no room for complaining and small thinking.

In Jesus' Jewish tradition, spiritual muscle is built by the gratitude expressed vocally throughout the day in the form of blessings and prayers. Children grow up hearing such verbiage so that the meaning behind this shimmering language of power and declaration is engrained into their own slant to living. They greet the morning with the humility of declaring: "Blessed art Thou, LORD our God, Master of the Universe, who forms light and creates darkness, who makes peace and creates all things. Blessed are Thou, LORD, who forms lights." In the evening they decree: "Blessed are You, O LORD, our God, King of the Universe, who created day and night. You roll away the light from before the darkness, and the darkness from before the light. Blessed are You, LORD, who creates the evening twilight."[3]

Jews normally do not say "grace" before meals, but rather after they have eaten, they recite: "Blessed are you, LORD our God, Master of the universe, Who nourishes the whole world in goodness, with grace, kindness and compassion. He gives bread to all flesh, for His mercy endures forever. And through His great goodness, we have never lacked, nor will we lack food forever, for the sake of His great Name. For He is God, who nourishes and sustains all, and does good to all, and prepares food for all His creatures which He created. Blessed are You, LORD, who nourishes all."

They announce and retell truth repeatedly as they, the created, turn all eyes on the Creator. The focus this must give

a person's very soul through the habit of both emotional and intellectual adoration is stunning.

I have a friend, Lydia, who, although she does not recite these exact blessings, has lived out her acknowledgement of them. She decided long ago to give to others what she has required for herself: celebration, joy, gratitude, peace, refuge, fun, and refreshment. Growing up in Greece and now carrying the Spirit of God over to Russia with her young family for nearly eight years, she has mimicked God and given these very gifts to those around her.

An impact has been made in Russian culture, tiny imprints left on thirsty hearts. Recruiting her husband and children to help her efforts, Lydia has hosted everything from wedding showers and baby dedications to surprise parties and anniversary celebrations, breaking cultural and linguistic divides to speak the universal and necessary act of embracing the gift of being. A simple text message, a phone call, some flowers, a candy bar, an encouraging card slipped to someone from the stash of blank ones she keeps in her purse—for a moment someone can feel the glow of being important. She allows herself to be a conduit of God and his great love for all peoples. She said to me, "These are but small gestures, but they are droplets of Christ's water onto affection-starved souls. My greatest compliment has been that I left this example for others to follow."

Lydia meets what can be the harshness of a culture so unlike her own with the understanding that God created cultures and languages. He calls us out to leap into them and find just where he may be and where he may need to be found through women like you and me. She discovered that there were no lullaby CDs available for her many pregnant friends. So she wrote the lyrics and music, sang and recruited other local musicians, and

produced her own. The CD addressed the fragile miracle of life and the insecurities, trembling honor, and hope of attending to new life.

When called by her friend, Olga, who could not make it to a planned dinner due to her sick baby, Lydia responded by piling her family into the car with paper plates and warm dishes out of the oven to drive across town. Not waiting for joy to come to her, she went forward and brought it into a tiny one-room apartment. Olga welcomed this response with delight.

We must go forward and bring joy and celebration to each other, for no other occasion than that we were given breath for yet another day. The gratitude such celebration will foster in spite of life's expected and unforeseen circumstances will do its work in making indelible marks both within you and on your children.

RUNNING

My God, again I yield control to you and choose to believe that the circumstances beyond my control in my children's lives may be the ones in which you choose to grow them and instill in them true gratitude, so they can live in celebration. You are the One I adore and the One who sustains my moments, no matter what those moments may hold now and in the future. Let joy be no small thing to extend to others through encouragement and acknowledgement of them. I declare that your joy is our capacity to endure[4] for it produces energy and strength. I ask you to invade my mothering and my home with thanksgiving and joy in powerful ways. Thank you that you can use me in powerful ways of celebration, and thank you that you honor my thirst. Amen.

Joy is always a benefit of obedience. A place of obedience produces a place where laughter can abound—a place where we can "let go of the everlasting burden of always needing to sound profound."[5] Read these Scriptures and see some of the benefits of such joy and celebration: Exodus 15:20; 2 Samuel 6:14; and Proverbs 15:30.

PART 3:

INTENTIONS

THE SPACE BETWEEN US:
GUILT CRUCIFIED

Come, let us return to the Lord.... Let us acknowledge the
Lord; let us press on to acknowledge him. As surely as the sun
rises, he will appear; he will come to us like the winter rains, like
the spring rains that water the earth. Hosea 6:1, 3

I'VE WOKEN MANY MORNINGS TO THE VOICE OF GUILT,
condemnation, and a cloud of expectations so heavy on me that
I thought I might never be able to rise from the bed. At twenty-
four years old and a first-time mother, I was sure that I would
scar my child for life in some way. All my flaws and struggles
would become his dysfunction. I was bound to all the guilt of my
inadequacies, all of my mistakes, all the expectations I thought
every good mother was supposed to live up to. Emerging in
an era where everyone was going back to their inner child and
playing the victim to the tune of what must have been naive and
negligent parents, I was frightened. I believed I would spend all
my days trying to cover the great expanse between all I was and
all I thought I should be. The cross of Christ did not seem to

be large enough to cover the fact that I was a growing human on display.

This monster of guilt has, in some aspect, harassed you and your mothering practice—I am sure of it. I have never met a woman who was not somewhat haunted by this type of remorse. One mother, now with grandchildren, recently told me, "There is guilt that my children were hurt by my poor skills as a mother, my lack of sacrificial love, my own selfishness and immaturity; shame that I did not provide all the opportunities I should have provided for them; fault that I did not prevent the loss of their father. I should have done better."

Another mother commented, "My nurturing skills and my spiritual growth at the time were not stellar. I think in many ways, I stunted my children. I look back and I see a lot of control and blame coming out of me. My following of Christ was not authentic. To a watching world that viewed their performance, my children were not perfect, and I reacted with firm discipline that stemmed out of shame and guilt. I often mothered for approval, and my efforts were to evade my constant sense that I was not all I should be for them."

Other mothers have told me they feel very guilty for taking any time for themselves. They feel that to take any amount of time to care for their own interests and needs is selfish, and they fear it will negate the intense love they have for their children. If their hobbies, assignments, and friendships do not correlate with those of their children, they struggle with feelings of neglect.

Some women who parent children with severe developmental, physical, or learning disabilities are tempted to believe that, deep down, they are responsible for the difficult situation. Guilt may also appear with their ensuing frustration or feelings of anger and depression with the ongoing challenges.

We often proclaim to our children, "I am not perfect, so don't expect me to be!" We live with a sense of innate disappointment with all we are and all we have to offer—bound by our limitations, whether they are physical, financial, or otherwise. We offer this model to our children.

Some think self-discovery is the answer to the guilt; others appease it with more toys and trips. Still others are parenting conference junkies, have mom groups where they cry and pat each other on the back in empathetic fashion for their failures, or become the models of tight-lipped self-denial and martyrdom, even refusing to be open to learn and grow in their mothering practice.

I believe it is all enough! We cannot accept it any longer as part of motherhood. It is time to dig deeper and unearth the root of this weed that consumes us. At its most basic level, guilt is related to sin. If we cannot grasp sin in its truest sense, we cannot address guilt. The Bible teaches that sin entered the world from the rebellious choices of Adam and Eve, who doubted the goodness of God. Inheriting a rebellious nature from our original parents, we sin also, and those around us feel the consequences. We all need personal deliverance and a love that covers a multitude of sins (1 Peter 4:8). The latest techniques for creature-centered positive self-discovery will not even begin to address the type of liberation and love we need. They may appease our guilt monster for a short time, but they will ultimately fail, for we do not have the power to heal ourselves.

The Bible speaks of guilt in a legal sense, meaning justly charged, responsible for grave breech of penalty, and worthy of blame.[1] The verdict is condemnation, utter doom. Genuine guilt comes as result of sin—violating an absolute standard of behavior. Perhaps we who become mothers waken to our own

spiritual state in ways we never comprehended before—we feel the weight of our sin. We know our ignorance, inattention, and violation of some unseen standard.

We know we miss the mark of perfectly formed relationships with our children. We will sometimes lack integrity, display rebellion against mothering and authority in our lives, as well as fail to empathize with, understand, and meet the needs of our children. We will be agitated and restless at times, and at other times we will be mean, impatient, and selfish. We may find ourselves competing with other mothers, living for approval and recognition rather than living out of a grateful heart under the gaze of God. We may harden in an inability to truly love our children and who God has created us to be. Often, we will simply be physically and emotionally worn out.

These are some of the consequences of sin and our basic humanness. There is no denying it—we will sin; we will battle the natural flesh and the onslaughts of the enemy. The balls and chains of sin and struggle encumber our hands and feet while we carry our babies and chase our children or grandchildren. We are weighed down in all our words and actions; we live as slaves.

But this is not the end of the story; it is not our destiny, nor the inheritance we leave to our children. For those who have been immersed in Jesus, guilt has been crucified. The space between all that we are and all that we should be is of no consequence now. Our identity is no longer that of a guilty one, but one who has been set free from the ball and chain. Jesus took all of our sins upon himself and he, who was wholly divine, also became abundantly human. He is not one who cannot take away our guilt or empathize with our frailty. We do not have the mindset of an obligated debtor, and in him we are no longer powerless over sin and ungracious towards our human limitations.

God does not stand aloof and make demands on us as mothers that we cannot meet. His Spirit comes alongside us, inhabiting our hearts and minds with his vision and ability. He knows the task of mothering is too great for us. His expectation is simply that we run to him, immerse ourselves in him, and feel free to receive and grow in the absolute fullness of his love. And with that same love, we are able to give to our children with an open and filled heart. Perfect love is able to cover over our abundance of failings and utter weakness.

Yes, we may feel guilt when we have left something undone. We may feel guilt, even after our confession, for all the ways we have fallen short. We may have a sense of guilt over things that have happened to us or our children that were not our fault. We need healing in the sense of knowing that Jesus was there; we were not alone, and our children were not alone. Our freedom from dented emotions may take time as Jesus winds his binding slowly and softly around our broken hearts—one of his ministries to us.

If guilt still attacks, it is the arsenal of Satan to hold us back from the presence of God and all he has planned for us to become. This is when we as women *must* rise up into the intellect that overrides our emotions! Our feelings *must* align with truth in the renewing of our minds; they must not drive our days. C.S. Lewis wrote about this to his future wife, a mother named Joy:

> Remember what St. John says: "If our *heart* condemns us, God is stronger than our heart." The *feeling* of being, or not being, forgiven and loved is not what matters. If there is particular sin on your conscience, repent and confess it. If there isn't, tell the despondent devil not to be silly. You cannot help *hearing* his voice but you must treat it merely

as a buzzing in your ears or any other irrational nuisance. When you have found the answer to your sense of guilt, do, or stop doing it. You see, one must always go back to the practical and definite. What the devil loves is the vague cloud of unspecified guilt feeling or unspecified virtue by which he lures us into despair or presumption.[2]

There are times in your immersion when God will come up close to your heart and press on it. You will pay attention to the nudge and the direction he is pointing and begin to travel there, not out of fear and shame, but excitement that your good and loving Father wants to show you a better, more true, way. The apostle Paul wrote, "Godly sorrow brings repentance that leads to salvation and leaves no regret, but worldly sorrow brings death" (2 Corinthians 7:10).

For some reason, when we become mothers we try to become sin bearers, as if we want to be God to our children. Our pride and today's prevailing culture leads us to believe we are the creators of our children and their fate ultimately lies in our hands. We relentlessly second guess our choices for them and the opportunities we do or do not afford them. Just as Eve wanted to become like God, so we want to follow her lead and become like God to our children. We must not follow such a dreadful example, but rather extend our hands to them and run with them hard into God. There must be the trust that he will take them and hold them in a way we cannot. He will be their protector and provider, their sustainer and their comfort. He will cover what we cannot. We must trust this. He will often use us to flow his provision to them, but that is just it: we are his conduits. Our children know we are only earthen, fragile containers of him, but he is able to shine out through us.[3]

Three times I have had the same vivid dream. There is a colossal stadium all glowing and alive in the light of the sun. The populace within, their beautiful flesh colors of black, brown, olive, and milky white glisten in the noonday sky like a human rainbow. My children—who have been spectators to my growth and neither ashamed nor surprised by my humanness—are sitting in the front row with me. There are mothers with their children all around, waiting for something, breathless and anxious, looking forward and up. Suddenly, I see a light descending, and I turn away for it is such a pure white that my eyes cannot endure it. A hush falls and every knee bows, every arm is raised high, every palm extended, every mother's and child's voice proclaiming in every language that Jesus is enough—the one true King and his cross is enough to bridge the space to him, the space to each other.

He is the great and glorious groom, and no power is strong enough to stop him in his purpose to retrieve us, his bride. There is no space between us as women and our children, and the river of life begins to flow out from the King, covering us all in sweet water that washes away all guilt and shame, all shortcomings to holiness, all of the accusations and fears that distance us from each other. We have encountered Christ, and in the purest love, we have been changed. My children and I rise and move, twirling and swaying as if we were weightless in all the sweet water. The intoxicating joy of being free and loved fills every pore of our liberated selves. Women and children are dancing everywhere, from every nation and every tongue, as far as my eyes can see.

Perhaps my dream is the visual of the hope and of the truth I carry in my heart for you, for me, and for our children. Not only is the Water coming again, he has already come. We are already free.

RUNNING

My God, I thank you that you are not a God that stands at a distance and makes demands on me that I cannot meet. All of my genuine guilt and my false guilt you, Jesus, bore on the cross, and I am no longer to live under its heavy weight and nagging thoughts. You are enough; the cross is more than enough. Thank you for the cross. Enable me to sense immediately when your Spirit is pressing my heart and moving me in a new direction that is better and not offensive to you. I confess you are the God of my children; I am not their sin bearer, nor their redeemer, nor the ultimate overseer of their lives. I give you all praise for all you have done and how you have set the captives free! I run forth into that magnificent freedom; I run to you. Amen.

DEEPER IMMERSION

Make a list detailing your actions that cause feelings of guilt. Next, divide these according to genuine guilt and false guilt. Confess and ask forgiveness for that which you are personally guilty. Write the word *forgiven* over each item. Give no allowance to feel depressed, rejected, or worthless. It is finished; you may not return to it. Over that which is false guilt, write *lie*; and next to each entry, counter it with some truth. The next time the enemy tries to accuse you, apply the truth of the Word of God: 1 John 2:12; Romans 5:1, 9–10. Run into your freedom!

A WAY OF SEEING:
PURPOSED VISION

I planted the seed, Apollos watered it, but God made it grow. So neither he who plants nor he who waters is anything, but only God who makes things grow. The man who plants and the man who waters have one purpose, and each will be rewarded according to his own labor. For we are God's fellow workers, you are God's field, God's building. I Corinthians 3:6–9

VINCENT VAN GOGH BECAME A PAINTER AFTER HIS vision shifted and he became conscious of beauty. Although living as an artist is wholly significant and worthy of studious pursuit, it was not his original intention. He assumed there must be many other things in life much more sacred and intelligent, as many of us do. In writing a letter to his dear brother from his small, rented room in London where he lived while studying to be a clergyman, he looked outside. He was struck by the pale twilight, the outline of a thin lamp stand on the street corner and a flick of gleaming star overhead. He wrote, "It is so beautiful, I must show you." And as

if he was seeing it all for the first time, he drew a delicate sketch on a piece of thin, cheap, lined paper.[1]

I became a mother in the truest sense after my vision changed, and I grew conscious of the beauty of such a part. Although living as a woman in this manner is entirely significant and worthy of my intelligence and effort, it was not my original intention. I assumed there were other practices far more sacred and certainly more spiritually formative. I have peered out from these narrow lies and have been compelled by the view I see—so different from all the assumptions, so vast and rich and deep. Yes, so beautiful that I wanted to remind myself and show you too by writing this book.

When I could see, I could envision; and when I could envision, I could begin to create, entering the process with God. My life is a creative process, and what delight he must take in the weaving and painting, molding, and chiseling. He also has been good enough to draw my children into my process of becoming all that he envisions while I, in turn, partner with him in what he is bringing forth in them. He has invented an ingenious synergy. Scripture tells us that God's vision and his goal to make us like Christ begins with who he has created us to be, based on what he has already done for us.[2] Our quest is to know and love him in immersion and also to diligently adopt his character traits into our lives. Scripture promises that these will increase in our lives through practice. These virtues will prove to be useful and fruitful and keep us from stumbling. His vision for us and our sense of worth is not based on our talents, intelligence, or gifts, but based in our identity in Christ and our growth into his character.

Vision enables us to have a sense of purpose and destiny, steering us in the right direction. People with vision are able to settle into their particular mode of following Christ without a

nagging sense of restlessness and frustration. As mothers, it is not enough to have an agenda for our children; rather we must seek out God's plan for their lives. Ask God for the enablement to truly see your child, and then come alongside to assist, motivate, and train in any way you can.

Neil Anderson, the founder of *Freedom in Christ Ministries*, said that to live successful lives we need to distinguish godly goals or visions from godly desires.[3] A goal is any specific orientation that reflects God's purposes for your life and is not dependent on people or circumstances beyond your ability or right to control. A desire is any specific result that depends on the cooperation of other people—things you have no ability to control. Unrealistic expectations that you put on yourself and others can cause you to have a critical spirit from which you judge the purposes God intends for his creatures. Do not let your human desires and expectations be elevated to the level of God's visions for you or your children, or you will struggle with disappointment, anger, anxiety, and depression.

One mother told me that when her children were young, the vision she had for them came from her legalistic background. It was reduced to wanting and expecting them to be just as she was and make the decisions she made, in effect creating carbon copies of herself and her lifestyle. She said, "Both of my children are pursuing Christ, but they exercise their faith in radically different ways than I ever have. I used to degrade them through my tone and sarcasm for some of the choices they were making that were not biblically wrong; they were just not similar to my approaches. I do not think I considered vision as much as I simply had hope that they would turn out all right, as long as I told them what was right and wrong. I do not believe anymore that that was enough, nor was it thoughtful or intentional on my part. I

wish I would have asked the Holy Spirit for more revelation so that I would have been a mother of greater vision."

We can begin to form a vision for our children by removing any obstacles that will hinder them from entering the presence of God. In the book of Isaiah, God shouts, "Build up, build up, prepare the road! Remove the obstacles out of the way of my people" (Isaiah 57:14). In Isaiah's day, people in the villages prepared for the visitation of the king in advance. Workmen cleared the path and built a road. Cracks were filled, and dangerous obstacles were removed. In this passage God is emphasizing that we are the travelers and that for our journey into him he desires that any obstruction be removed. He wants nothing to hinder people from coming into his presence in the fullest sense.

What obstacles are in your life that would hinder others from coming to God? What cracks need to be filled? What distortions and impurities in you are contaminating others' understanding of Jesus' passion for them? Your obstructions may be religious tradition, anger over your own blocked goals and desires, the input of pop culture, or maybe even a sense of dishonor that pervades your familial relationships. Your obstacles could be a sense of greed and materialism, an obsession to control, or the quenching of the power and presence of the Holy Spirit. Inquire through prayer and counsel to seek what these may be so your path and your children's paths may be free and clear, as much as it depends on you. It is your immersion into God as a follower of Christ that will have the most power to make this a reality.

If you have not already done so, choose a life verse for your children. Read it to them as babies and teach it to them as soon as they can talk. Let them feast on the rich language; hang it in their souls, and drip it into their ears. Read it like you would a sonnet from Shakespeare or a command from a king. Dig into it

as though you have found a treasure and are revealing it to them. Do not dumb down the wonder of the Word. Post it and pray it over them every night. From that verse develop a vision statement for your children. Pray and work at it until what emerges reflects a person who will play their life tune to the direction of the Master composer, not to your small symphony. When you read Scripture on your own, pray what you are learning over your children. Ask that they may come before kings and paupers alike; ask that they may grasp how wide and deep is the love of Christ for them; and ask that they may comprehend that passion for Jesus is about his passion for them.

With each stage of development in our children's lives comes a need for new goals to fit into the vision. When my children were babies, my aim was that they learn to trust those who loved them, being comfortable in the care and affection. I wanted them to see me as consistent, available, and patient.

Later on, my little explorers needed to know that they were to respect me just as I was to respect them. I spoke often to them of Jesus' immense love for them and how delighted I was that he made them and I got to be their mother. With clenched teeth, I worked on not taking all the three-year-old frustrations and tantrums personally—as it was not about me; it was about their accountability to honor and obey.

In the preschool and early-kindergarten phase, children are able to reflect and evaluate their own behavior, and they are hungry for notice and approval. Everything is taken literally, and delayed gratification is difficult to grasp. A sense of calm is essential to them, as are the daily rituals of life. They become aware of how you process conflict, and they can even internalize it. They have a natural longing for peace and order.

My oldest son, now almost nine, is at the stage where he needs more freedom. He is becoming more activity driven and discovering his own individuality through social interactions and opportunities to test his interests. His family identity is being defined more sharply, and this is when he will reject or take on that identity. In a new way, he is enjoying thoughtful worship, and he shows love and serves voluntarily. He often hears my acceptance of him, and Ben and I work to provide a pleasant and consistent atmosphere for him to rest. He is learning how to effectively express his hurt, anger, and disappointment void of outbursts or disrespect.[4]

For now, some of my goals—as part of my overall vision for him—are that he increase in his respect for elders, exhibit basic manners and social graces, develop more friendships, begin to understand proper and godly human sexuality, learn how to deal with rather than avoid conflict, accept training and correction without degrading himself, develop no boundaries in his thinking that would limit the full embrace of life, and grow in his own personal prayers to Jesus. As an avid reader, I want to encourage him to read books that will fill his soul, call him into deeper character, and enchant his imagination.

My sister-in-law, Debbie, a mother of two teenage boys, wrote of similar goals when she asked for prayer that her sons would develop self-control and learn to be sacrificial in their friendships. I appreciate the opportunity to know about and join the vision and goals of other mothers. It spurs me on to be thoughtful and intentional with my own.

The goal of our immersion into Christ is not only to make him more famous and find our true significance, but also to be transformed personally. In all of creation, identity is a challenge only for humans. David Benner wrote, "Humans encounter a

more challenging existence. We think. We consider opinions. We decide. We act. We doubt. Simply being is tremendously difficult to achieve and fully authentic is extremely rare. We all live searching for that one possible way of being that carries with it the gift of authenticity."[5] How strong a part we can play in our children's lives to celebrate their uniqueness!

It will not be long before my boys will become conscious of their search for identity in a new way. My vision is that by then their identity will be rooted in Jesus. But I know that they, as I did, will need to find and take their particular place within the kingdom of Jesus and the expression he means them to have. This need will take front stage as they will try various clothing styles, haircuts, and hobbies. I am aware that hormones and the angst of adolescence will produce an energy imbalance. My husband and I pray that God will funnel and direct the gift of their passions as we maintain high expectations of them, for as the apostle Paul wrote, "Don't let anyone look down on you because you are young, but set an example for others in speech, in life, in love, in faith, and in purity" (1 Timothy 4:12). We will hold them to this standard, for it is God's desire for them.

My prayer is that they will emerge from this developmental stage without any masks—that they will be simple and strong men, not afraid to do hard things and having no space between their public selves and their true selves. I hope that they will not be ignorant of their selves—what tempts them, what natural tendencies they have, what stirs up their souls, what captures their good imagination, what courage they need to stride through life unhindered. As Soren Kierkegaard wrote, "The thing is to understand myself, to see what God really wishes me to do . . . to find the idea for which I can live and die."[6]

I echo the voice of a dear woman I know who serves in Mexico, a strong widow and the mother of four grown children: "We want our children to follow Jesus. That is all, no matter where it takes them. We want them to know that pursuing him and living according to all he has set forth is all that is worth spending their life on."

In his compelling book *Visioneering,* Andy Stanley wrote:

> Visions are born in the soul of a man or woman who is consumed with the tension between what is and what could be. Vision gives significance to the otherwise meaningless details of our lives. And let's face it, much of what we do doesn't appear to matter much when evaluated apart from some larger context or purpose. Vision provides motivation. The mundane begins to matter. Maybe the most practical advantage of vision is it sets a direction for our lives, it prioritizes our values, it translates into purpose, and it evokes emotion.[7]

Your immersion into Christ and the beliefs and practices that involves allow you to see that God has a vision for you far beyond this life. He has the same for your children; you are preparing them for eternity. We do not have to sit around questioning the vision we should have for our children. Aside from our personal goals for them that involve equipping them with life skills such as balancing a checkbook, planning a trip, reading a map, using their time wisely, shopping within a budget, and educating them about the nations of the world, there are superseding visions to which the Bible refers.

C.S. Lewis agreed with these sentiments when he wrote,

> If you read history you will find that Christians who did most for the present world were those who

thought most of the next. The apostles themselves, who set out on foot to convert the Roman Empire, the great men who built up the Middle Ages, the English evangelicals who abolished the slave trade, all left their mark on earth, precisely because their minds were occupied with Heaven. It is since Christians have largely ceased to think of the other world that they have become so ineffective in this one. Aim at Heaven and you will get earth thrown in. Aim at earth and you will get neither.[8]

Look at your children and have eternity in your vision. No goal God has for their lives or yours is impossible or uncertain, nor can it be blocked.

RUNNING

Holy Spirit, enable me to have your vision when I look at my children. I need to discern between my desires and your goals for them. Let my vision go deeper than mere right and wrong. Show me any obstacles I need to remove in my life and in their lives so they may enter into you more deeply. Show me the words to pray over my children. Let me not expect any less from them than you do. Keep them rooted in you so they may know their identity is in you. I choose to collaborate with you in the work you are doing in my children's lives. Make them mighty warriors for you. Amen.

DEEPER IMMERSION

David wrote, "Then our sons in their youth will be like well-nurtured plants" (Psalm 144:12). What does he mean by this? According to Proverbs 1:1–4, wisdom and knowledge are not only for adults. Grab hold of the vision for passing on the truth of God to your children, or Judges 2:10 may be said of your family.

Read Psalm 71:18 for guidance in your understanding and vision for your children.

OUT OF OUR HANDS:
THE RELEASE

For in you is the fountain of life; in your light we see light.
Psalm 36:9

ESTHER CONFESSED TO ME THAT WHEN SHE FIRST became a mother over twenty years ago, she determined everything would be different for her daughter from what she had experienced. She and her daughter, Sydney, would attend a healthy church together. When her daughter wanted to speak, the men in her life would not trample her. Sydney would learn and soar and never be punished or belittled for it, as Esther was so many times.

As a mother, Esther resolved to never lose her temper. Her demeanor would always be gracious. She would read every Christian book on parenting she could get her hands on. Modeling care for herself, she would continue her own higher education. She bought copies of all the great classics for children, and she planned to take her daughter to the theater and art museums; her daughter would be cultured! Esther did all of that and more. Still, life was not perfect, no matter how perfectly she tried to control it. Her husband was unfaithful and resentful of her

success in school and career. Their marriage ended in divorce. Sydney disliked school, reading, and many of the cultural experiences Esther tried to give her.

Esther's daughter became a very strong woman, but spoiled in many respects because she learned that her well-being was the most important thing in the world to Esther. And she knew her mother would do almost anything to give her what she never had. Eventually, Sydney walked away from all forms of Christian community.

Sydney is a grown woman now, and for the longest time Esther thought she would walk away forever from Christ and his followers. Slowly, Esther has begun to see that her daughter has been working out her own faith in response to her own pain and questions. Sydney has called and asked for prayer when she has hit the skids. She has clung to the Bible for a while and then has backslid again. A tough woman with nerves of steel and passionate affections, Sydney has never been easy to deal with. Despite it all, her mother believes the seeds she faithfully, yet imperfectly, planted have grown.

Esther wrote me last week, asking that I pray for her daughter. Sydney is now serving in the armed services stationed in the Middle East, the only woman in her army unit. It is no secret that male soldiers commit crimes against women even in their own units during times of war. Her daughter, the woman who for years had worked as a tough and fast-on-her-feet nurse in the emergency room, was afraid. She prayed to God, and she called her mother.

When Esther brought Sydney home from the hospital all those years ago and put little pink booties on her feet, she never imagined those feet would one day wear combat boots. However, she believes the permissive will of God has allowed Sydney to go where she would have never chosen her daughter to go, all to woo her to himself. As difficult as it is, Esther would take this

over rote, second-hand faith any day, no matter how painful it has been for their whole family.

Esther had always taught her daughter about the nations and what it was to have God's heart toward the world. They read about different countries, cooked ethnic meals, and sometimes traveled. She wondered if that and all she had tried to pour into Sydney meant anything. Esther spent many days flat on her face crying out to God as he—and she—allowed Sydney to fall repeatedly. She could never have guessed where her daughter's path would go and how God would go with her to the other side of the earth, all the time creating an unexpected fresh relationship between mother and daughter.

I have asked many mature mothers—women who have chosen to run hard into God, like Esther—what it is like to look at their grown children. They speak to me of the regrets, of the need to pray hard, of the necessity to tend to children while they are young and to shut down the voices saying that time spent with your children is less than intellectual and contributing. Many mothers have spoken of the importance of allowing Jesus to set you free from the guilt and fear that you are not doing all that you should do and of the importance of meeting each day with joy.

These mothers are passionate about the fact that everything pales in comparison to instilling in your children how deeply Jesus loves them and how much he longs to live his life through them. The mothers reflect on the need for forgiveness and grace to restore all relationships, and they express their desire to respect their grown children and not seek to control them or their choices.

Some have told me how important it is for children to learn to honor others as well as to respect each child's individual thoughts and feelings. Mothers who now hold their grandbabies

in their arms grew wistful in remembering how astounded they were that a child so unlike them in basic personality could come from their womb. They told me of the frustration and misunderstanding it caused and how important it is to uncover who God has made each child to be in personality and interests, not how you prefer a child to be. Our homes are to be communities of learning and growth, with hope that we will become our children's eventual wise advisors and friends.

A large majority of mothers with grown children urge our generation not to believe the lie that to need help, mentoring, counseling, or the gift of deep godly friendships is a sign of weakness. Satan would like you to believe you are alone and that you must raise your children alone. The truth is you are not alone, and as the mother of your children, you are irreplaceable.

Jesus said to his disciples, "Follow me," and he changed the course of history. Your calling as a mother is not only to follow Jesus but also to say, "Follow me," to your children, and it too will change the course of history. Jesus' first disciples—that motley handful of young men who chose to run into the Water and immerse themselves in the God who quenched their restless hearts—really had no idea what they had signed up for. However, they knew that nothing else would be worth running into; they had found life. They placed their final aim of life beyond this life. Like Esther, their mothers had no idea where God would lead them and how their faith would become anything but religious.

As for Judas, we all know what happened to him. Andrew preached the life, death, and resurrection in modern-day Georgia, Bulgaria, and Greece.[1] He was crucified, suspended on an olive tree, and buried in Greece. Bartholomew told of Jesus in India, and he too was crucified, head down. James, the son of Alphaeus, when preaching in Jerusalem, was stoned to death by the Jews and was buried beside the temple. James, the son of Zebedee and

the brother of John, preached in Jerusalem and was beheaded by Herod Agrippa I. John was banished to the island of Patmos where he wrote his Gospel and received the apocalyptic vision we read in Revelation. He died of old age, and though his remains were sought after, they could never be found. Matthew translated the Gospels into the Hebrew language, published them in Jerusalem, and then died. Peter, who with Paul had laid the foundation for the church in Rome, was crucified under Nero. He asked to be crucified upside down because he felt he was unworthy to suffer in the same way Christ had. Philip preached throughout modern-day Turkey and was crucified head downward. Simon was the second bishop in Jerusalem and died there at the age of 120. Thaddeus preached throughout all Mesopotamia and died there. Thomas, an active missionary, was executed in India.

All of the disciples who were killed could have avoided their executions if they only had denounced their God and Savior, Jesus. They refused. They would not recant. They looked death in the eye and did not flinch. Reverend Barbara Brown Taylor said, "Fear of death always turns into fear of life, into a stingy cautious way of living that is not really living at all . . . to follow Jesus means going beyond the limits of our own comfort and safety. It means receiving our lives as gifts instead of guarding them as possessions."[2]

I cannot promise you what the outcome of your life and your children's lives will be as you immerse yourself with every ounce of your passionate intellect, emotion, will, and body into the Water. But I can tell you it will be life as life is meant to be lived. And I can tell you that Jesus does not restrict his kingdom work to only the most beautiful, educated, or eloquent women. I am none of those, yet still I have heard his invitation. He delights to work through women who commit themselves to him first of all, instead of to simply meeting needs and accomplishing tasks.

He calls you to himself, to devote everything in your life to service for him who lavishes on you his love. To live like this is to live with no fear and laugh at the years to come. For you and your children are not citizens of this world, trying to make your way to heaven; you are citizens of heaven, moving like pilgrims through this world.

Extend your hand to your children and whisper to them when you are young and when you are old and grey, "We are swimming together, swimming upstream, homeward bound."

RUNNING

My Savior, I trust that you are teaching my children in ways I do not even comprehend. I ask you to secure a future friendship between my children and me as they become adults, full of respect, honor, and forgiveness. Run ahead of the years and pave the way. Equip my life with wise prophets and counselors who will help me on my pilgrimage and be instruments of my growth and increased knowledge and love of you. I release my children to fully follow you. I release them to do all that you have prepared them to do, serving your purpose in their generation (Acts 13:36), without fear or reserve, but in excitement that you have a future and a hope for them. May they fully live! I commit myself to you and choose to keep running hard to you. Immerse me in more of you in the coming years so I shall be a woman who is known for great depth and beauty of soul, a woman of valor paving the way for the coming generations. Amen.

DEEPER IMMERSION

Read the book of Nehemiah, and note the vision of Nehemiah and how it developed. What steps do you see? What obstacles? What was his response in all of this? What was the outcome of his vision?

THE SUM OF IT ALL

This is our calling. This is part of our richness in Christ: the reality of true spirituality, the Christian life. It is not to be practiced in a dull, ugly way; it is to be a thing of beauty, observed by those within, and those outside. Francis Schaeffer

There is a river whose streams make glad the city of God, the holy place where the Most High dwells. God is within her; she will not fall; God will help her at the break of day. Nations are in uproar, kingdoms fall; he lifts his voice and the earth melts. Psalm 46:4–6

SEVERAL YEARS AGO, BEN AND I ATTENDED A WEDDING reception. In a gorgeous glass atrium flooded with light and flowers, the black-tuxedoed groom rose from his seat, waiting for his mother. She walked down the candlelit isle in the midst of the sound of clanking wine glasses and soft murmurs. The room grew silent as the son waited and the mother walked to meet him.

I wondered if she was thinking of that moment when she first felt the movement of his life within her, first saw his face, or of the wee mornings when he pattered into her room to snuggle with her. Perhaps she remembered all those rocks she had to take out of his pockets before doing the laundry, the first time he read aloud to her, or her delight when she discovered his interests and abilities. Maybe it was the years their relationship was tested through the challenges of adolescence or when she noticed that he now had eyes for another woman. Was she remembering herself on her long prayer walks for him and times of listening to the Spirit about how to best partner with God in his growth? When did she know that because of his life hers was so much richer?

God's gift to her of a son was not just of having a child, but also of having more of Christ. Now, he stood as not only her son, but also her brother. She was probably not the same mother that she was all those years ago, for she was a woman who had grown while he grew; and they both had been going from glory to glory. Those moments together on the dance floor as woman and mother, man and son, were more than mere sentiment. And the dance was to stand for more than a sweet photograph. They were a symbol of the movement of all the beliefs, all the practices, all the intentions that God has created for all of our spiritual and eternal transformations. The son led her out to the wooden dance floor, and they moved under the flickering silver ball to the crooning of "What a Wonderful World."

I thought of my own two sons and all the times we have spun around together through the kitchen and into the living room. Their hands in mine, their legs wrapped around my hips, twirling, laughing, and singing together. I thought of you, you

women of the nations whom God is so passionate toward in his obsessive love.

You who have chosen to run into Water, all the truth about God the Father, God the Son, and God the Holy Spirit will be your three-pronged crown. The enduring exquisite church, the esteeming love of Jesus, the reality of the unseen battle, the source of your significance—it will all be a part of your countenance. You will know what you believe, for you have devoted yourself to possessing revelation and understanding. Your immersion into Jesus resulted in your contemplative wonder, intercessory prayer, and the very rest of God. It will be evident that your body is the dwelling place of the Holy Spirit, your life being flamboyantly poured out to others because of how much you have been truly loved. You will be a woman who has kept short accounts and is acquainted well with not only lament and waiting but also mercy and forgiveness. Your days have been your worship, your wisdom has been surer than a fleeting horse, and your gratitude for all that is will be your defining feature. You will have lived out your beliefs with great courage and intellect. Your guilt is washed away, your imperfections irrelevant, your vision unwavering, and your hope of heaven sure. You will have been an intentional, intelligent, and heartfelt woman and mother, rejecting stagnancy. The generations to come, the very nations, will never be the same.

Yes, someday we might dance with our sons, our brothers, and stand beside our daughters, our sisters, who rise to meet the world before them. It will not at all be the end, but a new beginning as we all will still be running, running into Water. And one day, we will attend together the wedding we each have been preparing for for our whole lives.

Then I saw a new heaven and a new earth, for the first heaven and the first earth had passed away, and there was no longer any sea. I saw the Holy City, the New Jerusalem, coming out of heaven from God, prepared as a bride beautifully dressed for her husband. And I heard a loud voice from the throne saying, "Now the dwelling of God is with men, and He will live with them. They will be his people, and God himself with be with them and be their God. He will wipe every tear from their eyes. There will be no more death or mourning or crying or pain, for the old order of things has passed away. He who is seated on the throne said, "I am making everything new!" Then he said, "Write this down, for these words are trustworthy and true...."

"I am the Alpha and Omega, the Beginning and the End. To him who is thirsty I will give drink without cost from the spring of the *water* of life...."

Then the angel showed me the river of the *water* of life, clear as crystal, flowing from the throne of God and of the Lamb down the middle of the great street of the city. On each side of the river stood the tree of life, bearing twelve crops of fruit, yielding its fruit every month. And the leaves of the tree are for the healing of the *nations*. No longer will there be any curse. The throne of God and the Lamb will be in the city, and his servants will be with him. They will see his face, and his name will be on their foreheads. There will be no more night. They will not need the light of a lamp or the light of the sun, for the Lord God will give them light. And they will reign forever and ever....

The Spirit and the bride say, "Come!" And let him who hears say, "Come!" Whoever is thirsty, let him come; and whoever wishes, let him take the free gift of the *water* of life (Revelation 21:1–6; 22:1–5; 22:17, emphasis mine).

AMEN.

THE WATER CRISIS:
JOIN ME IN BEING AN ADVOCATE FOR THE THIRSTY

THIS BOOK IS MEANT TO BE MORE THAN A MERE bundle of words; it is meant to be a mission, a call to deeper immersion into Christ, acknowledging our spiritual thirst. I also want to draw us into a deeper awareness of the needs of this world, acknowledging the physical thirst of so many.

Water. It is the metaphor of this book, and it is at the heart of a daily crisis faced by a billion of the world's most vulnerable people—a crisis that threatens life and destroys livelihoods on a devastating scale.

Unlike war and terrorism, the global water crisis does not make media headlines, despite the fact that it claims more lives through disease than any war claims through guns. Unlike natural disasters, it does not rally concerted international action, despite the fact that more people die each year from drinking dirty water than from the world's hurricanes, floods, tsunamis, and earthquakes combined.

This is a silent crisis experienced by the poor and tolerated by those with the resources, technology, and the political power to end it. Yet this is a crisis that is holding back human progress,

consigning large segments of humanity to lives of poverty, vulnerability, and insecurity.

Living Water International[1] is addressing this most basic of needs by helping deprived communities acquire safe, clean water. Their goal is to substantially ease the global water crisis while addressing root causes such as injustice, oppression, and abject poverty. As this happens, communities and worldviews are transformed—both among those in desperate physical need and among those who have been blessed with much.

Perhaps this book has given you a broader understanding of the shared challenges and joys of women and mothers worldwide, many of whom spend twenty hours per week collecting water, often walking up to seven miles to find it in the dry season.

It is typically women, like you and me, who collect water. They get up very early or go out late at night to get their water, and then they carry their heavy loads for long distances over uneven terrain. It is mothers, like you and me, who have to buy, scrounge, or beg for water, particularly when their usual sources run dry. The tragedy is that the water they work so hard to collect is often polluted and unsafe to drink.

Women trapped in this situation have little time for other activities such as child care, rest, or productive work. The time spent collecting water disempowers women by reinforcing poverty and lowering incomes. According to the Human Development Report of 2006, "Research in Uganda found households spending *on average 660 hours a year collecting water.* This represents *two full months of labor,* with attendant opportunity costs for education, income generation, and female leisure time."[2]

Living Water International works to train, equip, and consult nationals in order to ensure that the energy and resources contributed by volunteers and donors result in sustainable,

participatory water systems that meet the long-term needs of communities.

But water is not the best that they have to offer; they also proclaim Jesus Christ. Through him every human being can be in a right relationship with God, and only Jesus has the power to transform, to redeem, and to turn lives into stories of hope and purpose.

You can be a part of this movement through your awareness, advocacy, prayers, giving, and purchase of this book. A tithe of all royalties from *Running into Water* will go directly to supporting the work of Living Water International. I am pleased to partner in this vital work around the world. Visit their Web site at www.water.cc, and join me in being an advocate for the thirsty, providing a cup of water in Jesus' name.

Angela Blycker[3]

ACKNOWLEDGEMENTS

BLAISE PASCAL ONCE WROTE, "SOME AUTHORS, WHEN talking of their works, say, my book, my commentary, my history. I recommend them to say, our book, because in general they contain much more of what belongs to other people than themselves." He was not impressed with authors having inflated egos, nor did he have any patience for not recognizing how individual efforts always grow out of some type of nurturing community. I want to express my gratitude to those who have been a part of my creative community, who without their generous gifts, there would be no book.

Literary agent Tim Beals who freely counseled me to move my manuscript forward with *Authentic*, acquisitions editor Dana Carrington and publisher Volney James at *Authentic* who could see the potential of the proposal and were willing to take a risk on a first-time author. John Dunham, managing editor whose attentiveness and familiar face set me at ease, Michael Dworak, director of marketing whose jovial introduction to the other side of writing and firm grasp of the mission of this book will prove

to be pivitol, and skillfully thorough editor Bette Smyth who showed herself to be a delight to work with and learn from.

Shelly Beach, a seed dropper and cultivator, who four years ago followed the prompting of the Spirit and brought her daughter Jessica's former roommate and aspiring wordsmith to a writer's conference in Iowa.

Thank you, Shelly, for introducing me to the rest of the Guild, opening the door to such faithful friends who love the power of ideas and words just as much as I do: Cynthia Beach, Ann Byle, Sharon Carrns, Lorilee Craker, Katrina DeMan, Tracy Groot, Julie Johnson, and Alison Hodgson. Your collective wisdom and wit have been an integral part of my growth as a woman and a writer.

My faithful parents Larry and Glenyce Hansen, sister Elisabeth Anne Hansen, sister Kim and her husband Joy and children Alec, Julien, and Isabella Saquing and in-laws Dr. Philip and Mary Arleen Blycker. Your encouragement and creativity, as well as your sacrificial intercession have been the wind that has kept me moving forward.

Dr. James M. Danhof (1948–2009), the gifted studier, teacher, and orator who discipled me in my youth as my pastor and spoke words of blessing over my little writings all those years ago. Thank you for creating even deeper thirst in me.

Crossroads Church in Naples, Florida, with special acknowledgement to Brad, Kristy, and Caleb Smith, Carlton and Doris Smith, and Pastor Michael Bannon. Your selfless service through childcare, writing retreats, meals, prayers, and insight have been a quiet part of my hope in and for the Church.

For the women in this book who entrusted me with their stories. You are my teachers and heroes. And for the many mighty women pursuing Jesus, including my own mother and

the now deceased mothers of my parents, Mildred Dewey and Marjorie Hansen, who prayed and cheered me on as a girl, and the many women who have done likewise through this labor of faith when I thought I had nothing more to give. You know who you are. Thank you for speaking so richly into my life.

For the endurance to live above the realities of many, many months of sporadic meals, the occasional clean sock, and a living room full of books and papers, my boys Larsen and Anders (our daughter is due soon at the time of this writing). Thank you, my sons, for sowing into this work through your sweet prayers, pledged proud support, and most of all simply by being. You have been the beautiful and wild background music to this book and a true blessing.

And to Benjamin, my dear friend and committed husband who firmly holds the belief that God can do through others what they could never do in and of themselves. Thank you for your unwavering dedication to this undertaking, for helping me to keep my blinders on, and for engaging me in the intellectual substance of my writing—helping me to think better when my ideas and words are less than what you know they can be. Your maddening attention to precision is just what God knew such a globally-minded woman would need.

And finally, all gratitude to my God, to whom all praise is due.

> Oh, the depth of the riches of the wisdom and knowledge of God! How unsearchable his judgments, and his paths beyond tracing out! Who has known the mind of the Lord? Or who has been his counselor? Who has given to God, that God should repay him? For from him and through him and to him are all things. To him be the glory forever!
> —Romans 11:33–36

NOTES

Note to the Reader

1. C.S. Lewis, *An Experiment in Criticism* (Cambridge, UK: Cambridge University Press, 1961), 88–89.

2. Ken Gire, *The Reflective Life* (Colorado Springs, CO: Chariot Victor Publishing, 1998), 17.

Introduction: Your Invitation

1. A.W. Tozer, *The Pursuit of God* (Camp Hill, PA: Christian Publications, 1982), 11–12.

2. Willa Cather, *The Professor's House* (London: Virago Press, 1981), 19.

3. Jonathan Hewett, "Water in the Bible," http://www.learnthebible.org/water-in-the-bible.html.

4. Leo Tolstoy quoted in *Pilgrim Souls: A Collection of Spiritual Autobiographies*, eds. Amy Mandelker and Elizabeth Powers (New York: Simon & Schuster, 1999), 63.

5. G.K. Chesterton, *Orthodoxy*, (Orlando, FL: Relevant Books, 2006), 8.

Chapter 1: God Is: The Gravest Belief

1. James Fowler, *Stages of Faith: The Psychology of Human Development and the Quest for Meaning* (San Francisco: Harper, 1981), 123.

2. A.W. Tozer, *The Knowledge of the Holy* (New York: Harper Collins, 1961), 1.

3. See Romans 8:35–39.

4. Glenn Loury, professor of economics at Boston University made mention of this idea in *Finding God at Harvard—Spiritual Journeys of Thinking Christians* (Grand Rapids, MI: Zondervan, 1996).

5. See Deuteronomy 10:17; Psalm 138:6; Isaiah 57:15; 66:1–2.

6. This is the subtitle of the book *Why Sin Matters* by Mark McMinn (Wheaton: Tyndale House Publishers, 2004).

7. Jo Ann Lyon, *The Ultimate Blessing—Rediscovering the Power of God's Presence* (Indianapolis: Wesleyan Publishing House, 2003), 24–25.

8. "The Spirituality of Moms Outpaces that of Dads," http://www.barna.org/barna-update/article/15-familykids/104-the-spirituality-of-moms-outpaces-that-of-dads, May 7, 2007.

9. According to the Christian Research Association, in a survey conducted among Thai seminary students in 1996, 70 percent of the students said their mothers were the "most important influence" on their becoming Christians out of a Buddhist society. This article by Philip Hughes, "Accepting the Christian Faith in Thailand," can be found at http://www.cra.org.au/pages/00000185.cgi.

Chapter 2: Following the Sage: Divine Apprenticeship

1. Maria Doria Russel, *A Thread of Grace* (New York: Ballantine Books, 2005), 423.

2. Madeleine L'Engle, *Walking on Water—Reflections on Faith & Art* (Wheaton, IL: Harold Shaw Publishers, 1980), 31.

3. David Bivin, *New Light on the Difficult Words of Jesus: Insights from His Jewish Context* (Holland, MI: En-Gedi Resource Center, 2005), 5.

4. Ibid., 4. For this information Bivin references Shmuel Safrai, professor of Jewish History of the Mishnaic and Talmudic Periods, Hebrew University of Jerusalem.

5. David Flusser with R. Steven Notley, *The Sage from Galilee: Rediscovering Jesus' Genius* (Grand Rapids, MI: Eerdmans, 2007), 14.

6. The term *Hellenistic* is derived from the word, *Hellene*, which was the Greek word for the Greeks. It refers to the spreading of Greek culture and colonization over the non-Greek lands that were conquered by Alexander the Great in the fourth century BC. See http://wsu.edu/~dee/GREECE/HELLGREE.HTM.

7. Joy Alexander, "In Conversation with Evangeline Paterson," *Journal of the Irish Christian Study Centre* 4 (1989): 32.

8. This is a statement from Ann M. Veneman, Executive Director of the United Nations Children's Fund made in the 2007 UN report of the state of women and children. *The State of the World's Children 2007—Women and Children: The Double Divided Gender Equality*, p. vii, http://www.unicef.org/pfo/files/2007_State_of_the_Worlds_Children.pdf.

9. Gerhard Kittel and Gerhard Friedrich, eds., *Theological Dictionary of the New Testament*, 10 Volume Edition, original trans. Geoffrey W. Bromiley (Grand Rapids, MI: Eerdmans, 1964–1976), vol. 5, p. 636.

10. George Barna, *Transforming Children into Spiritual Champions: Why Children Should Be Your Church's #1 Priority*, (Ventura, CA: Regal Books, 2003), 39.

11. Everett Ferguson, *Backgrounds of Early Christianity* (Grand Rapids: MI: Eerdmans, 2003), 81–83.

12. Francis A. Schaeffer, *True Spirituality—How to Live for Jesus Moment by Moment* (Wheaton, IL: Tyndale, 1971), Introduction.

13. I want to acknowledge that the overall insight and research for this chapter were gleaned from numerous teachings by Dr. Dwight A. Pryer of the Center for Judaic-Christian Studies; lectures by Dr. R. Steven Notley, professor of Biblical Studies at Nyack College; works by David Flusser such as *The Sage from Galilee: Rediscovering Jesus' Genius*; works by Dr. David Bivin, including *New Light on the Difficult Words of Jesus: Insights from His Jewish Context*; and gleanings from the Web site *Jerusalem Perspective*.

Chapter 3: The Indwelling: A Practical Mystery

1. Walter Wangerin, "The Use of Story for Spiritual Formation" (lecture series at Children's Spirituality Conference: Christian Perspectives, River Forest, IL, June 2003).

2. Some key passages on the Holy Spirit where these ideas can be found are Psalm 104; Genesis 1:2; 41:38; Exodus 31:3–5; Numbers 11:25; 24:2; Deuteronomy 34:9; Judges 3:10; 14:19; 1 Samuel 10:6–10; Ezekiel 2:2; Joel 2:28–29; Zechariah 4:6; Acts 1:16; 4:25; 2 Timothy 3:16; 2 Peter 1:21. The Spirit's work continued after Pentecost pointing us to Jesus who has liberated us from the chains of sin and death, teaching us truths about Jesus, and drawing us to him (John 6:44; 1 Corinthians 2:14). The Spirit acts as the divine initiator in the hearts of people so they can choose how they will respond to God. He teaches, counsels, and reproduces his character in the lives of Jesus' disciples through serving and sustaining them. Interceding for us before the throne (Romans 8:27), he convicts us of sin and comforts us in our weakness and loss. He still gives great gifts to each disciple to grow up others and advance the kingdom against the gates of hell. We are powerless without the power of the Spirit. Because of Jesus restoring our relationship with God, we are sacred temples inhabited by the presence of God, sewn of flesh and bones, but now given a new heart (Ezekiel 36:26–27; 1 Corinthians 3:16; 6:19; 12:13–14; 15; 1–4; Ephesians 1:13).

3. *Anointed* simply means to be set aside and used by God for a specific task. The New Testament Greek words for "anoint" are *chrio*, which means "to smear or rub with oil, and by implication to consecrate for office or religious service"; and *aleipho*, which means "to anoint." In ancient times people were anointed with oil to signify God's blessing or call on that person's life (Exodus 29:7; Exodus 40:9; 2 Kings 9:6; Ecclesiastes 9:8; James 5:14). A person was anointed for a special purpose—to be a king, to be a prophet, to be a builder, etc. Another meaning for the word *anointed* is "chosen one." Jesus was anointed by God with the Holy Spirit to spread the gospel and bring freedom (Luke 4:18–19; Acts 10:38). Jesus left his followers the gift of the Holy Spirit (John 14:16). In a very real sense, we are all chosen for a specific purpose in furthering God's kingdom (2 Corinthians 1:21–22; 1 John 2:20).

4. Brother Lawrence, *The Practice of the Presence of God* (Boston: Shambhala, 2005), 16.

5. Matthew 5:43–48.

6. David Flusser with R. Steven Notley, *The Sage from Galilee: Rediscovering Jesus' Genius* (Grand Rapids, MI: Eerdmans, 2007), 57.

Chapter 4: The Scent of the Body: The Smell of Death or Life?

1. Merriam-Webster Dictionary online defines *evangelical* as "emphasizing salvation by faith in the atoning death of Jesus Christ through personal conversion, the authority of Scripture, and the importance of preaching as contrasted to ritual." Evangelical followers of Jesus tend not to privatize their beliefs as do other streams of Protestantism.

2. See 2 Corinthians 2:15–16.

3. George Barna, *Transforming Children into Spiritual Champions: Why Children Should Be Your Church's #1 Priority* (Ventura, CA: Regal Books, 2003), 47.

4. Maya Angelou, *I Know Why the Caged Bird Sings* (New York: Random House, 1993), 15.

5. Deitrich Bonhoeffer, *Life Together: The Classic Exploration of Faith in Community* (New York: HarperOne, 1978), 26.

6. Mark Harris, *Companions for Your Spiritual Journey: Discovering the Disciplines of the Saints* (Downers Grove, IL: InterVarsity Press, 1999), 102.

7. C.S. Lewis, *Letters to Malcolm: Chiefly on Prayer* (Orlando, Fl: Harcourt Brace, 2002), 10.

8. Catherine Stonehouse, *Joining Children on the Spiritual Journey: Nurturing a Life of Faith* (Grand Rapids: Baker Book House, 1998), 37.

9. See David Kinnaman as interviewed in *Biola University Magazine* (Spring 2008): 5.

10. Michael J. Anthony, editor, *Perspectives on Children's Spiritual Formation: Four Views* (Nashville: Broadman & Holman Publishing, 2006), 33.

11. John Wilson, "Stranger in Strange Land: On Eloquence," *Books & Culture: A Christian Review* (January/February 2008): 9.

12. Paul-Gordon Chandler, *God's Global Mosaic: What We Can Learn from Christians around the World* (Downers Grove, IL: InterVarsity Press, 2000), 16.

13. Holly Pivec, "Worlds Apart," *Biola University Magazine* (Spring 2008): 7.

14. Mark 16:17; Isaiah 61:1; 2 Corinthians 5:18.

Chapter 5: A Brave New Worldview: Unseen Realities

1. See John 3:36; Rom 6:23; and 1 Peter 3:18. See also Brian Godawa, *Hollywood Worldviews: Watching Films with Wisdom and Discernment* (Downers Grove, IL: InterVarsity Press, 2003), 26. Godawa laid out this simple premise of the Christian worldview in his discussion on how movie plots are formed.

2. John W. Sire, *Discipleship of the Mind: Learning to Love God in the Ways We Think* (Downers Grove, IL: InterVarsity Press, 1990), 97.

3. Dostoevsky is quoted in Helmut Thielicke, *The Waiting Father: Sermons on the Parables of Jesus* (New York: Harper & Brothers, 1959), 81.

4. C. Fred Dickason, *Names of Angels* (Chicago, IL: Moody Press, 1997), 14.

5. Ibid., 14–15.

6. See Ephesians 6:10–18; 2 Corinthians 4:4; 10:3–5; 11:13–15; 1 Peter 5:8.

7. John Piper, *Desiring God: Meditations of a Christian Hedonist* (Portland, OR: Multnomah, 2003), 56.

8. Ibid., 14.

9. Nehemiah 8:10.

Chapter 6: Practicing Contemplation: The Paprika Man

1. Darrow L. Miller with Stan Guthrie, *Nurturing the Nations: Reclaiming the Dignity of Women in Building Healthy Cultures* (Colorado Springs, CO: Paternoster, 2007), 245.

2. Mark Steyn, "It's the Demography, Stupid: The Real Reason the West Is in Danger of Extinction," *The New Criterion 24* (January 2006), 10.

3. Nathaniel Hawthorne, *Mosses from an Old Manse* (New York: Random House Modern Library Classics, 2003), 37.

4. Ravi Zacharias, *Recapture the Wonder* (Brentwood, TN: Integrity Publishers, 2003), 43.

5. Psalm 19:14. For a word study of *meditate* see http://ww.biblestudytools.net/Lexicon/Hebrew/heb.cgi?number=01897&version=kjv.

6. 1 Timothy 4:13–15.

7. Catherine Stonehouse, *Joining Children on the Spiritual Journey: Nurturing a Life of Faith* (Grand Rapids, MI: Baker Books, 1998), 23.

8. Ana-Maria Rizzuto, *The Birth of the Living God: A Psychoanalytic Study* (Chicago: University of Chicago Press, 1970), 179.

9. This consensus statement comes from the *Motherhood Project of the Institute for American Values*, 2001. This excerpt entitled "*Watch Out for Children: A Mother's Statement to Advertisers*" is an executive statement by founder Enola Aird. The full report can be accessed at http://www.motherhoodproject.org/wp-content/themes/mothe2/pdfs/watch_out.pdf.

Chapter 7: Practicing Prayer: Into Golden Bowls

1. Acts 17:26–27.

2. Brennan Manning, *A Ruthless Trust: The Ragamuffin's Path to God* (New York: HarperCollins, 2000).

3. Isaiah 50:10–11.

4. http://www.thefreedictionary.com/intercession.

5. Alice Smith, *Beyond the Veil: Entering into Intimacy with God through Prayer* (Ventura, CA: Renew Books, 1997), 34.

6. Pete Greig and Dave Roberts, *Red Moon Rising: How 24–7 Prayer Is Awakening a Generation* (Orlando, FL: Relevant Books, 2005). Web site at www.24–7Prayer.com.

7. Revelation 5:8; 8:3–4.

8. Jennifer Dean, *Legacy of Prayer: A Spiritual Trust Fund for the Generations* (Birmingham, AL: New Hope Publishers, 2002), 36.

9. Stormie Omartian, *The Power of a Praying Parent* (Eugene, OR: Harvest House Publishers), 1995.

Chapter 8: Practicing Fasting: Training Desire

1. Matthew 6:18; Luke 2:37; Acts 13:2.

2. Matthew 6:16; Acts 13:1–3; Acts 14:23.

3. Judges 20:26; 1 Kings 21:27; Ezra 8:21; Joel 1:14; Jonah 3:5.

4. Catherine Stonehouse, *Joining Children on the Spiritual Journey: Nurturing a Life of Faith* (Grand Rapids, MI: Baker Books, 1998), 182.

5. There are many examples in Scripture where it seems God *does* change his mind. In Isaiah 38:1–6 Hezekiah's prayers were in acceptance of God's will but still reminding God to consider his overall life. God heard a prayer that was within his will and acted upon it—a change from his original words to Hezekiah that altered generations. In Jonah 3:1–4, 10, death and destruction were overturned as a result of prayer and responses within his will. In both cases new paths were forged because of godly responses. God knows in advance that our prayers and fasting will move his mind to act in a new direction, but still he mysteriously invites us into this process. Prayer and fasting change things in a way that honors God. Fasting makes your flesh go backwards and your spirit move forward to hear more clearly his heart and approach him with boldness.

Chapter 9: Practicing Study: Recitation of the Mind

1. James Fowler, *Stages of Faith: The Psychology of Human Development* (San Francisco: Harper, 1981), 63–64.

2. Richard Foster, *Celebration of Discipline: The Path to Spiritual Growth* (San Francisco: Harper, 1998), 62.

3. Mark Noll, *Scandal of the Evangelical Mind* (Grand Rapids, MI: Eerdmans, 1995), 26.

4. Alan Wolfe, "The Opening of the Evangelical Mind," *The Atlantic Monthly* 286, no. 4 (October 2000): 55–76.

5. John Stott, *Your Mind Matters: The Place of the Mind in the Christian Life* (Downers Grove, IL: InterVarsity Press, 2007), 33.

6. The quote from A.W. Tozer is found in Martin H. Manser, *The Westminster Collection of Christian Quotations*, First Edition (Abingdon, UK: Westminster John Knox Press, 2001), 309.

7. This quote from Charles Malik is from his keynote address given at the dedication of the Billy Graham Center at Wheaton College in Wheaton, Illinois, in 1980.

8. Lois Tverberg with Bruce Okkema, *Listening to the Language of the Bible: Hearing It through Jesus' Ears* (Holland, MI: En-Gedi Resource Center, 2004), 61.

9. Hosea 6:6, King James Version. See also Deuteronomy 30:15–20; Psalm 19:7–14; Proverbs 2.

10. Os Guinness, *Fit Bodies, Fat Minds: Why Evangelicals Don't Think & What to Do About It* (Grand Rapids, MI: Baker Books, 1994), 46.

11. Robert Coles, *The Spiritual Life of Children* (Boston: Houghton Mifflin, 1990), 221.

12. UNICEF, *The State of the World's Children 2007: Women & Children: Double Dividend of Women's Equality*, pg. 2. You can find this report at http://www.unicef. org/sowc07/docs/sowc07.pdf.

13. Rabbi Levy is quoted in Rabbi Susan Grossman, "The Testimony of Women Is as the Testimony of Men," Committee on Jewish Law and Standards of the Rabbinical Assembly, p. 3. This article can be found online at http://www.rabbinicalassembly. org/teshuvot/docs/19912000/grossman_womenedut.pdf.

14. Daniel Sperber, "Congregational Dignity and Human Dignity: Women and Public Torah Reading," *Edah Journal* 3, no. 2 (2002): 3:2.

15. Nicola Slee, *Women's Faith Development—Patterns and Processes: Explorations in Practical, Pastoral and Empirical Theology* (Burlington, VT: Ashgate Publishing, 2004), 24, 77.

16. Leland Ryken, Jim Wilhoit, Tremper Longman, Colin Duriez, Douglas Penney, Daniel G. Reid, eds., *Dictionary of Biblical Imagery* (Downers Grove, IL: InterVarsity Press, 1998), 280.

17. Micah 2:12–13; Matthew 11:12.

Chapter 10: Practicing Rest: Sabbath Theology

1. Judith Warner, *Perfect Madness: Motherhood in the Age of Anxiety* (New York: Riverhead Books, 2005), 36.

2. Andrew Murray, *Absolute Surrender* (Minneapolis, MN: Bethany House, 1985), 150.

3. Genesis 2:3; Exodus 20:8–11.

4. Sabbath was decreed as a sign of Israel's covenant with God in Exodus 31:17 and Deuteronomy 5:12–15 and referred to as a blessing and delight in Isaiah 58:13–14. See also Isaiah 30:15.

5. For an understanding of *rest* according to a Hebrew lexicon, see: http://www. biblestudytools.com/Lexicons/Hebrew/heb.cgi?number=07673&version=kjv. See also James L. Anderson, *For God's Sake, Rest: Discovering the Pleasure of His Rest* (Enumclaw, WA: Pleasant Word, 2007), 27.

6. Exodus 16:5; 22–23.

7. Hebrews 4:11; 1 Timothy 6:12.

8. Psalm 27:4.

9. Miles J. Stanford, *The Green Letters: Principles of Spiritual Growth* (Grand Rapids, MI: Zondervan, 1975), 81.

10. Ravi Zacharias, *Recapturing the Wonder* (Brentwood, TN: Integrity Publishers, 2003), 41.

11. Hannah Whitall Smith, *The Christian's Secret of a Happy Life* (Nashville, TN: Thomas Nelson, 1999), 104.

Chapter 11: Practicing Simplicity: One True Word

1. Ernest Hemingway, *A Moveable Feast* (New York: Bantom, 1965), 24.

2. James 1:19.

3. Wayne Martindale and Jerry Root, eds., *The Quotable Lewis* (Wheaton, IL: Tyndale House, 1986), 265.

4. Lois Tverberg with Bruce Okema, *Listening to the Language of the Bible: Hearing It through Jesus' Ears* (Holland, MI: En-Gedi Resource Center, 2004), 61.

5. Ibid., 4.

6. Ravi Zacharias, *Recapture the Wonder* (Brentwood, TN: Integrity Publishers, 2003), 159.

7. Tedd Tripp, *Sheparding a Child's Heart* (Wapwallopen, PA: Shepherd Press, 1995), 84.

8. Valerie Bennett, Ginger Faulk, Anna Kovina, and Tatjana Eres, *Inheritance Law in Uganda: The Plight of Widows and Children*, 7 Geo. J. Gender & L. 451 (October 16, 2006). See this article at http://lawprofessors.typepad.com/trusts_estates_prof/2006/10/inheritance_law_1.html.

9. Quentin Schultze, *An Essential Guide to Public Speaking: Serving Your Audience with Faith, Skill and Virtue* (Grand Rapids, MI: Baker Academic, 2006), 16.

Chapter 12: Practicing Beauty: Intentional Submission

1. George Eliot, *The Mill on the Floss* (New York: Penguin Classics, 1994), 391.

2. Betty Blake Churchill, *Fantasy: An Insatiable Desire for a Satisfying Love* (Orlando, Fl: CruPress, 2005), 36.

3. Dallas Willard and Jan Johnson, *Renovation of the Heart in Daily Practice: Experiments in Spiritual Transformation* (Colorado Springs, CO: NavPress, 2006), 113–118. See also Romans 12:1–2.

4. Matthew 10:28; 1 Thessalonians 4:3–8; 1 Timothy 4:8.

5. Genesis 4:5; Genesis 31:2; Deuteronomy 28:50; 1 Samuel 17:42; Nehemiah 2:2; Proverbs 15:13.

Chapter 13: Practicing Service: Pondering Me Less

1. John and Barbara Wilkke, *Abortion Questions and Answers: Love Them Both* (Cincinnatti, OH: Hayes Publishing, 2003), 291. Europe and Japan are dying. Japan has a total fertility rate of 1.4 (children per woman, with a rate of 2.1 that is needed to maintain population parity). If this continues in the next century, its population will drop from 125 to 55 million. Europe is in a similar fix. Eighty-three countries

are now below replacement fertility levels. This encompasses 2.7 billion people, 44 percent of the world's population.

2. Acts 2:42–47.

3. Philippians 2:1–8.

4. Ronald Sider is quoted in Heather Zydek, *The Revolution: A Field Manual for Changing Your World* (Orlando, FL: Relevant Books, 2006), 200.

Chapter 14: Practicing Confession: True Declarations

1. Charles Williams, *He Came Down from Heaven and the Forgiveness of Sins* (Berkeley, CA: Apocryphile Press, 2005), 68.

2. "The Natural," *Vogue Magazine* (September 2007). This is the feature story with First Lady Michelle Obama. You can find this article at http://www.style.com/vogue/feature/2007_Sept_Michelle_Obama.

3. C.S. Lewis, *Mere Christianity* (New York: MacMillan, 1952), 165.

4. Nathaniel Hawthorne, *The Scarlet Letter* (New York: Penguin Books, 2003), 176.

5. For this information on feminism see Darrow Miller with Stan Guthrie *Nurturing the Nations: Reclaiming the Dignity of Women in Building Healthy Cultures,* (Colorado Springs, CO: Paternoster, 2007), 73.

6. Ibid., 48.

Chapter 15: Practicing Guidance: Where Wisdom Rides

1. James 1:5.

2. Lois Tverberg with Bruce Okema, *Listening to the Language of the Bible: Hearing It through Jesus' Ears* (Holland, MI: En-Gedi Resource Center, 2004), 29.

3. Richard Foster, *Celebration of Discipline: The Path to Spiritual Growth,* (New York: HarperCollins, 1998), 176.

4. Acts 13:2.

5. Hannah Whitall Smith, *The Christian's Secret to a Happy Life* (Nashville, TN: Thomas Nelson, 1999), 101.

Chapter 16: Practicing Worship: A Chosen Response

1. Dan Allender, "The Hidden Hope of Lament," *Mars Hill Review,* Premier Issue (1994): 25–38.

2. Abraham Heschel, *God in Search of Man: A Philosophy of Judaism* (New York: Farrar, Straus and Giroux, 1976), 70.

Chapter 17: Practicing Celebration: Breathing Is the Occasion

1. Matthew 16:1–4.

2. Joel C. Rosenberg, *Epicenter: Why the Current Rumblings in the Middle East Will Change Your Future* (Carol Stream, IL: Tyndale House, 2006), 227–228.

3. John J. Parsons, "Common Hebrew Blessings," September 15, 2006, online at http://www.hebrew4christians.net/Blessings/blessings.html.

4. Nehemiah 8:10.

5. Richard Foster, *Celebration of Discipline* (New York: HarperCollins, 1978), 198.

Chapter 18: The Space between Us: Guilt Crucified

1. Leviticus 5:14–19; Romans 3:9–26; Romans 5:12.

2. C.S. Lewis, *Letters to an American Lady*, Entry 21, July 1958 (Grand Rapids, MI: Eerdmans, 1967), 77.

3. 2 Corinthians 4:7.

Chapter 19: A Way of Seeing: Purposed Vision

1. This information about Van Gogh is found in Brenda Ueland, *If You Want to Write—A Book about Art, Independence and Spirit* (Saint Paul: Greywolf Press, 1987), 19.

2. Exodus 4:11–12; 2 Corinthians 3:18; Ephesians 4:24; Philippians 3:12–14; 2 Peter 1:3.

3. Neil T. Anderson, *Victory Over Darkness* (Ventura, CA: Regal Books, 2000), 131.

4. Larry D. Stephens, *Your Child's Faith* (Grand Rapids, MI: Zondervan, 1996), 37.

5. David Brenner, *The Gift of Being Yourself: The Sacred Call to Self-Discovery* (Downers Grove, IL: InterVarsity Press, 2004), 95.

6. *Soren Kierkegaard's Journals and Papers, vol. 5: Autobiographical Part 1: 1829–1848* (Indiana University Press, 1978). Entry August 1, 1835.

7. Andy Stanley, *Visioneering: God's Blueprint for Developing and Maintaining Personal Vision* (Colorado Springs, CO: Multnomah Publishers, 1999), 9.

8. C.S. Lewis, *Mere Christianity* (New York: Collier Books, 1960), 104.

Chapter 20: Out Of Our Hands: The Release

1. This information on the disciples can be found online in an article entitled "Reasonable Faith: Rational Evidences for Jesus Christ: What Happened to the 12 Disciples of Jesus?" at http://www.ichthus.info/Disciples/intro.html.

2. Reverend Barbara Brown Taylor, *The Seeds of Heaven: Sermons of the Gospel of Matthew* (Louisville, KY: Westminster, 2004), 79.

The Water Crisis

1. The information on these pages was taken by permission from the Web site of Living Water International at www.water.cc.

2. United Nations Development Program, "Beyond Scarcity—Power, Poverty and the Global Water Crisis," *Human Development Report 2006.* See online report at http://hdr.undp.org/en/reports/global/hdr2006.

3. I would also like to direct readers to these books on the global water crisis: Fred Pierce, *When the Rivers Run Dry: Water—The Defining Crisis of the Twenty-First Century* (Boston, MA: Beacon Press, 2006); and Marq De Villeirs, *Water: The Fate of Our Most Precious Resource* (New York: Mariner Books, Houghton Mifflin Company, 2000).